Sony® α DSLR A300/A350 Digital Field Guide

Sony® α DSLR A300/A350 Digital Field Guide

Tom Bonner

WILEY

Wiley Publishing, Inc.

Sony® α DSLR A300/A350 Digital Field Guide

Published by
Wiley Publishing, Inc.
111 River Street
Hoboken NJ 07030-5774
www.wiley.com

Copyright © 2009 by Wiley Publishing, Inc., Indianapolis, Indiana

Published simultaneously in Canada

ISBN: 978-0-470-38627-9

Manufactured in the United States of America

10 9 8 7 6 5 4 3 2 1

WILEY

About the Author

Tom Bonner has been a photographer and journalist for more than three decades. His early work revolved around automotive and motorsports subjects, and his photos appeared extensively in automotive and travel magazines in the U.S. and Canada. He also edited a monthly publication for the International Show Car Association and traveled throughout the U.S. on photographic assignments for the ISCA.

At the start of the electronic publishing revolution, Bonner accepted a position with Applied Graphics Technology, where he worked closely with several major advertising agencies helping develop digital workflows and retouching ad images for Chevrolet, Buick, and GMC trucks.

The turn of the millennium found Bonner in coastal North Carolina. He continued to employ his photographic skills, recording golf courses, exclusive beach homes, and architectural subjects with both film and digital cameras.

Always a Minolta user, Bonner transferred his allegiance to the fledgling Sony Alpha dSLR line when Sony took over the photographic assets of Konica Minolta Corporation. In addition to exploring the new dSLRs from Sony, Bonner began to blog about the Alpha dSLR models at Alphatracks.com. Covering anything of interest to Sony Alpha and Minolta SLR owners, Alphatracks serves as an outlet for Bonner's abiding interest in cameras, lenses, and photographic techniques.

Credits

Acquisitions Editor
Courtney Allen

Project Editor
Chris Wolfgang

Technical Editor
Bert Pasquale

Copy Editor
Lauren Kennedy

Editorial Manager
Robyn B. Siesky

Vice President & Group Executive Publisher
Richard Swadley

Vice President & Publisher
Barry Pruett

Business Manager
Amy Knies

Senior Marketing Manager
Sandy Smith

Project Coordinator
Erin Smith

Graphics and Production Specialists
Carrie A. Cesavice
Andrea Hornberger
Jennifer Mayberry

Quality Control Technician
Jessica Kramer

Proofreading
Lynda D'Arcangelo

Indexing
Sherry Massey

For Vicki, who waited while I wrote...

Acknowledgments

Special thanks to Courtney Allen, who believed in me enough to suggest I write this book; and who was a constant encouragement during the book's development. I would also like to thank Chris Wolfgang, who as project editor, went out of her way to answer questions and make suggestions that unquestionably made for a better book. Technical editor Bert Pasquale was another source of encouragement, and it was comforting to know that with his long experience with Sony and Minolta SLR cameras he was watching my back. Finally, I owe thanks to Lorena D'Amato of Paine PR, who always responded immediately to requests for specifications and artwork regarding the Sony Alpha A300 series.

Contents

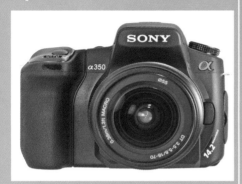
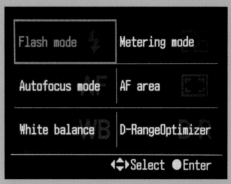

Chapter 4: Lenses and Accessories 63

Chapter 5: Lighting Fundamentals 85

Part III: Shooting with the Alpha A300 107

Chapter 6: Photo Subjects 109

Chapter 7: Creating a Digital Workflow 193

Appendix A: Sony Alpha Resources 213

Appendix B: Troubleshooting 221

Glossary 231

Index 239

Introduction

With the introduction of the Alpha A300 and its near twin the A350, Sony has blurred the distinction between introductory and advanced dSLR cameras. Both models include the features that users have come to expect in a high quality dSLR, but Sony has added icing to the cake with the exciting Quick Live View system. While other dSLR makers are also offering live view systems, the live view on the Sony A300 series is in a class by itself. At the time this was written, no other dSLR has a live view system that can match the features Sony has incorporated into the LCD on the A300 series.

Of course, the live view technology is only a single part of the A300 series. Both models include Sony's Super Steady Shot image stabilization feature, which incorporates stabilization in the body, rather than in the lens. Image stabilization reduces camera shake in low light conditions, and with the Sony system, users do not need to buy special image stabilized lenses; nearly every A-mount lens will be stabilized on the A300 series.

With a maximum shutter speed of 1/4000 second and a choice of either a 10 or 14 megapixel sensor, the A300 series provides features that, until recently, even the most professional camera couldn't match.

The great news is that Sony gives users the choice between a simple to use automatic exposure system or a fully customizable manual set up. No matter what level your photography experience, you can tune the A300 series to match.

Which illustrates the need for this book. Whether the A300 series camera is your very first dSLR or you have been shooting with a SLR for many years, the intent of this book is to help you get the most out your camera. While the automatic and semi-automatic features will allow you to create incredible images, automatic settings will only take you so far. If you really want to exploit all the features on the A300 series, you will need to delve beyond the automated settings and take full control of the camera. Both models in the A300 series are simple to use, but a full understanding of the controls will pay huge dividends when you are ready to move beyond creating mere snapshots.

Getting the most from this book

No matter where you stand on the photographic experience scale, it will be worth your while to study Chapters 1 and 2. These chapters explore the controls and menus on the A300 series in depth, and after reading them you will be well equipped to set up your camera for any conceivable photographic situation.

Chapter 3 will review the basics of photography, especially as they relate to digital SLR cameras. By reading through Chapter 3, you will be able to fully take advantage of the information you learned in Chapters 1 and 2.

Chapters 4 and 5 explore the accessories available for the A300 series, most notably auxiliary lenses and electronic flash units. If you are brand new to the world of dSLR photography, you may elect to skip these chapters the first time you read through this book. At some point, however, most dSLR owners find a need for additional lenses and lighting equipment. When that time comes, a careful perusal of Chapters 4 and 5 will prove very helpful.

Chapter 6 is the meat of the book, as it consists of exercises designed to hone and polish your photographic skills. If you take the time to work through some or all of the exercises in Chapter 6, you will be well on your way to mastering the A300 series.

Chapter 7 concludes the book by exploring your workflow options. There is a myriad of software options available to process and edit the images you shoot with the A300 series, and you should make sure you are aware of your software choices.

Finally, you will find troubleshooting information and a list of resources for Sony Alpha users in the Appendix section. The information here can help you to keep your A300 series healthy and introduce you to the extended Sony Alpha community.

Remember, this is a field guide, and as such it is designed to be carried with you on your photography excursions. Keep it handy in your camera bag, because you never know when you will encounter a situation where it could prove helpful. Don't worry about the book becoming worn or dog eared. If you wear this book out while exploring photographic pursuits, you will undoubtedly increase your skills and knowledge. That means the book will have done it's job well.

Finally, don't just read about photography. Go out and have fun with your camera!

Using the Sony Alpha A300 Series

◆ ◆ ◆ ◆

◆ ◆ ◆ ◆

Exploring the Sony Alpha A300 and A350

The Sony A300 and Sony A350 are twins: With the exception of the sensor, the cameras are identical. All the controls and menus work in exactly the same way. If you placed either an A300 or A350 into the hands of an experienced A300 series user, she wouldn't know which camera she was using unless she peeked at the camera's nameplate.

Of course, the real difference is the sensor inside the camera. The A350 records 14.2 megapixels (mp) of information, while the A300 captures 10.2 mp of data.

Some people will jump to the conclusion that the A350, with its higher resolution sensor, is the better of the two cameras. In truth, both cameras are great dSLRs, and are designed to appeal to different users. For some photo pursuits, the A300 is definitely the better choice, while in other situations the A350 excels. To say that one camera or the other is superior is a misnomer. At the end of the day, each camera can record wonderful images that meet its owner's particular needs.

Some people think 14 mp is overkill, especially when you consider that, until recently, many professional photographers were shooting with 6 mp cameras. Don't overlook the advantages of a high-resolution sensor, however. In the first place, that high resolution will allow you to make huge prints. When images from lesser cameras start to fall apart, images from the A350 will still have resolution to make an excellent poster or wall hanging.

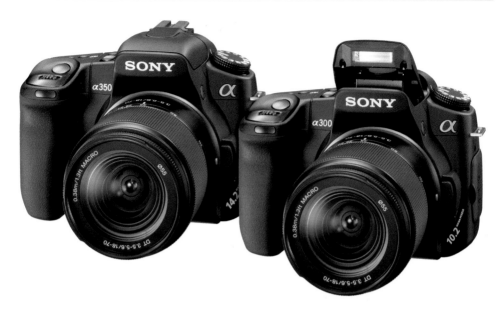

1.1 The A300 and A350 are functionally and cosmetically identical. The A350 boasts a higher resolution sensor, while the A300 offers a faster burst mode and marginally better image quality at high ISO settings.

The other major advantage comes when you crop images. If you need to crop extensively, images from a higher resolution sensor give you more pixels to work with. If you crop away 75 percent of the pixels from a 14.2 sensor, you still have 3.55 mp to work with. Eliminate 75 percent of a 10.2 mp sensor and you are left with 2.55 mp. If you always shoot in a studio, and have full control of the crop, then this may not be important to you. If you shoot sports, concerts, political functions, or other events where unexpected photo opportunities require you to shoot even when you can't fill the frame, that extra 4 mp could be a lifesaver.

Despite the advantages of the A350's sensor, however, the A300 provides its own strong points.

Because it is dealing with less pixel data, the A300 can shoot at 3 frames per second (fps) when using the optical viewfinder. The A350

can only muster 2.5 fps. A half frame a second may not sound like a major difference, but that means in a two second burst; the A300 can squeeze out six frames to the A350's five. That extra frame could be the most important in the sequence.

A300 users are also dealing with smaller image files. File sizes of RAW and large JPEGs from the A350 are roughly 4 mp larger than those from the A300. This necessitates more space to store the images, reduces the number of images that can be recorded on a memory card, and requires more computer power to process images.

Finally, there is the issue of high ISO noise. In order to shoehorn four more megapixels onto the A350's sensor, Sony engineers had to make the individual pixels smaller. Smaller pixels collect less light, so the A350 requires more image amplification than the A300 to achieve a specific ISO. More

amplification creates more noise, so the A300 enjoys a slightly better image quality at higher ISO settings.

None of these comments are intended to suggest that either camera is flawed. At the end of the day, both models are excellent, full-featured dSLRs that can provide stunning images.

Working with the Sony Quick AF Live View System

1.2 Most models of the A300 series are black, but Sony has announced a champagne-colored A300 version, which is only available from the Sony-Style website. Reportedly, Sony will offer a very limited champagne-colored A350 in the Japanese market.

The A300 series has broken new ground in the dSLR arena, as both models come with Sony's brand new Live View system. Sony is not the first dSLR maker to offer a live LCD

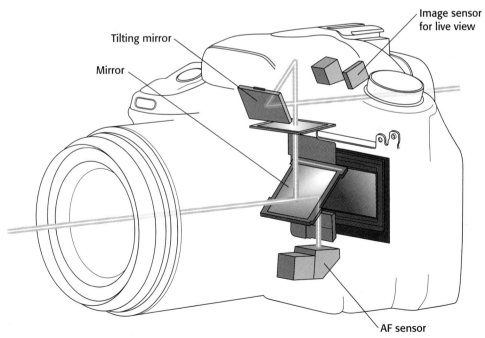

1.3 Unlike most of the competition, Sony's Quick AF Live View system features two sensors. By focusing off the second sensor, the Alpha design can focus rapidly in the Live View mode, a major advantage over competitors.

view, but the A300 live preview offers significant improvements over similar systems from the competition.

While almost all point-and-shoot cameras allow you to compose off the rear LCD screen, until recently dSLR users could only compose and focus with the camera's optical viewfinder. Because SLR cameras utilize a mirror in the light path, it is difficult to design an LCD preview system that allows users to use the LCD screen as a viewfinder.

Sony's approach to this dilemma is to use a switch to allow the user to switch between the optical viewfinder and the LCD.

In the normal optical viewfinder mode, the camera operates like any other SLR. When you look through the viewfinder, a system of mirrors and a ground glass allow you to see exactly what the lens is seeing. In this mode, the LCD is strictly for selecting menu options and viewing images you have already shot.

Moving the switch on the top of the camera into the Live View mode changes the camera from a dSLR into an electronic viewfinder (EVF) camera. The mirror moves out of the light path and the optical viewfinder is no longer useable. Instead, a second sensor located in the bottom of the mirror chamber displays the view through the lens

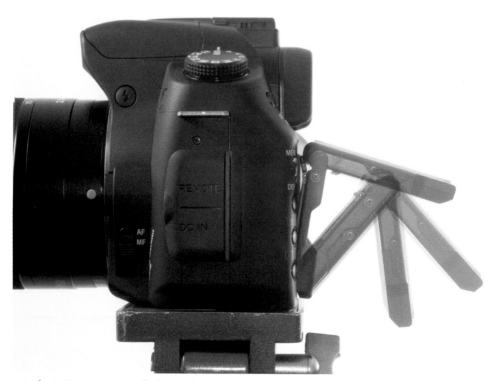

1.4 The LCD screen can tilt through a wide range of angles, so you can see the preview image from above, below, and behind.

on the LCD screen. You can focus or zoom and see the results instantly. If you move the camera very quickly, the image on the LCD screen may smear slightly, but all in all, the LCD view is perfectly useable as a viewfinder.

By using an additional sensor, Sony's system is much faster than competitors that read the live view data off the actual image-capturing sensor. Most of these system can't focus very well in the Live View mode, because the mirror has to be up to read the data from the sensor, and come back down to focus. Thus, these systems are much slower when shooting in Live View because the camera waits until the time of the shot to focus the lens, requiring additional time before the shutter can fire.

In contrast, Sony's dual sensor system can autofocus as fast in the Live View mode as it can with the optical viewfinder, earning the A300 series the reputation of having the fastest and most accurate live view system to date. As the owner of an Alpha A300 series camera, you may not appreciate just how much better the Sony Live View is until you compare it to dSLRs from other makers. Some competing models are starting to improve, but most of the live view implementations from other manufacturers fall short compared to the system A300 series owners enjoy.

If Sony's Live View simply offered a fast LCD live view, it would still be superior to the competing live view technologies. But Sony didn't stop there. The LCD screen tilts up and down, making it much more useful. Tilt the top of the screen out and you can use the LCD screen when the camera is above you. This is very helpful if the camera is on a tall tripod, or when you're holding the camera above to get a "bird's eye view" of your subject.

Tilting the screen out from the bottom gives you the opposite effect. Now you can use the LCD screen as a waist-level viewfinder or get an extremely low point of view without crawling on the ground.

The angle of the LCD is fully adjustable up to 90 degrees from the camera's back, so you can obtain the perfect angle for viewing.

Tip *Using the Live View LCD as a waist-level viewfinder is a great way to add interest to your images. By shooting up at your subject, you create the impression that they are strong, brave, and larger-than-life. The A300 series gives you the option to shoot either from eye level or waist level with a flick of a switch.*

You have to remember to switch back to the OVF setting when you want to use the optical viewfinder. Until you do, the optical viewfinder will be totally black.

One other component of the Live View mode is the Smart Teleconverter feature. While not strictly part of the Live View system, the Smart Teleconverter relies on the Live View system to display the effect of the digital zoom.

The term teleconverter implies that the camera is somehow magnifying the focal length of the lens to provide a greater telephoto effect. That is what an actual teleconverter does, so new users of the A300 series can be forgiven if they expect the same thing to happen when they employ the Smart Teleconverter feature.

That is not what happens, however. If Sony had called the feature "Smart Cropping," users might have a better idea of what the feature actually does.

The Smart Teleconverter doesn't magnify anything. Instead, it simply crops away a portion of the image to make the final image look larger (1.4 times or 2 times larger). The result is exactly the same as if you recorded a full-resolution JPEG, then cropped it to a smaller size in a software program on your computer. Both images would look like they were taken with a longer focal length lens, but the resulting resolution would be lower.

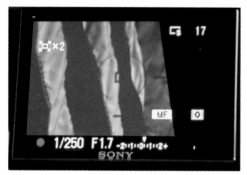

1.5 The Smart Teleconverter actually crops away parts of the image to create the appearance of image magnification.

That doesn't mean the Smart Teleconverter is useless. If you intend to print images directly from the memory card, with no postprocessing, the Smart Teleconverter will make your images appear as if they were taken with a longer focal length lens. Because the image is already cropped to a smaller size, the image on the print will be enlarged, making it appear it was taken with a longer telephoto lens.

The Smart Teleconverter can only be used when the camera is in the Live View mode. You cannot use the Smart Teleconverter in RAW capture mode.

To use the Smart Teleconverter, follow these steps:

1. **Turn on Live View.**

2. **Point the camera toward the subject and observe the subject on the LCD screen.**

3. **Press the Smart Teleconverter button.**

 The Smart Teleconverter icon with the indication x1.4 appears on the LCD and the preview image appears 1.4 times larger.

4. **Press the Smart Teleconverter a second time.**

 The Smart Teleconverter icon with the indication x2 will appear on the LCD screen and the preview image will appear 2 times larger.

5. **Pressing the Smart Teleconverter button a third time returns everything to the normal 1 to 1 setting.**

An image taken at the 1.4x or 2x setting will be cropped to the view displayed on the LCD.

If the camera is switched off or the LCD blacks out to save power, the Smart Teleconverter returns to the normal 1 to 1 setting.

If the camera is not in Live View mode or the camera is set to record RAW files, pressing the Smart Teleconverter button displays the cryptic notice "Invalid Operation" on the LCD screen.

Mastering the A300 Series Controls

Your A300 series camera includes several controls that enable you to take full charge of your photographic experience. Knowing where those controls are and how to use them may seem intimidating at first, but that's where this section comes in to help.

Front camera controls and features

Looking from the front, the A300 series controls are kept to a minimum. On the left is the built-in grip with the shutter release button and control dial.

The control dial is used to adjust either the aperture or shutter speed, depending on which mode the camera is in.

Below the control dial, you will find the self-timer lamp. It flashes red when the self-timer is counting down to make an exposure.

On the right front, you will find the lens release button. To remove a mounted lens, press the release button and twist the lens counterclockwise until it is free.

Top camera controls and features

The A300 series has several controls located on the top plate of the camera. A single mode dial is located to your left when you look at the camera from a shooting position. You will use the mode dial often to control which picture-taking function you want to

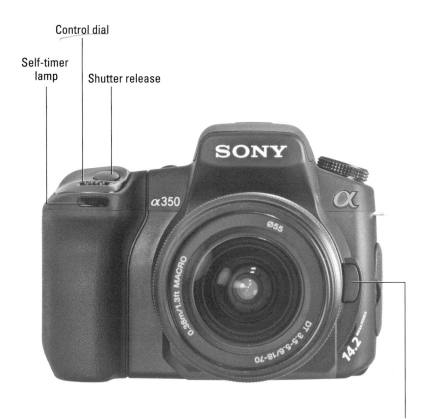

1.6 The business end of the A300 series is simple and uncluttered. It is also the only angle where you can tell the two models apart, thanks to the name badge and megapixel decoration.

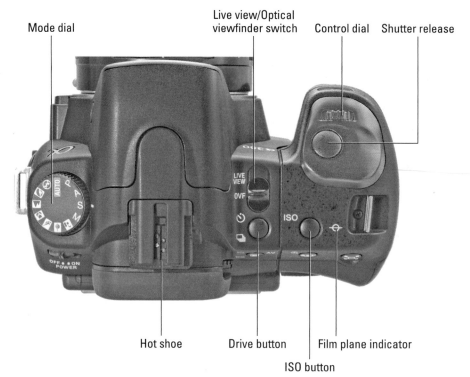

1.7 The A300 series from the top, showing the mode dial, prism, and controls.

use. Many settings and menus are dependent on which position the mode dial is in; you will always need to be aware of which mode you are using when setting up your camera.

 The mode dial and available modes are explored in depth in Chapter 2.

On the very top of the camera you will find the hotshoe for the A300 series. The hotshoe provides a location to attach external flash units and accessories. Like all Sony Alpha dSLRs, the hotshoe is derived from the proprietary Minolta shoe design.

Some other Sony Alpha models come with a plastic cap that keeps dirt and debris from the hotshoe contacts. Sony doesn't provide

a cover with the A300 series, but it does sell caps as an accessory on the Sony Style Web site. It isn't strictly necessary, but adding the optional cap will keep your hotshoe clean and give your camera a more finished appearance.

 The Sony hotshoe design is discussed further in Chapter 5.

To the right of the prism area, you will find the Live View switch and the drive button. You have already learned about the Live View switch in the live view portion of this chapter.

The drive button brings up a menu on the LCD that allows you to select how the A300 series handles image capture sequence. There are six modes in the drive menu:

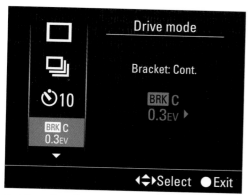

1.8 Pressing the drive mode button displays a menu allowing you to select single or continuous shooting modes, automatic bracketing options, and white balance bracketing. You also use the drive menu to engage the self-timer.

✦ **Single Shot mode.** This is the default drive setting. In Single Shot mode, the camera takes a single shot, no matter how long you keep the shutter release pressed down.

✦ **Continuous mode.** In the Continuous or burst mode, the A300 series fires the shutter contin- uously for as long as you keep the shutter release pressed down. This is similar to a film motor drive mode and is especially useful for sports and action photography. Certain camera settings affect how the con- tinuous shooting mode works.

If you shoot in RAW or the RAW + JPEG modes, both models have a limit to how many images you can capture in a single burst (which is due to the buffer capacity). If you record in JPEG mode, the A300 series happily keeps shooting until you fill up your memory card.

Table 1.1 lists the maximum num- ber of images that can be captured in a single burst by both models of the A300 series.

Because the image files are smaller, the A300 offers a faster burst mode of 3 fps and can capture a six-image RAW sequence. The A350, with its larger images, can only capture a four-frame RAW sequence at a speed of 2.5 fps.

On both models, if you switch to the live view mode, the frame rate drops to 2 fps regardless of image quality settings.

✦ **Self-timer.** As a photographer, you are usually left out of the photos you take, because you are behind the lens rather than in front of it. The self-timer allows you to set a time delay so you can place your- self in the scene. Many photogra- phers have also found that using the self-timer can reduce camera shake when taking long exposures with a tripod. Because the timer delays the firing of the shutter, any vibration caused when pressing the shutter button will have dissipated by the time the shutter opens.

Using the drive menu, you can elect to shoot with either a ten-second or two-second time delay. When you scroll to the self-timer icon in the menu, you can use the right and left buttons on the controller to choose the delay you prefer. Pressing the center of the controller locks in the self-timer setting. With the camera on a tripod or other firm support, you can focus and compose nor- mally. When you press the shutter release button, the camera fires after the appropriate delay.

Table 1.1
Maximum Continuous Image Capture Rates

File Type	A350 Capture Rate	A300 Capture Rate
RAW	Maximum: 4	Maximum: 6
RAW + JPEG	Maximum: 3	Maximum: 3
JEPG Fine	Unlimited	Unlimited
JPEG Standard	Unlimited	Unlimited

Note *The self-timer mode remains activated even if you turn the A300 series off. When you turn the camera on, you will still be in the self-timer mode, which could cause you to miss the next shot. You should get in the habit of disabling the self-timer when you are finished using it. Use the drive mode menu to select another mode, such as single or continuous shooting to disable the self-timer.*

When using the optical viewfinder with the self-timer, stray light can enter through the viewfinder because there is no one behind the camera. This light can confuse the meter, causing inaccurate exposures. Sony includes a plastic cover with the A300 series that is designed to prevent light from entering the camera through the viewfinder. Unfortunately, to use the cap, you have to remove the rubber eye shade and then snap the cap in place. A much easier solution is to simply switch into the live view mode, which eliminates any light from the viewfinder affecting exposure.

✦ **Continuous auto bracketing.** When faced with tricky lighting situations, good photographers bracket their image exposures, deliberately taking a series of images with different exposures. By varying the exposure across the series, there is a much greater chance that one of the shots in the series will be perfectly exposed.

The A300 series allows you to automate the bracketing process, automatically taking a series of normal, underexposed, and overexposed images. In the Continuous auto bracketing mode, you focus and compose normally. When you hold the shutter release button down, the A300 series will fire three shots in the burst mode, varying the exposure each time it records an image. You have the option to vary the exposure by ±0.7 stop or ±0.3 stop, using the controller.

Continuous auto bracketing makes the entire process of taking a bracketed sequence painless.

✦ **Single shot bracketing.** There may be situations where you want to bracket exposures, but don't want to shoot the images in a continuous burst. If you select Single Shot bracketing mode, the camera will first take an image at the base exposure. The next time you shoot a picture, the photo is underexposed by the chosen value. The following image will be overexposed

by the preferred amount. To determine your current place in the sequence, depress the shutter release button halfway down and you will see the indicator br1/br2/br3, respectively.

You can bracket flash exposures in the Single Shot mode, providing time for the flash to recycle after each image. Once again, the camera uses the base exposure, then shifts the flash exposure to a lesser and greater amount in an attempt to achieve the perfect exposure. Indicators Fbr1/Fbr2/Fbr3 show the sequence location.

If you set flash or exposure compensation (varying the exposure from the camera's default settings), the A300 series uses the compensation exposure for its base exposure and bracket on either side of the base.

You can also bracket in the Manual exposure mode. By default, when in Manual exposure mode, the camera brackets by shifting the shutter speed. If you wish to bracket in Manual exposure mode using the aperture, you can press and hold the AEL (Auto Exposure Lock) button on the back of the camera. If the base exposure occurs with the lens at maximum aperture, there is obviously no way to open the lens further. In this case, if you set the camera to Manual exposure mode and hold the AEL button, the third exposure and the base exposure will be the same.

✦ **White balance bracketing.** The A300 series is very good at choosing an appropriate white balance setting in the Auto mode. In tricky, multiple light scenarios, the automatic white balance may not produce accurate colors. You can use white balance bracketing to shoot a series of exposures. Unlike exposure bracketing, in the White balance bracket mode, the A300 series will record a single image and apply three different white balance settings to that image. When you download images from your memory card or view images on the LCD, you will see there are three images for each photo recorded in the White balance bracketing mode. Each will have a slightly warmer or cooler temperature. Using the controller button, you can choose to bracket the white balance by a high (hi) or low (lo) amount. When set to the lo mode, the A300 series brackets in increments of 10 mired. In the hi mode, the white balance bracket is changed by 20 mired units.

Note *Mired is a unit of measurement used to indicate the temperature of light. There are complicated formulas to express the mired values of different light sources. You don't need to understand the mired scale to use the A300 series white balance bracketing feature. All you really need to know is that in the hi mode, the camera shifts the white balance temperature twice as much as in the lo mode.*

Tip *It is more important to use white balance bracketing when shooting in JPEG mode. RAW files allow for rendering a full range of color adjustments without penalty to the image, while shifting the color of a JPEG image may produce undesirable results.*

1.9 The White balance bracket mode captures a single photo and applies different white balance (WB) adjustments to three copies of the image. When you download the results from your memory card, there will actually be three images, each with a different WB adjustment.

The final button on the top of the camera is the ISO button. Pressing this button brings up a menu, allowing you to select which ISO you want to shoot with. In the Auto mode, the camera will attempt to set the best ISO for the lens and lighting conditions. You can also choose to set a dedicated ISO setting between 100 and 3200.

Cross-Reference *You will find a full discussion of ISO and how it affects your images in Chapter 3.*

Right side of the camera

On the right (as viewed from the back of the camera) of the A300 series, you will find the door that opens to provide access to the compact flash slot and the USB terminal.

Sony has chosen to use a two-position latch on the door. To open the compartment, you first must slide the door to the rear of the camera, then swing it open. If you try to swing the door open before the slide latch is cleared, you could damage the door or the camera. It is a good idea to practice opening the door until the process becomes second nature. If you need to switch memory cards in a hurry, you want to be able to open the compartment quickly and confidently.

It is also wise to memorize the orientation of the compact flash card. The label of the CF card should be facing you when you insert it. The slot has ramps to prevent a card from being inserted the wrong way, but when you are rushing to switch cards during an important event it is possible to damage the card or camera by forcing the card

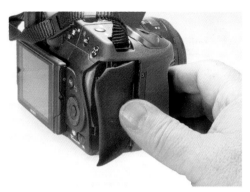

1.10 Practice opening the Compact Flash (CF) compartment door, so you can rapidly change memory cards when you need to.

past the ramps. Remember the label has to face you when you are inserting a card.

The USB port provides a variety of functions. You can use the port to:

✦ Transfer images directly to a computer (see Chapter 7).

✦ Print images directly to a PictBridge-compatible printer (see Chapter 2).

✦ Display images on a compatible television set. You can use the supplied cable to connect the A300 series to television with a video input jack. Turn both the camera and television off, then connect the cable between the camera and television. Turn both devices on and images from the memory card in the A300 series will be displayed on the TV set. Use the controller to switch images. You may have to set up your television for video input; consult the manual that came with your television set.

When the A300 is connected to a television, the rear LCD will be inactive.

Left side of the camera

The left side of the A300 series presents you with the autofocus (AF) switch, the popup flash button, and the covered ports for the remote release and DC input.

The AF switch (located directly under the lens release button) controls whether the camera will use auto or manual focusing. Switch into Manual when the camera cannot lock in the focus on your selected subject. You control the focus by turning the manual focusing ring on whichever lens is attached to the camera.

Unlike some earlier Alpha dSLR models, the A300 series users can raise the pop-up flash with a button on the left side of the pentaprism housing. In truth, this isn't a major advancement, as it was always a simple matter to lift the flash up manually. Still, there may be times when you are shooting and want to use the flash as a fill light. You can touch the flash pop-up button and the flash housing will spring up, ready for action. You can continue shooting without interruption. It is a little thing, but small touches like this make either A300 series model a great camera to shoot with.

1.11 Pressing the flash pop-up button brings up the flash when you need a little artificial light.

Underneath the plastic cover you will find the ports for DC power and the optional remote cable release.

If you will be using your A300 series in a studio or other location where AC power is available, it can be convenient to power the camera from a wall outlet. You will lose the freedom of moving about without a cable, but there is no need to be concerned about battery life. The camera can be used indefinitely when plugged into a wall outlet. To use the DC-In port, you will need the optional AC-VQ900AM adapter and charger, available from larger camera stores and the SonyStyle Web site.

The remote cable port allows you to trigger the camera with an electronic cable release. Simply plug the release into the port and you can use the release to fire the camera without accidentally jarring it when you press the shutter button. Sony sells a release with a 16-foot cable, so you can trigger the camera even when you are several yards away.

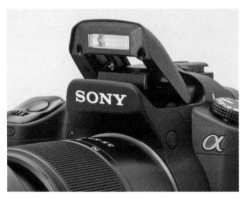

1.12 You can use the pop-up flash in a variety of low light and fill flash applications. You can also use it as a controller for the Sony wireless flash system.

Back of the camera

The back is where the bulk of the A300 series controls are located, as well as the all-important LCD screen.

On the right, you will find the power switch as well as the controls for displaying the menus, recorded images, and camera settings. Using the buttons on the left edge of the camera, you can activate the menus, display the current camera settings, and play back the recorded images on a memory card. You can also delete a single image without taking time to delve into the menu system to locate the delete image command.

The middle of the camera back is occupied by the eyepiece and the LCD screen. If you look closely at the eyepiece, you will see two sensors that are used by the Eye Start system. When the Eye Start system is activated, these sensors will activate the AF system as soon as they detect someone is looking through the viewfinder. This can improve autofocus response, as the camera will attempt to focus immediately, without waiting for you to press the shutter release button part way down. Chapter 2 teaches you how to turn the eye start system on or off using the custom menu.

The diopter adjustment wheel is located on the right side of the eye piece. You can use the wheel to adjust the viewfinder to match your eye sight. Find a brightly lighted scene and turn the wheel while looking through the viewfinder. After the lens completes autofocus, adjust the wheel to display the clearest and sharpest image. You will find this adjustment will make a major difference when composing and focusing, especially if you have less than perfect vision.

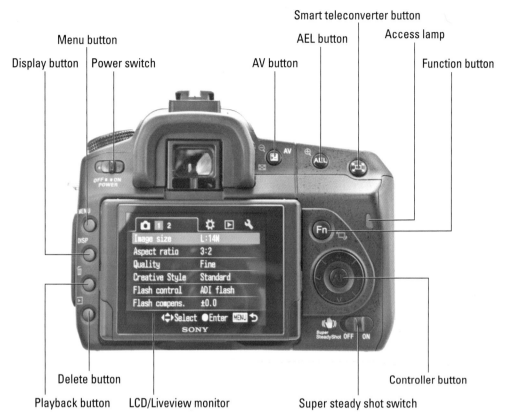

Smart teleconverter button

Menu button AEL button Access lamp

Display button | Power switch AV button Function button

Delete button Controller button

Playback button LCD/Liveview monitor Super steady shot switch

1.13 The back of the A300 series contains a neat arrangement of controls and dials. If you take some time to learn the function of each control, you will become a much better photographer.

Sony also sells eyepiece correctors designed to snap in place over the viewfinder and correct for vision problems. Eyepiece correctors are available in diopter ranges from +3 to −4. If the diopter wheel cannot adjust the viewfinder to meet your needs, investigate adding an eyepiece corrector to compensate for your near- or farsightedness.

Across the top of the camera's back, you will find three buttons. You have already learned about the Smart Teleconverter button in the live view section of this chapter. The other two buttons are the AEL and AV buttons.

These two buttons are combo buttons, meaning they control different functions of the camera depending on the mode you are in.

The main purpose of the AEL button is to lock the exposure in high-contrast light situations. Imagine you are trying to shoot a photo of someone standing in front of a bright light source. The camera exposes for the intense light and creates a semisilhouette of your subject. You can overcome this problem by moving close and filling the entire frame with your subject. The camera's meter now establishes an exposure that

provides good detail in the subject. If you simply move back at this point, the meter responds to the bright back lighting and closes up, returning to the silhouette view.

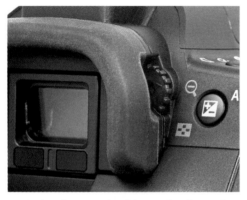

1.14 The diopter wheel is used to focus the viewfinder to your eye sight.

If, however, you press and hold the AEL lock button down while you are up close to your subject, the camera locks in the exposure. Now you can move back and frame your subject however you wish. As long as you hold down the AEL button, the close-up exposure setting will be maintained, and the camera will ignore the back lighting. When you shoot in harsh lighting conditions, you will find the AEL lock function to be invaluable, so take the time to experiment with it and become comfortable using it.

 Cross-Reference *In Chapter 2 you will find instructions on using the custom menu to turn the AEL button into a toggle button. To turn off the exposure lock, you simply press the button a second time.*

The second button is labeled AV and is used to adjust the exposure compensation. Exposure compensation allows you to adjust

the meter's exposure reading to correct for conditions where the meter consistently over- or underexposes in a particular situation.

Suppose you are shooting a white boat on a dark green lake. The meter tries to expose for the dark water, causing the hull of the boat to be overexposed with blown highlights. The obvious solution is to reduce exposure to record detail in the boat. You could do that in the Manual mode, but if the light changes you will have to continually readjust the settings.

Exposure compensation allows you to change the overall meter reading to add more or less light. In the illustration of the boat, suppose you discover that one extra f-stop of exposure will repair the lost highlights. You simply change the exposure compensation amount to reduce the exposure by one stop. From that point on, every image you take will include an additional stop of exposure. Even if the lighting changes radically, your camera will still reduce the overall exposure by one stop.

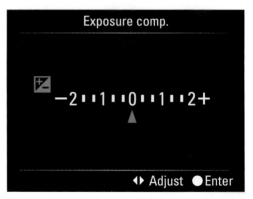

1.15 The exposure compensation indicator allows you to adjust the compensation through a four-stop range, in quarter-stop increments.

To use the exposure compensation feature, press the AV button. If you are in the Optical viewfinder mode, a scale showing the available compensation appears on the LCD screen. The compensation scale is always displayed at the bottom of the viewfinder screen, as well.

If you are in the Live View mode, the compensation scale appears at the bottom of the LCD screen.

You can add or subtract up to two f-stops of compensation, adjustable in quarter-stop increments. When you press the AV button, you enter the compensation mode. You can watch the compensation scale change as you turn the controller or use the right and left edges of the controller. When you get comfortable with the process, you can change the compensation while looking through the viewfinder, using the control dial to dial in the compensation you prefer. T his is another control you should practice with until you are fully comfortable with the

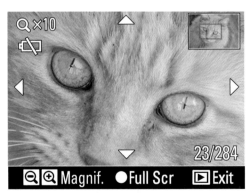

1.16 There are times when even the 2.7-inch LCD on the A300 series can't show you minute details of a captured image. Pressing the AEL button allows you to zoom in to check focus, expressions, and small elements of your captured images.

process. Once you understand how exposure compensation can improve your images, you will find yourself using it constantly.

It is a good practice to always return exposure compensation to zero when you put your camera away after a shoot. If you fail to do this, the compensation will remain in place the next time you shoot. If you don't notice this, you may shoot a memory card full of under- or overexposed images, because the compensation was incorrect for the conditions. This happens more often than most photographers would like to admit, so get in the habit of resetting the exposure compensation after every shoot.

Both the AEL and the AV buttons have other functions. If you are reviewing images you have shot on the LCD screen, the AEL button allows you to zoom in to see fine details. To use the AEL button as a zoom button, follow these steps:

1. While playing back a recorded image on the LCD, press the AEL button.

2. The image on the LCD will be magnified to show small details. The exact amount of magnification depends on the camera model and the size the image was recorded at. You can zoom in further by pressing the AEL button again. Each time you press the button, the image will be magnified further, until it has been magnified by a factor of 14x on the A350. The maximum magnification is 12x on the A300.

3. To zoom out, use the AV button. Each time you press the AV button, the image will zoom out, until the full image is displayed on the LCD. You can quickly zoom all the way

out to the full screen view by pressing the center of the controller. The controller will serve as toggle, shifting between the last zoom position and the full screen display each time you press the center button.

4. You can use the edges of the controller to navigate around the image to check different details.

If you press the AV button while displaying any recorded image in the full screen view, the A300 series switches to the image list display mode. This shows you a matrix of images stored on the memory card. You can choose to display a matrix of 4, 12, or 25 images on the LCD screen. To work with an image list, follow these steps:

1. Display a full screen view of any recorded image located inside the folder you wish to view as an image list.

2. Press the AV button.

 A matrix of images appears on the LCD.

3. To change the size and number of the images in the matrix, press the DISP button on the back of the camera until you see the matrix size you want.

4. You can navigate through the image list with the controller button.

 As you move through the image list, an orange rectangle appears around the current selected image.

5. When you find an image you would like to see in greater detail, press the center of the controller button to exit the image list. The selected image fills the LCD screen.

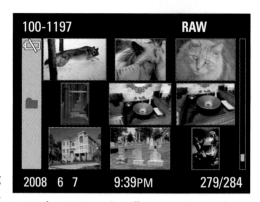

1.17 The A300 series allows you to preview and scroll through recorded photos in groups of 4, 12, and 25 images.

The AV button has still one other function. When you wish to change exposure settings in the Manual mode, you can set either the shutter speed or aperture with the control dial. The actual function of the dial is established by a menu setting. In the default setting, the dial will shift through the range of shutter speeds. You can use a menu command to change the function of the dial so it varies the aperture instead (see Chapter 2).

Obviously, it would be cumbersome to change both the shutter speed and aperture with this arrangement. Suppose the dial is set to the default mode, so that it changes the shutter speed. You would have to set the desired shutter speed, then find the menu that changes the function of the control dial and switch it so the dial manages the aperture. Then you could set the aperture you desire. But what if you wanted to change the shutter speed again? You would have to go back through the menu and reset the control dial's function once more. Meanwhile, that great sunset fades away while you are playing with the menus.

Fortunately, Sony foresaw this problem and made it possible to change the function of the control dial with the AV button. If the

control dial is set to change shutter speeds, holding down the AV button switches the control dial's function to open or close the aperture. If you have used the custom menu to change the function of the control dial to adjust the aperture, then holding the AV button down causes the dial to select different shutter speeds.

Similarly, holding down the AEL button switches the control dial function to change the aperture setting, but also adjusts the shutter speed to maintain a constant exposure. (Or vice-versa if the control dial is set to aperture adjust.) This is useful when you have already set a preferred exposure, yet still want to adjust one of the settings.

If the menu is set to shutter speed, holding the AV button in changes the function to aperture. If the actual menu is set to aperture, holding the AV button switches the function to shutter speed. Holding down the AEL button does the same thing, but also adjusts the other parameter to maintain a constant exposure.

These are major time savers, but the functions are not terribly intuitive. Take the time to understand how the AV and AEL buttons can be used to change the function of the control dial. As you mature as a photographer, you will find yourself using these shortcuts often.

The Function (Fn) button is completely explained in Chapter 2, and the many functions of the controller are discussed throughout this book. The controller is probably used more than any other control on the A300 series, but the operation of the button is fairly straightforward. Basically the button is a small joy stick; you use the edges to scroll and pan through menus, images, and commands. Pressing the center of the button activates a particular command or option.

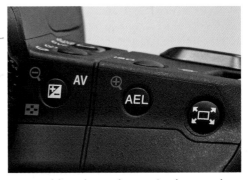

1.18 Holding the AV button in changes the function of the control dial to the opposite of the menu setting.

Because using the controller is discussed thoroughly in the sections where it applies, there is no need to delve further into the button here. It is important not to confuse the controller with the control dial. The names sound alike, and in some cases the controls can be used interchangeably. Most of the time, however, the controller and the control dial perform two different functions.

The final control on the back of the A300 series is the Super Steady Shot (SSS) switch. The operation is fairly self-explanatory, and SSS is fully explored in Chapter 5. The switch is easy to operate even when you aren't looking at it, so you should practice turning SSS off and on while looking through the viewfinder.

At this point, you should have a firm grasp of the controls on the A300 series and how to use them. To get the most out of the camera, however, you will also have to become familiar with A300 series menu system. Chapter 2 provides you with a full rundown of the menus and how they can improve your photographs.

AEL - lighting (if backlighting creates
a sillouette).

AV - adjusts exposure in high
contrast situations (when camera
will adjust to dark portion,
thus washing out details in
lighter section).

Setting Up Your Alpha A300 Series DSLR

Blind navigation of your A300 series menus isn't a life-and-death matter, but it is crucial to getting the most out of the camera and advancing your photography skills. An in-depth knowledge of the menu system has many advantages:

✦ **It saves time.** If you are unfamiliar with where a specific command is located, you could miss a great, never-to-be-repeated photo while you are searching through the menus.

✦ **You won't keep your subjects waiting.** As a photographer, few things are more embarrassing than having a group assembled for a photo and not knowing how to set up the camera for the conditions. Your subjects grow impatient and restless, while you frantically paw through the menus, muttering, "I know it's here somewhere"

✦ **You'll know about settings hidden in the menus.** Many digital photographers are oblivious to the full capabilities of their cameras because they haven't taken the time to investigate the menu system. When shown the commands buried in the menus, they are amazed to find their camera has options and adjustments they were completely unaware of.

This doesn't mean you have to memorize the complete command system. You should, however, understand the feature set of the A300 series and have a general idea of where you can reach the commands. Fortunately, the menu system on

the A300 series is straightforward and easy to navigate. You won't find it burdensome to master the menu system on either the A300 or A350.

Using the Menu List

The A300 series actually has more than a single menu system. The engineers at Sony have logically arranged the most-often changed settings into a quickly accessible menu list. Pressing the Fn (function) button on the rear of the camera activates the menu list on the LCD.

From the menu list, you can quickly change a variety of settings such as the following:

✦ Flash mode

✦ Autofocus mode

✦ White balance

✦ Metering mode

✦ AF area

✦ D-Range Optimizer

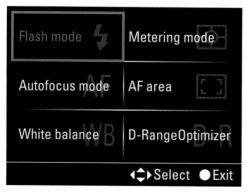

2.1 Pressing the Fn button displays the menu list, which offers you quick access to often-changed settings.

Flash mode

This may be one of your most used menu commands. Many of the settings in the Flash mode apply to an external flash unit, as well as the camera's pop-up flash. Tweaking flash settings can dramatically improve your images, so you'll come to appreciate having the Flash mode available in the menu list. You can access the following settings from the Flash mode (Fn–Flash mode):

✦ **Flash off.** In this mode the flash will not fire, even in the Auto mode.

✦ **Auto flash.** The default flash mode for the A300 series. When the mode dial is set to Auto or a scene selection mode, and the flash menu is set to Auto, the built-in flash pops up and fires if the camera senses it needs additional light.

The Auto flash and flash-off menu icons will turn gray and be unavailable when the mode dial is set to the Program, Aperture Priority, Shutter Priority, or Manual positions.

Tip *If you want to use the flash in the Program, Aperture Priority, Shutter Priority, or Manual modes, you need to raise the flash manually. With the flash up (or an external flash attached to the hotshoe), the camera fires the flash if it senses it needs additional light. If you want to force the flash to fire regardless of the lighting conditions, use the Fill flash mode.*

✦ **Fill flash.** In this mode, the flash pops up and fire every time you take a photo. This is highly effective

for outdoor portraits. Bright sunlight creates harsh shadows on your subjects. The Fill flash mode will open up these shadows, without affecting the exposure in the rest of the image.

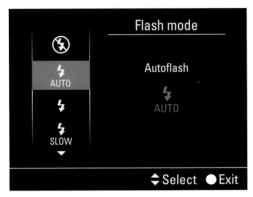

2.2 Choosing the Flash mode from the menu list allows you to manage the built-in flash as well as external flash units mounted on the hot shoe.

✦ **Slow sync.** Ordinarily, the A300 series camera will automatically set a shutter speed of 1/160 second when shooting with the flash. This is the fastest speed the camera can sync with a flash unit. Usually, you want the fastest shutter speed possible to eliminate ghosting and blurring. However, a fast shutter speed may cause everything not illuminated by the flash to appear black. Imagine you take a flash picture of a couple dancing at a wedding reception.

With the normal flash sync speed, it may look like the reception was held inside a coal mine, as anything outside the flash range will be extremely underexposed. In the slow sync mode, the camera will use a slower shutter speed, providing a

brighter, more acceptable background.

✦ **Rear curtain sync.** Normally, the flash will fire as soon as the shutter is fully open. If you shoot a moving subject with a slow shutter speed, you will likely see a blurred ghostly image of the movement that took place after the flash fired. Because the movement happened after the flash fired, the motion effects will appear to be in front of the moving subject, rather than behind it.

With rear curtain flash, the flash is fired just before the shutter closes. As a result, the blurred movement is recorded first, then the flash fires to freeze the subject. The effect is fast moving object, with movement streaks trailing behind.

✦ **Wireless flash [(WL]).** Use the WL mode to trigger a compatible Sony or Minolta wireless flash unit. Wireless flash allows you to illuminate your subject with one or more remote flash units positioned away from the camera to precisely control the light.

 You will find complete details on how to use wireless flash in Chapter 5.

Autofocus mode

The A300 series provides three AF modes, selectable from the menu list (Fn – Autofocus mode):

✦ **Single Shot Autofocus (AF-S).** When you press the shutter button down halfway in the AF-S mode, the focus will lock on the target and you will hear the focus confirmation chirp. As long as you keep the button halfway down, the focus

will remained locked and will not change as you shift the camera view.

✦ **Automatic Autofocus (AF-A).** The AF-A mode attempts to automatically determine if the camera should use Single Shot or Continuous AF. If the subject appears stationary, the camera will use Single Shot AF. If the camera detects subject movement, it will switch to Continuous AF

✦ **Continuous Autofocus (AF-C).** In the Continuous mode, the camera will continue to adjust the focus when the shutter button is depressed halfway. This mode is generally used for sports or fast-moving subjects. There is no focus confirmation chirp, because the focus will continue to change as the subject moves.

White balance

Every type of light source has a different color temperature. The temperature of the light determines how the colors in the highlights and lighter areas of your images appear. Tungsten light produces a red cast on your images, electronic flash is aqua blue, and light from fluorescent light tubes reproduces as yellow-green.

In the past, photographers had to carry various filters to neutralize the color-casts from different light sources. With the advent of electronic sensors, cameras can adjust the colors of an image to match the light temperature. This is known as *white balance adjustment*.

You have complete control over the white balance (WB) settings from the menu list. (Fn – White balance):

✦ **AWB.** The auto white balance mode. The camera will approximate the light temperature and set the white balance accordingly.

✦ **Daylight.** This setting is for bright outdoor sunlight.

2.3 Selecting Autofocus mode in the menu list allows you to select from the A300 three autofocus (AF) variations. Use Single Shot AF when you are shooting stationary subjects. Choose Continuous AF for moving subjects. Automatic AF will evaluate subject motion and automatically switch between AF single and AF continuous.

2.4 The A300 series offers a full palette of white balance settings.

✦ **Shade.** The camera corrects for the light in deep shade, which is cooler, reproducing with a blue cast.

✦ **Cloudy.** The camera corrects for cloudy light, which is also cooler than bright sunlight.

✦ **Tungsten.** The camera corrects for ordinary incandescent light bulbs, which exhibit a red cast.

✦ **Florescent.** The camera corrects for florescent tubes, which create a greenish hue. Note that many of the new energy efficient light bulbs are actually florescent, so you may find yourself using the florescent mode with household lamps.

✦ **Flash.** The camera corrects the tones for images illuminated with electronic flash, which exhibits an aqua blue cast.

✦ **Color Temperature.** If the above options won't provide the color tones you want, you can use the color temperature and color filter options to set a precise color temperature. You can adjust the temperature between 2500 and 9900 Kelvin (k). The default temperature

is 5500k (the approximate temperature of direct sunlight). Adjusting the temperature below 5500k will shift color tones toward the blue range, while temperatures above 5500k will appear more reddish.

This mode also allows you to approximate the use of color compensation filters. Using the controller knob, you can dial-in nine shades of green filtration and nine shades of magenta filters.

Don't be concerned if this seems overly complicated. Most photographers won't need to set a precise color temperature or dial in a compensation filter setting. It is nice to know that your A300 series offers such precise control, but most of the time you will probably use one of the preset white balance modes or will set a custom white balance as described next.

Custom. You might think that with all the preset white balance options, you wouldn't need a custom white balance option. But even the best guess by eye can leave post-production color correction to be done, which is both tedious and subject again to your eyes' predisposition. When you start to mix light sources, however, it isn't always easy to determine which light source is predominate. The A300 series allows you to overcome this problem by setting a custom white balance from the menu list. To establish a custom white balance, follow these steps:

1. **Find a neutral white card or cloth and place it under the lighting conditions you will be shooting under.**

2. **Activate the custom WB function and use the controller**

2.5 You can set the A300 series to record images at a specific color temperature and specify green and magenta filters to precisely manage tones.

(right arrow) to select the SET option.

3. Press the center of the control knob to enter the custom WB set-up mode.

4. Completely fill the viewfinder with your neutral white subject and press the shutter release all the way down.

The camera now accurately determines the best color temperature and uses that for the custom WB setting. This temperature remains set as the custom white balance until you change it by setting up a new custom WB.

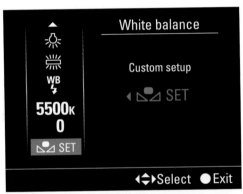

2.6 If the preset white balance settings aren't able to match the lighting conditions, use the SET command to designate a custom WB setting.

Metering mode

The A300 series has three different metering modes. If you shoot under varying conditions, you will find all three modes helpful. You change the metering modes from the menu list (Fn – Metering mode):

✦ **Multi segment.** The Multi segment mode divides the image into numerous zones and averages the exposure in an attempt to provide an accurate exposure for the entire image. This is helpful when there are a wide range of light and dark tones in the image, as the meter won't be fooled by reading the light in a single area of the image.

✦ **Center weighted.** The Center weighted mode works similarly to the multi segment mode, but gives more emphasis to the zones in the center of the image. With center weighted metering engaged, aim your camera at the most important part of the scene and hold down the AEL button. This locks the exposure for the main subject. As long as you hold the AEL button down, you can shift the camera to achieve a better composition without losing the exposure setting.

✦ **Spot.** The Spot mode ignores most of the scene and obtains the metering information from a small sampling in the center of the frame. The spot metering area is marked by a circle indicator in the viewfinder and on the live preview LCD screen. Place the circle on the most important part of the scene to obtain the best exposure for that subject. Hold down the AEL button to maintain the exposure setting if you move the camera after establishing a spot reading.

2.7 The Metering mode option lets you control whether the A300 series uses multi segment, center weighted, or spot metering to determine the best exposure.

2.8 Selecting AF area from the menu list allows you to fine-tune the zones the A300 series uses for focusing.

AF area

You can control how the A300 series determines the autofocus points. By shifting the autofocus area under different shooting conditions, you can ensure the camera is focusing on the most important elements of an image.

You control the AF area from the menu list (Fn – AF area) using these modes:

✦ **Wide.** The A300 and A350 have nine AF areas. The nine areas are marked with small indicators in the viewfinder and on the LCD screen. In the Wide mode, the camera determines which of the nine areas to use when focusing.

In the Wide mode, you can designate which of the AF areas the camera should use for spot AF. Set the AF area to Wide. Hold the center of the controller knob down while simultaneously shifting the edges of the controller toward the AF area you want to use. This takes some dexterity to use effectively, but with a little

practice you can shift the preferred AF area to one of the indicators.

✦ **Spot.** The camera will focus in the center zone exclusively.

✦ **Local.** In the Local mode, you select which of the nine AF points you want to use as the focus area. Shift to between the AF areas using the controller knob.

D-Range Optimizer

Exclusive to all models of the Sony Alpha, the D-Range Optimizer is intended to increase dynamic range in your photographs. Because image sensors cannot display the same range of light and dark areas the human eye can see, photographers have to make compromises when there is a significant difference between light and dark zones in an image. The D-Range Optimizer attempts to provide more dynamic range by processing different zones of an image at different exposures, giving more processing to the dark areas and reducing processing in the light areas. The result is an image that appears properly exposed across the full range of the image.

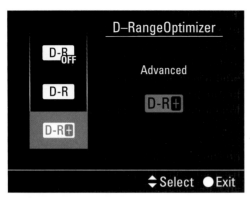

2.9 Sony's D-Range Optimizer can provide dramatically improved dynamic range when shooting JPEG images.

You control the D-Range Optimizer from the menu list (Fn – D-Range Optimizer) using these modes:

✦ **Off.** No special processing is used.

✦ **Standard.** The camera attempts to even out the differences between the light and dark areas.

✦ **Advanced.** The camera divides the image into small zones, then analyzes the contrast in each zone. The processing is applied after the image has been recorded. The advanced setting only works with JPEG files; it has no effect on RAW files.

Surveying the Main Menu Options

The quick-navigation menu system gives you ready access to the most used settings on the A300 series. The main menu system takes you deeper into the heart of the camera, allowing you to fine-tune your A300 series camera for almost any photographic situation.

From Chapter 1, you should already know how to access the main menu by pressing the menu button on the back of the camera and how to scroll through the menus with the controller. The main menu system is divided into four major classifications:

✦ **Recording menu.** Camera icon, two screens

✦ **Custom menu.** Gear icon, one screen

✦ **Playback menu.** Delta icon, two screens

✦ **Setup menu.** Wrench icon, four screens

Recording menu 1

Recording menu 1 is identified with a camera icon followed by an orange square with the number 1. The available options include:

✦ Image size

✦ Aspect ratio

✦ Quality

✦ Creative style

✦ Flash control

✦ Flash compensation

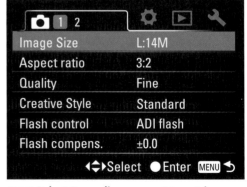

2.10 Select Recording menu 1 to set image size, aspect ratio, image quality, and creative style options. You can also set flash type and flash compensation.

Image size

Not available for RAW or RAW & JPEG modes, the image size menu allows you to set large, medium, and small image sizes for JPEG images shot in Standard and Fine quality settings.

Specific image sizes will be determined by which model of the A300 series is being used and whether the 3:2 or 16:9 aspect range is in effect. Tables 2.1 and 2.2 list the pixel sizes for each setting.

RAW images are always recorded at the large size for the specific camera model being used. If you select the RAW & JPEG quality, a full-size RAW image and a fine quality large-size JPEG image will be recorded.

Aspect ratio

You can choose to record images in the default 3:2 ratio, or select the 16:9 widescreen mode. The 3:2 ratio is what most photographers are used to, as it corresponds directly to the familiar 4 × 6 print size. The wider and narrower 16:9 size is the ratio used by the letter-box-style movies. This size is starting to gain traction in the photo print arena, as photographers look for ways to make their photos stand out with a fresh style.

Many HD television sets use the 16:9 format, so if you connect your A300 series to your television, you may want to shoot in the 16:9 format to match.

You can observe the widescreen effect in the live preview mode, but the optical viewfinder cannot display the 16:9 aspect ratio. However, you will find four engraved lines that indicate the widescreen area on the viewing screen. You will always see the chosen aspect ratio when you play back your images on the LCD.

Table 2.1
JPEG Image Sizes (Sony Alpha A350)

	3:2 Aspect Ratio			16:9 Aspect Ratio	
	Size in MB	Pixel Dimensions		Size in MB	Pixel Dimensions
Large	14MB	4592 × 3056	Large	12MB	4592 × 2576
Medium	7.7MB	3408 × 2272	Medium	6.5MB	3408 × 1920
Small	3.5MB	2288 × 1520	Small	2.9MB	2288 × 1280

Table 2.2
JPEG Image Sizes (Sony Alpha A300)

	3:2 Aspect Ratio			16:9 Aspect Ratio	
	Size in MB	Pixel Dimensions		Size in MB	Pixel Dimensions
Large	10MB	3872 × 2592	Large	8.4MB	3872 × 2176
Medium	5.6MB	2896 × 1936	Medium	4.7MB	2896 × 1632
Small	2.5MB	1920 × 1280	Small	2.1MB	1920 × 1088

Quality

The quality settings are RAW, RAW & JPEG, Fine, and Standard.

RAW capture produces uncompressed, full-size files that contain all the data recorded by the camera. They are not processed by the camera; they must be processed and converted to a useable format with computer software.

JPEG images are compressed images that are processed inside the camera. Because they do not require additional processing, JPEG images can be send directly to a printer or uploaded to the Web.

The RAW & JPEG option saves a RAW file and a large fine JEPG file of the same image. This gives you a JPEG to use immediately and a RAW file that can be enhanced in post-processing at a later date.

Fine is the highest quality JPEG available on the A300 series. Fine JPEGS have less compression, so their file size is larger, but the quality is superior. Standard JPEGs have more compression, which reduces the overall file size, at the expense of quality. Standard and Fine JPEGs can be recorded in large, medium, and small sizes using the image size menu.

Creative style

Not to be confused with the scene selection modes available from the Mode dial, creative styles can be used to tailor the appearance of your photos to specific subjects and shooting conditions.

> **Note** If you have selected a scene selection mode from the Mode dial, the creative style menu will appear grayed out and will not be available. You must shift into one of the primary modes to use the creative style menu.

You can choose to shoot with the following creative style options:

✦ **Standard.** Default shooting style.

✦ **Vivid.** Designed to increase saturation and image contrast to make colors pop. Great for scenes with splashy colors.

✦ **Portrait.** Designed to enhance skin tones and soften backgrounds.

✦ **Landscape.** Enhances saturation, contrast, and sharpness to make details in scenery stand out.

✦ **Night View.** Adjusts overall contrast to make night scenes more true to life.

✦ **Sunset.** Enhances reddish-orange colors to improve sunset photos.

✦ **Black & White.** Records images in black and white tones.

✦ **Adobe RGB.** Records images in the Adobe RGB color space, which can display more colors than the default color space.

Flash control

✦ **ADI flash.** ADI stands for Advanced Distance Integration. This mode relies on using a lens with an encoder that can transmit the distance from the lens to the subject. With the built-in flash or an external flash attached to the hotshoe, the camera can control the flash output to create a very accurate exposure.

The system uses the distance and information from the camera's preflash beam to calculate the exposure.

Sony has followed Minolta's practice of identifying lenses equipped with a distance encoder with a D

code in the model name. However, that isn't a definitive guide; the Zeiss and G style lenses do have encoders, but have no D in the model name. Most of the new Sony lenses feature an encoder, but some of the older style lenses lack this feature. Most of the better aftermarket A-mount lens offerings include an encoder, but you should check with the manufacturer if ADI flash is important to you

✦ **Preflash TTL.** The preflash through the lens system uses the preflash beam exclusively to calculate the exposure. It may be less accurate than ADI flash because it can be fooled by reflections off the subject. In most cases, however, Through-the-Lens (TTL) flash will yield excellent results.

The TTL mode must be utilized when using an off-camera flash, given the lens encoder has no way to determine where the flash is located and cannot calculate the exact distance from flash to subject. Because of this, the camera will automatically switch to TTL flash in the wireless mode or when an external flash is attached with a PC cable.

You should use the TTL mode when you modify the light output from a flash unit with a diffuser, a wide-angle panel, or when using neutral density (ND) filters on the lens. These light modifiers will cause the ADI flash calculations to be inaccurate.

Flash compensation

The flash compensation menu allows you to increase or decrease the level of light provided by the flash, in 1/3 stop increments. If images illuminated by the flash look too

dark, you can increase the flash level by as much as two stops; if flash images are washed out, you can decrease the flash power up to 2 stops. This applies to the pop-up flash as well as dedicated flash units attached to the camera's hotshoe.

If you are already shooting at the maximum power of the flash, adding additional compensation has no effect. In this case, you may try increasing your ISO, moving closer to your subject or using a smaller f-stop setting.

Recording menu 2

Use recording menu 2 to determine whether the camera can shoot without focus confirmation, control the AF illuminator, set noise reduction settings, and reset the Recording menu options to the defaults.

Priority setup

The somewhat cryptic name priority setup menu actually refers to the menu that governs whether the camera will fire if the camera cannot get a focus lock. The default position is AF, which will prevent the shutter from firing if the camera cannot focus onto an appropriate target. If you select Release, the camera will fire even if the AF system

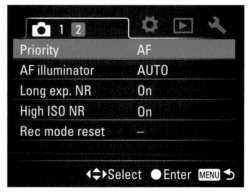

2.11 The display of Recording menu 2.

cannot lock on to a target. If the camera is switched into Manual focus, the priority setup menu has no effect.

AF illuminator

The A300 series has an AF illuminator beam to help it focus in dimly lit conditions. This allows the AF system to achieve focus confirmation in near darkness. The AF illuminator has no effect on exposure, as it fires as soon as you press the shutter halfway down in low light conditions. This gives he AF system sufficient light to set the focus. If you want to prevent the AF illuminator from announcing your presence, you can turn it off. Select Auto when you want to turn the illuminator back on.

Long exp. NR

When you take exposures longer than 1 second with a digital camera, the long exposure usually adds additional noise to the image. The A300 series features noise reduction processing, which attempts to reduce the noise after the image is recorded. While the noise reduction post-processing is happening in the camera, the shutter is locked and you cannot take another picture until the process is concluded.

You can turn long exposure noise reduction on and off with this menu. You may see more noise with the menu set to Off, but you will be able to take long exposures without waiting for additional processing. Long exposure NR (noise reduction) will not operate when the camera is in the continuous shooting mode.

High ISO NR

This menu is a close cousin of the long exposure NR menu option. At higher ISO settings, the camera will attempt to reduce

noise by performing NR processing after the image has been recorded. You can turn this processing off if you need to shoot without waiting for the additional processing.

Rec mode reset

With so many menu options, it is a good idea to reset everything to the default settings from time to time. Otherwise an obscure menu setting may prevent the recording menu from operating the way you expect. The Rec mode reset will return all the recording menu options to the factory default settings.

 Note *The Rec mode reset command only resets options available in the recording mode. To reset all camera settings (including the recoding menu settings), use the reset default command from setup menu 3.*

To access the Rec mode reset command, the Mode dial must be set to Program (P), Aperture Priority (A), Shutter Priority (S), or Manual (M).

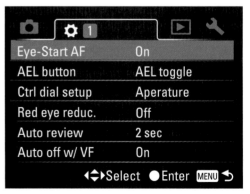

Eye-Start AF	On
AEL button	AEL toggle
Ctrl dial setup	Aperature
Red eye reduc.	Off
Auto review	2 sec
Auto off w/ VF	On

◀↕▶Select ●Enter MENU ↩

2.12 You can use the custom menu to set your A300 series camera to tailor your A300 series camera to your individual wants.

Custom menu

The custom menu is where you establish your preferences regarding how your A300 series operates.

Eye-Start AF

All current Alpha digital single lens reflex cameras (dSLRs) feature Sony's Eye Start system. Eye Start will enable the AF system as soon as it senses someone is looking through the viewfinder. This helps eliminate lag time given the AF system starts looking for a target whenever you look through the viewfinder; you don't have to do anything to start the process. The Eye Start system also prevents battery drain and allows you to keep the camera on in a standby mode for quick shooting. You can turn the Eye Start menu on and off with this option.

AEL button

The Auto Exposure Lock (AEL) button can be used in two ways. In the default setting, you focus on a subject and hold the shutter halfway down. After the camera determines the proper exposure, you hold the AEL button in with your thumb to lock the exposure value. The exposure you locked in will remain set until you release the button. Even if you take a series of images, the exposure will remain locked as long as you hold the button down.

Instead of holding the AEL button down, you can change the button to toggle on and off. If you set the menu option to toggle, pressing the AEL button will lock the exposure. You can release the button and the exposure will remain locked until you press the AEL button again. Even if you take a series of photos, the exposure will be locked until you press the AEL button or turn the camera off.

Cntrl dial setup

The control dial is located in front of the shutter release and should not be confused with the controller located on the back of the camera. The control dial functions in various ways, depending on which position the mode dial is set for and which option is selected in the setup menu.

The control dial setup menu lets you choose to set either aperture or shutter speed with the dial. When set to aperture, the dial will change the f-stops. If it is set to shutter speed, the dial will change the shutter speeds as it is rotated.

This only applies in the Manual or Program modes. If the mode dial is set to Aperture Priority, the control dial will change the f-stop value, regardless of how the control dial menu is set. If the mode dial is set to Shutter Priority, the control dial will override any menu settings and adjust shutter speed values.

 Note *In Chapter 1, you learned how to set the program shift modes. The control dial setup menu determines whether you can enter the program shift aperture priority or the program shift shutter priority modes.*

Red eye reduc.

Most photographers have run into the phenomenon of red eye at least once. Light from an electronic flash placed close to the axis of the camera's lens causes cells in the human eye to appear blood red. The iris of the eye fails to close down quickly enough to the light of the flash and the camera records the red color reflected from the interior of the eye. Red eye or eyeshine appears in animal photos as well, but the color may be gold, blue, or neon green instead of red. In any case, the subject looks unnatural.

The best way to eliminate red eye is to use a remote flash unit and move it a distance away from the lens. This completely eliminates the red-eye problem. If you are shooting with an external flash unit that has an adjustable head, you can use bounce lighting to prevent red eye.

If you are using the built-in flash of the A300 series you obviously cannot move it away from the lens or bounce the light.

The solution is to use the red eye reduction setting. When set to on, the flash fires several low power beams before the actual exposure. The rapid bursts of light cause the iris in your subject's eyes to close down and the red reflection is reduced or eliminated.

Auto review

The default A300 series image review will display a short 2 second preview immediately after shooting an image. You can change this setting to preview the image for 5 or 10 seconds. This will increase the time the preview image will appear after capture.

Displaying images on the LCD is one of the biggest drains on the battery of your A300 series. For that reason it is usually better to use the shorter review time to conserve power. You can also turn the review function off entirely to reduce battery drain.

Auto off w/ VF

Your A300 series is pretty smart about power consumption. You obviously cannot look at the LCD panel when you are looking through the viewfinder (VF), so to conserve battery power, the LCD will turn off when the camera senses someone is looking through the viewfinder. You can use this menu command if you find it necessary to keep the LCD panel on when looking through the viewfinder.

Playback menu 1

The playback features are fairly self-explanatory. Still it is worth a quick stroll through the playback commands to familiarize yourself with all the features the A300 series has to offer.

Delete

You can choose to delete all images on a memory card, or you can mark a series of images to delete. If you choose to mark images, you are presented with a slide show of all the images on the card. Use the controller knob to scroll through the images one by one. When an image you want to delete is displayed, press the controller knob to mark the image. If you make a mistake or change your mind, simply press the controller knob again to unmark the image.

When you have marked all the images you wish to delete, press the menu button on the back of the camera and confirm you want to execute the delete command. The camera will take a few seconds to delete the marked images from the card.

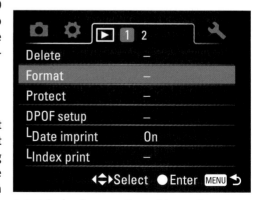

2.13 Playback menu 1 provides options to delete, format, and protect images, as well as several DPOF printing settings.

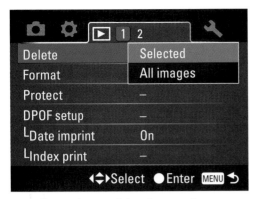

2.14 If you elect to delete images from a memory card, you can choose to delete all images or mark individual images to delete while leaving the unmarked images on the card.

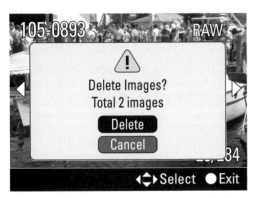

2.15 When you delete a series of marked images, the A300 series asks for confirmation before executing the command.

Format

The format command removes all the images on a card and then initializes the card with a fresh file system. It is a good idea to format a card the first time you use it and periodically during the life of the card. Formatting the card in the camera ensures the memory card is fully compatible with your A300 series. It also eliminates any data on the card that your camera cannot read. If the camera can't read the data, it cannot delete it. Formatting wipes the card clean, giving you the full capacity of the card.

Protect

If you are afraid you might accidentally delete an important image, you can choose to protect it in the Playback menu. This command works similarly to the delete command, as you can choose to protect all images or mark specific images to protect them in a batch. You can also cancel protection for all images.

A protected image cannot be deleted by the delete command. It also cannot be deleted using the Delete button on the back of the camera when reviewing images. Protection does not extend to formatting, however. If you format the card, all images will be wiped out, even if they are marked as protected.

> **Note** Protection set by your A300 series only applies to file operations performed in your camera. If you mount your memory card on a personal computer, the protection will not prevent deletion of the protected data.

DPOF setup

The Digital Print Order Format (DPOF) can be used to specify which images to print from a memory card as well as how many copies of a particular image should be printed.

This function only woks with a DPOF printer. If you have a DPOF printer, you can use the DPOF menu to print JPEG images directly from your memory card, without using a computer. Most photo labs provide DPOF printing services, so you can define a DPOF order before dropping off your card for processing.

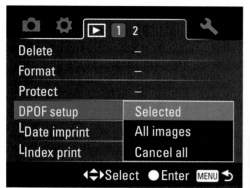

2.16 The DPOF command can be applied to all JPEG images on the card, or you may choose specific photos to be printed on a DPOF-compatible printer.

When you select the DPOF setup option, the A300 asks you to choose between all JPEG images on the card or just marked images. If you select the marked images option, you will enter the usual slide show display and you can mark the images by pressing the center of the controller. Each time you add an image to the DPOF queue, you can indicate how many copies should be printed. When you first add an image to the DPOF queue, DPOF1 will appear on the image. To increase the print count for the currently displayed DPOF image, press the AEL button. The number will increase by one each time you press the button, up to a maximum of nine. If you want to decrease the number of prints, press the AV button.

When you mark individual images, you can specify different numbers of prints for each image. You can order five prints of one image and three of another. The total number of prints in the entire order will be shown on the bottom of the LCD next to an icon of a printer.

If you choose the option to add all images on a card to a DPOF order, the camera prompts you to enter a print quantity number. This quantity will be applied to all images on the

card. If you want to change the number of prints for a portion of the order, you will need to go into the marked image mode and use the AEL and AV buttons to fine-tune the order for specific images.

2.17 To mark images with the DPOF setup command, you scroll through all images on the card and press the control knob to indicate which images should be included in a DPOF order. Pressing the AEL and AV buttons while in the DPOF setup mode will allow you to specify the number of prints to be made for each image. The green DPOF5 in the center of the image indicates that five prints will be made from this image. The number 7 next to the printer icon in the lower left indicates that the current DPOF order will total seven prints.

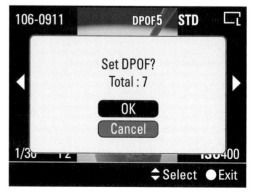

2.18 The Sony A300 series tell you exactly how many prints will be printed in a DPOF order.

Given that RAW files require post-processing on a computer before they are ready to be used, you cannot add RAW images to the DPOF queue. If you want to shoot in RAW and use the DPOF print function, you should shoot in the RAW & JPEG mode. You will have a RAW file for post-processing as well as a JPEG you can add to your DPOF order.

Date Imprint

If you use a DPOF compatible printing service or printer, you can elect to have the date printed on your photos. The imprint will apply to every print in the order. Some printers do not recognize the date command, so make sure your print house or your printer supports imprinting.

Index Print

You can create an index print, similar to a film contact sheet. You must add images to the DPOF queue before creating an index print. Only images in the queue will be included in the index. If you shoot additional images, or add marked images to the queue, only images included in the DPOF order will be added to the index. If you cancel the images in the DPOF queue, the index print will be cancelled as well.

Playback menu 2

You can set your playback options to rotate your images on the LCD automatically and create slideshows.

PlaybackDisplay

You can choose to have the A300 series camera automatically rotate vertical images so they display in the correct orientation on the LCD screen. This is the default setting; if you choose manual rotate, vertical images will not be rotated and will appear in the same

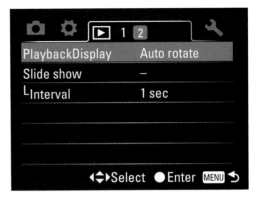

2.19 Playback menu 2 contains options to automatically rotate images and display a slide show on the LCD screen.

orientation as horizontal images. You can use the manual rotation technique discussed in Chapter 1 to change the orientation.

Slideshow

You can display all images stored on the card in a slide show on the LCD using these steps:

1. **Select Slide show from playback menu 2.** All images on the card will be displayed in order, each for the length of time specified on the interval command.

2. **If you want to pause the slide show to examine a particular image for a greater amount of time, press the center of the controller.** An icon of two bars will appear on the LCD and the image will remain paused on the screen.

3. **Pressing the controller knob a second time will cause the show to resume the show where you left off.**

4. **To end the show, press the menu button.**

Interval

The interval setting will let you choose the time each image in the slide show will be displayed. You can choose from 1, 3, 5, 10, or 30 seconds.

Setup menu 1

The menu pages in the setup menu are identified with the symbol of an open-ended wrench. Again, most of these menus are self-explanatory.

LCD brightness

You can adjust the LCD brightness with five preset settings. When the ambient light is high, you might want a brighter display; in dimly lit conditions, the default brightness might be excessive. It is important to remember that the LCD brightness has no effect on your images. Adjusting the LCD can give you a better idea of what your images look like, but making the LCD brighter will have no effect on image exposure.

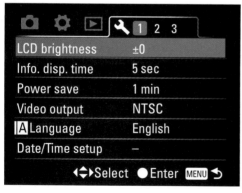

2.20 Setup menu 1 is where you will adjust the LCD brightness, the time the information display and camera stay active, the video output format, and the language for menus. You will also use this menu to set the date and time.

 Note *Sony has provided shortcut commands to allow you to adjust the LCD brightness without using the setup menu. The shortcut commands are discussed in Chapter 1.*

Info.disp.time.

You can elect the length of time you want the LCD information display to be active. The LCD information appears when you first turn the camera on, when you press the DISP button, and when you press the shutter speed part way down. The default setting is 5 seconds, but you can choose to extent this time to 10, 30, or 60 seconds. This only applies to the LCD data display; menus on the LCD data will remain active until the camera's power-save setting kicks in.

Power save

To conserve battery power, the A300 series will automatically enter a power-saving mode when it has not been used for a specified period. You can set the camera to power down after 1, 3, 5, 10, or 30 minutes. Obviously, shorter intervals will improve battery life, but there are times you might want the camera to remain live while you set up a critical shot.

If you connect your A300 series to a television set, the power save interval is automatically set to 30 minutes, regardless of the power save menu setting.

Video output

If you intend to connect your A300 series to a television display, you'll have to set the camera to the proper video signal output. The A300 and A350 support NTSC (National Television Standards Committee) and PAL (Phase Alternating Line) signals. NTSC is the predominate video format in the United States and Japan, while PAL is more often used in Europe and South America.

Language

You can choose the language for the menu displays. This may vary by the firmware installed in the camera, but most models sold in the United States support English, French, Spanish, and Italian, as well as oriental dialects.

Date/Time setup

This menu will allow you to reset the camera's internal clock and calendar. This information is stored in the EXIF (Exchangeable Image File format) data for each image. You can use this data for searching and cataloging images, so you should make sure it is accurate.

Setup menu 2

File number

You can choose between continual escalating sequential file numbers or resetting the number to 0001 when the memory card is erased, formatted, or replaced.

Folder name

The A300 series has two folder naming schemes. In the default setting, the folder

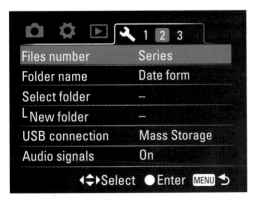

2.21 Setup menu 2 contains file number and folder settings, as well as options for the USB connection and audio prompts.

will be named with a three-digit number, followed by the letters MSDCF. From the factory, the A300 series places images in a folder called 100MSDCF. If you add new folders, they will increment as 101MSDCF, 102MSDCF, and so forth.

Instead of this somewhat cryptic folder naming structure, you can use the current date as a folder name. In this method, the folder name begins with a three-digit number, which is immediately followed by the last digit of the current year. Four more digits indicating the month and day complete the folder name. Thus a folder created June 6, 2008, would be named 10080606. A folder created on Christmas day would be named 10081225.

Select folder

You can create additional folders, so you may have two or more folders on a single memory card. If you are using the default folder naming convention, you can tell the camera which folder you want to save recorded images into. Once you select a folder to contain fresh images, your photos will be saved inside that folder until you designate another folder or install a different memory card. You cannot choose which folder to use when you use the Date form folder naming convention.

The select folder command will be grayed out if there is only a single folder available.

New folder

If you want to organize the images on a memory card, you can create additional folders with the new folder command. Each time you create a new folder, the A300 series will increment the three-digital number at the start of the folder name and set that folder to be the default folder for saving all future images. The new folder will remain

the default until you add another folder, switch to a different memory card, or change the default with the select folder command.

USB connection

The A300 series cameras are PictBridge-compatible, meaning that you can print directly from the camera to a PictBridge-compatible printer. To send images to a PictBridge printer without using a computer, you need to be in the PTP (Picture Transfer Protocol) mode.

Mass storage will allow you to connect your camera to a computer's USB port. You will be able to see the memory card inside the camera, just as if it were an external hard drive.

Audio signals

The A300 series features several audio clues to alert you to the current status of the camera. The focus confirmation chirp is particularly useful, letting you know that the camera has achieved a focus lock on the subject. You also get audio verification that the self-timer is operating as it counts down toward releasing the shutter.

Although these signals are usually helpful, there are times when you don't want to announce your presence with electronic beeps and chirps. The noise from the shutter and autofocus motors cannot be turned off, but if you cancel the audio signals and focus manually, you may be able to capture an image of a shy subject before the shutter clatter gives you away.

You can turn off the audio signals in setup menu 2.

Setup menu 3

Pixel mapping

Pixel mapping is designed to eliminate or reduce hot pixels on the LCD screen of the A300 series. It has no effect on the camera' sensor, only on the rear LCD.

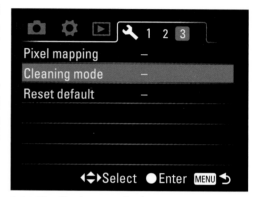

2.22 The final screen in the menu system for the A300 series is setup menu 3. Here you can reset defaults, raise the mirror to clean the sensor, and eliminate hot pixels on the LCD screen.

2.23 You can use the pixel mapping command to reduce or eliminate bad pixels on the A300 series' LCD screen. Pixel mapping only applies to the LCD screen. The command does not effect the camera's sensor in any way.

Rec Mode Reset Command

The reset default command will reset settings across all the menus in the A300 series. The rec mode reset command, already described under recording menu 2 will reset only the settings that involve the recording mode. This allows you to reset things like exposure compensation and ISO settings, without changing settings in the playback, custom, and setup menus. When you want to reset everything to the factory defaults, use the reset command in the setup menu.

Sony claims that 99.99 percent of the pixels on the LCD screen should be fully operational when the camera leaves the factory. Some cameras, however, may exhibit a small amount of permanent light or dark pixels. These will be visible when using the live preview mode as well as playing back images.

The dots do not affect the actual image, they only show up on the LCD screen. Pixel mapping will attempt to map out any bad pixels, giving you a clear LCD screen.

Pixel mapping can only be applied when the live preview mode is active. If your camera is set to use the optical view finder, the option will be grayed out and unavailable.

Cleaning mode

The cleaning mode raises the mirror so you can clean dust off of the sensor. See Appendix B for more information about removing dust from the sensor in the cleaning mode.

Reset default

If you make numerous menu changes, it is easy to forget which options are turned on or off. The reset default command, available in setup menu 3, will return the main functions of the camera to the factory default settings. It is a good idea to reset the defaults often, so an obscure setting doesn't aversely affect you images.

Any time you spend exploring and learning about your camera's settings will pay big dividends when you encounter unfamiliar shooting conditions and don't have time to research the situation. When it comes to your camera's menu system, a little learning goes a long way.

Now that you are familiar with how to set up your camera, it is time to expand your knowledge of the craft of photography. In the next chapter, you will learn how to use your mastery of the A300 series knobs and buttons to produce stunning photographs.

Creating Great Photos with the Alpha A300 Series

Photography Essentials

The Sony Alpha A300 series cameras are fully automatic, so you can concentrate on shooting great images and let your camera take care of the details such as ISO, exposure, and white balance.

Letting the camera make most of the decisions is fine for beginners. As your photographic expertise increases, however, you'll discover there are many situations when you will want to override the automatic settings. A few subtle tweaks can make the difference between a prize-winning photograph and an ordinary snapshot.

Of course, knowing when and how to override the automatic settings requires a solid understanding of the digital photography process. That doesn't mean you have to have a degree in photography to manipulate your camera. Most of the things you need to know are simple and easy to understand.

Without a little insight in how your camera operates, however, you will never be prepared to tackle advanced photographic situations. If you shoot in a variety of conditions, you will undoubtedly encounter situations where the automatic settings of your camera cannot produce pleasing images. You will also start to develop your own photographic style, which may require specific camera, lens, or lighting adjustments. Unless you know the basics, it will be difficult to set up your camera to consistently achieve the results you want.

By reading through this chapter, you will gain a strong foundation of the photographic techniques required to get the most out of your camera. Even if you are already familiar with many of these concepts, a little refresher may be in order.

Great photography starts with great exposure. No matter how good your camera or how interesting your subject, if the exposure isn't correct, your photos will look amateurish and substandard.

The formula for exposure is a balance of four variables: brightness of the subject, lens aperature (or f-stop), ISO, and shutter speed. Three of these are camera settings, and the other (brightness of the subject) can be controlled by external lighting sources or on-camera flash. Each setting can be adjusted manually or allowed to vary by the camera independently of the others.

How Aperture Affects Your Images

The *aperture* is an opening inside the lens that regulates how much light the lens will allow to pass through to the camera. There are a few specialty lenses that have a single fixed aperture. The vast majority of lenses you encounter will feature an adjustable aperture, allowing you to compensate for different lighting conditions.

Understanding aperture

A camera lens is identified by its *f-stop*, or *f-number*, a measure of its light-gathering capacity with the internal aperture wide open (expressed as f/2.8, for example). The adjustable aperture is formed by a series of thin metal blades that can be shifted to create a smaller circular opening inside the lens, resulting in a higher effective f-stop (for example, f/22). A larger f-stop affords greater focus latitude, or depth of field, but limits the amount of light, potentially underexposing the image. When shooting in dimmer light, the aperture can open wider to allow more light to pass through, maintaining a well-lit exposure.

Overexposed images, characterized by too much light, will look pale and the highlight areas will be blown out. Photographers use the term blown highlights to describe overly intense, bright white areas with no details.

3.1 The aperture is comprised of a series of thin metal blades that can shift to allow more or less light to travel through the lens.

Too little light results in underexposure. In this case the highlight area is gray or muddy and the shadow areas are a dense black. The aperture, which is also sometimes referred to as the diaphragm or iris, regulates the lighting to prevent over or underexposure.

Deciphering f-stops

Throughout the history of the development of optics, scientists and astronomers defined various useful formulas to describe the characteristics of a lens or of more complicated optical systems such as telescopes. One such formula related to the intensity of the image formed by a lens; this intensity is proportional to its focal length divided by its light-collecting diameter.

When the photographic industry began exposing film, they adopted this formula for a lens as its f-stop value. As modern cameras sought to become fully compatible with standard ISO speed films, lenses by all camera optics makers began to settle into established gradations of f-stops. Today all commercial cameras present the user a consistent set of values to choose from for f-stop, detector/film "speed" (ISO) and shutter speeds.

3.2 Your Sony A300 series displays the selected shutter speed in either the viewfinder or the Live View LCD.

With today's automatic exposure cameras, you don't have to memorize the f-stops available with your lenses. However, understanding a few key concepts about f-stops will go a long way toward increasing your photographic skills.

The first thing you should understand is that f-stops are arranged so that each time you open the lens one stop, you are doubling the amount of light passing through the aperture; for example, f/3.2 passes twice the light as f/4. Conversely, if you stop down the aperture a single stop, you are reducing the light by one half. You will see why this is important in a moment. For now, however, just concentrate on the fact that each stop either doubles or halves the amount of light traveling through the lens.

The second fact you need to know is that you can't simply multiply or divide the numbers of the f-stops to mathematically calculate the size of the aperture. You might expect that opening up the lens from f/16 to f/8 would double your exposure. This isn't the case, however. Because f-stops are inversely proportional to the diameter of the aperture stop, and the area of the opening is proportional to the square of the stop's diameter, opening the lens a single stop would place the aperture at f/11. Hence, a setting of f/11 would double the throughput. Opening another stop would place the aperture at f/8. Thus the difference between f/16 and f/8 is two stops. Given that each stop will double the amount of light through the lens, opening from f/16 to f/8 would actually quadruple the intensity of the light on your camera's sensor.

How Shutter Speeds Influence Your Photos

Time is represented by your camera's shutter speeds. All dSLRs possess a variety of shutter speeds that determine how long the shutter remains open when you make an exposure.

Although certain special affects may call for an ultra-long shutter speed, most of the time you will be using a shutter speed measured in a fraction of a second. As you may already know, very fast shutter speeds allow you to freeze a moving subject. When you slow the shutter speed down, anything other than an inanimate still life will start to exhibit motion blurring. The shutter speed required to prevent blurring will depend on how quickly the subject is moving.

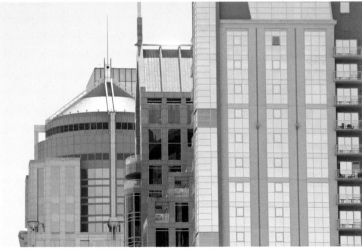

3.3 Above: The scene shot with a 200mm lens at a shutter speed of 1/30 sec. looks blurred due to camera shake. Below: Identical scene shot at 1/250 sec. appears sharp thanks to a faster shutter speed.

Particular lighting conditions also determine which minimum shutter speeds you can use while hand-holding various focal length lenses. Longer focal length lenses magnify the subject on the camera sensor. This makes the image more susceptible to camera vibration, so with longer focal length lenses, you need to use a faster shutter speed to prevent visible camera shake.

As a general rule of thumb, you need to use a shutter speed (in a fraction of a second) faster than the focal length of the lens (in mm) attached to your camera. Thus, if you are shooting with a 200mm lens, you need to use a shutter speed of 1/250 second or faster to ensure camera shake won't spoil your images. If you reduce the lens focal length to 50mm, you can reduce the minimum shutter speed to 1/60 second. Thus the longer the lens, the faster the shutter speed you' need to eliminate camera motion.

Of course the shutter speed also affects exposure. Light passes through the aperture in the lens, then is projected onto the camera's sensor for the duration the shutter is open. The longer the shutter is open, the more light that will reach the sensor.

Your Alpha A300 series camera has a maximum shutter speed of 1/4000 second. This freezes all but the fastest moving objects.

On the other end of the scale, the camera features a minimum shutter speed of 30 seconds. There is also a Bulb option that allows you to use an external release to keep the shutter open for longer periods for specialized photography. Most of the time, you will probably be using a shutter speed of 1/30 second or faster.

While most modern cameras can set a variety of intermediate speeds, the marked speeds follow a pattern of doubling the length the shutter is open for each setting. Like f-stops, named shutter speeds are similar for all dSLRs. If you study the available shutter speeds, you will notice that each marked speed is roughly half the one before it. The next fastest speed after 1 second is 1/2 second. The next setting is 1/4 second, then 1/8 second, 1/15 second, and so forth.

Here is where the knowledge of f-stops and shutter speeds can help you achieve better photos. You already know that opening the lens one stop doubles the light through the lens. It should be apparent that in a similar manner, changing the shutter speed one notch will either double or halve the amount of light passing through the shutter.

Suppose your camera's meter indicates the proper exposure is f/8 at 1/125 second. You want to shoot at a faster shutter speed because your subject is moving fairly quickly. You change the shutter speed setting to 1/500. This is a difference of two stops. Changing the shutter speed from 1/125 to 1/250 is one stop. Reducing the shutter duration from 1/250 to 1/500 is the second. To prevent the image from being two stops underexposed, you can simply open the aperture by two stops to regain the perfect exposure. Thus f/4 at 1/500 and f/8 at 1/125 result in exactly the same exposure. The faster shutter speed helps you freeze your active subjects, but for all intents the exposure is constant.

This interplay between aperture and shutter speed will provide you endless creative possibilities. Once you understand that you can

easily calculate f-stops and shutter speeds using basic math, you will be in position to select the best combination of aperture and shutter speed for a particular image.

Understanding Exposure

At this point you should understand how aperture and shutter speed combine to create a properly exposed image. However, there is a third factor involved. The responsiveness of the camera's sensor dictates how much light is required to record an image. Like all dSLRs, the Sony A300 series features an adjustable sensor that can be tuned to make the sensor's pixels more or less sensitive to light. The adjustable settings are controlled by the ISO number.

ISO is short for International Organization for Standardization, a group that establishes standards for a wide range of industries, including the photographic industry. The organization has created ratings that allow photographers to identify the sensitivity of their camera's digital sensor.

The role of ISO in exposure

In the days of film cameras, the type of film a photographer selected determined the ISO factor. Because the film was rated for a particular sensitivity, all the images taken on that roll were recorded at the same ISO.

With the advent of electronic sensors, it became possible to easily change the responsiveness of the sensor at any time. It is possible to change the ISO for each image, if necessary.

In bright light, you can tone down the sensitivity of the sensor. In dim light, you can make the sensor more responsive, greatly expanding the conditions you can shoot under.

The Alpha A300 series features six ISO settings: 100, 200, 400, 800, 1600, and 3200. You might wonder why there is a need for so many variations of ISO. Why not just have a single high ISO setting and use the aperture and shutter speeds to adjust for varying lighting conditions? Increasing the ISO rating is a double-edged sword. While a higher ISO will allow you to shoot in lower light conditions, it also increases digital noise in your images.

Noise shows up as unwanted, visible artifacts in your photos. When you increase the ISO rating, the camera amplifies the digital signal from the sensor. As the signal is amplified, it also increases the possibility you will see noise in your images.

At ISO settings of 200 or less, visible noise is usually nonexistent. Even at ISO 400, you can expect very little noise. As you increase the ISO, however, noise may start to become an annoyance. At 3200, depending on conditions, noise may become so prevalent your images will be unusable. To achieve the best quality, you should shoot at the lowest practical ISO setting.

The keyword here is practical. If you are shooting in bright sunlight, an ISO of 100 or 200 usually gives you great results. Suppose, however, you move indoors to shoot a basketball game. You may find that even at ISO 400 you cannot use a fast shutter speed to stop the action. Increasing the ISO to 800 may allow you to shoot at a shutter speed of 1/500, at the expense of added noise.

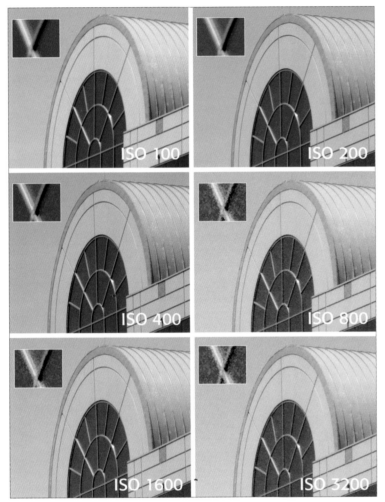

3.4 Top to bottom: Enlarged portions of images shot at ISO 100, 200, 400, 800, 1600, and 3200, respectively. Note the images recorded at lower ISOs are clean and free of artifacts, while those shot at higher ISO values contain visible noise.

As you gain experience with your Alpha A300 or A350, you will learn when you can safely boost the ISO to higher levels. There are times when shooting at ISO 3200 can make the difference between capturing a great image or missing the shot entirely. Most of the time, the lower ISO range provides richer, cleaner images.

Understanding exposure latitude

Exposure latitude refers to the camera's ability to record details in both the highlight and shadow areas of an image. You may be surprised to realize that your eyes have far greater latitude than even the most expensive professional camera.

Imagine you are chatting with a friend inside a cabin near a lake. There is a large picture window overlooking the shoreline. Your eyes have no difficulty seeing the details of your friend's face and clothing, while at the same time you can view sailboats cruising on the lake outside. Your eyes can perceive details in the cabin's interior, while simultaneously taking in the clouds, lake, birds, and boats outside.

Unfortunately, your camera doesn't behave the same way. If you expose for your friend's face properly, the view outside the window will be overexposed. If you expose for the brightly lit scene outside the window, your friend and the interior of the cabin will be clothed in shadow. Your digital camera simply doesn't have sufficient exposure latitude to display both your friend and the scenery out the window in the same image.

Because your eyes adjust so easily to differences in light, you may not even realize your camera is struggling to capture the scene you are viewing. You see soft, barely perceptible shadows. Your camera records harsh, dense areas of blackness with no details. If you change the exposure to show details in the shadows, the highlights become blown out.

The extent of the light and dark areas your camera's sensor can safely handle is referred to as the sensor's dynamic range. How well the captured image covers the range of tones is referred to as the image's dynamic range.

Working with highlights and shadows

When faced with this type of lighting, there is no magic setting that will correct it. Your choice is to move either yourself or your subject, or add additional light to fill in the shadows.

You can add light with a reflector, an electronic flash unit, or some sort of continuous lighting. The idea is to reduce the difference between the brightest and darkest areas to create a lighting situation your sensor's dynamic range can handle.

Often you don't want to eliminate the shadows completely because a shadowless photo can look staged and unnatural. The trick is to use sufficient extra light to soften the shadows so they will remain in the same range as the highlights.

You may have to experiment with different lighting methods to create a natural looking image within the dynamic range required.

Bright, high contrast scenes reveal the worst dynamic range problems. Shooting outdoors on a clear day when the sun in high in the sky will usually create bright and dark areas that your camera simply cannot handle. The extreme light creates dense shadows, which cannot be resolved in the same scene with bright highlights. The result is almost always an ugly photo, unless some sort of fill light is used.

3.5 This high contrast image displays poor exposure latitude. Notice that the highlight areas are blown out while the shadows are dense and distracting. Go ahead and increase the high-contrast effect in the photo — the casual observer will think it looks just fine.

A cloudy, overcast day, on the other hand, can frequently produce excellent images with no dynamic range problems. The cloudy sky defuses the light, which creates soft shadows and plenty of reflected light.

You can employ a variety of objects to produce the light you need for a specific shot:

✦ **A simple reflector.** Something as simple as a piece of white cardboard can reduce dynamic range problems. Held at the right angle, it fills in the shadows without totally eliminating them.

✦ **A piece of light, translucent cloth.** A cloth can duplicate the effect of an overcast day by defusing sunlight and reducing shadows.

✦ **Portable, electronic flash units.** Flash units can also control shadows. Even the popup flash unit on your A300 series camera can fill in dense shadows.

 Chapter 5 delves more deeply into the proper use of fill flash.

Understanding dynamic range is crucial to consistently bringing home great images. Given your eyes have so much more dynamic range than your camera, you need to train yourself to watch for dynamic range problems. What looks like a wonderful image through the viewfinder may turn out to be a high contrast mess when you return home. Learn to watch for potential dynamic range difficulties and take action to prevent them.

3.6 The dense shadows in this image create an unflattering photo because the highlights and shadows are outside the sensor's dynamic range.

3.7 This image is vastly improved by adding a simple reflector to direct light into the shadows.

Utilizing Sony's Dynamic Range Optimizer

As an owner of a Sony Alpha dSLR, you have another weapon available to help you ease dynamic range problems. The A300 and A350 both contain Sony's Dynamic Range Optimizer (DRO).

When you turn the DRO menu setting on, your camera will analyze the image and divide it into different zones, optimizing the dynamic range in each zone to bring out the maximum detail in each. The resulting image has more shadow and highlight detail without washing out the midtones.

The DRO process is handled completely in camera, so you never have to do anything except turn it on. The DRO adjustments are applied directly to your image before you download your photos. Proper exposure is still crucial: overexposing your image still makes the highlight detail unrecoverable.

You cannot use the DRO setting if you shoot in the RAW capture mode, which means you can only apply the A300's DRO settings to your original JPEG images. This means you cannot use the powerful RAW options when you shoot with the DRO setting. You also cannot use the A300 to apply DRO to images after you shoot them; DRO must be applied at the time of capture. A workaround to this is to shoot in RAW & JPEG mode. DRO settings will be applied to the JPEG, and if you are not satisfied with the results, you can later use the Sony Image Data Converter software on your RAW file to apply DRO settings and other parameters to create a more pleasing image.

If you frequently shoot in high-contrast lighting situations, it is worthwhile to experiment with DRO to get a feel for when and how it can help you in the field. You probably won't want to use DRO with every image, but it can vastly improve images shot in high-contrast lighting situations

The importance of optimum white balance

Just as your eyes can ignore the limitations of high-contrast scenes, they are also able to interpret a wide range of colors that your camera cannot see.

This can result in unnatural color-casts unless your camera is set to match the color of light falling on a particular scene. While your eyes don't normally perceive a large difference between various sources of "white" light, a digital camera records the light from the sun, tungsten light bulbs, fluorescent tubes, electronic flash, and candles as completely different colors. Even the distance your subject is from the light source can affect the color of light the camera captures.

Left uncorrected, all dSLRs will see tungsten light as red; fluorescents are usually green, and light from your electronic flash is aqua blue.

Fortunately, your A300 series camera can deal with most lighting situations automatically. When the white balance setting is set to Auto the camera will attempt to analyze the light in the scene and set the white balance accordingly.

The resulting images are free of distracting color casts. Like all automatic settings, however, the camera can be fooled into setting the wrong white balance. When this happens, the colors in your images, particularly in the highlights, will look strange.

Skin tones are particularly problematic, as faces in your photos may turn green, red, or yellow.

In addition, some light sources, such as mercury vapor lights or sodium lamps, are difficult to balance accurately.

You can usually prevent color cast problems by setting the white balance to match the light falling on your subject. Your A300 series camera offers white balance settings

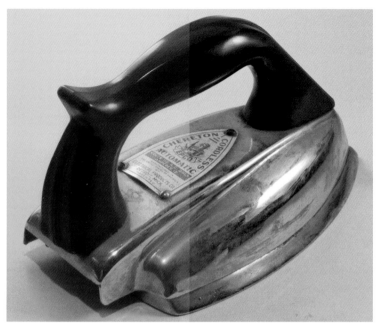

3.8 Incorrect white balance produces an ugly red cast in the photo on the left. Setting the white balance to recognize tungsten lighting eliminates the color shift and results in a photo with natural white highlights, on the right.

for most commonly encountered sources of light: Daylight, Shade, Cloudy, Tungsten, Fluorescent, and Electronic Flash, as well as specific, custom color temperatures.

Cross-Reference *You learn how to set white balance options in Chapter 2.*

Occasionally, it is difficult to set the white balance for a scene, especially if there are several types of lighting going on. An example might be a room lit with sunlight through a large window. If there is a small tungsten lamp in the scene, a pool of yellow light will appear where the lamp's light is shining. Everything else in the scene will look natural, but the lamp will look yellow.

There are various tools available to help you determine a custom white balance setting.

You can include a neutral 18 percent gray card in a scene, so the image (or a scene just like it) can be adjusted on the computer after the shot. By adjusting the image so the photo of the card matches a neutral gray color, all the colors in the scene should be correctly balanced.

The Expo-Disc and the Color Parrot accessories are used over the lens to calibrate a neutral color custom white balance. These can be helpful when there are various colors of lights affecting the scene.

Composition

Composition is the great equalizer in photography. There will always be some photographers who have access to superior lenses, better lighting equipment, or credentials that allow them entry into restricted areas. Make no mistake, these are true advantages.

At the end of the day, however, what the photographer decides to include or leave out from an image makes all the difference. Anyone with enough cash can acquire an expensive lens, but no amount of money can buy an eye for photography. Happily, while you cannot purchase the ability to create arresting images, you can teach yourself the required skills for free. Every time you pull your dSLR out of your bag, you have another opportunity to improve your composition expertise.

No one ever truly masters composition. There will always be subtle ways to improve a photograph, and some people will be unimpressed by the look of a photo that others rave about. As you dig deeper into what makes a photo appealing, however, you can't help learning how to use composition to its best advantage. Learn the basics of composition and your photos will move beyond snap shots into real art.

The rule of thirds

If you were to visit your neighbors and peek through their photo albums, you would undoubtedly discover dozens or even hundreds of images with the subject in the dead center of the image. When the average person takes an informal portrait, they usually concentrate on making the subject smile and watching to see they don't blink. They spend so much time on these things that they don't notice they have placed their subject in the center of the frame. They leave equal amounts of space on either side, and many times there will be an abundance of space above the subject's head as well. The subject themselves may be interesting, but placing them dead in the center of the frame makes for a bland photograph. That is where the rule of thirds comes in.

To apply the rule of thirds, you mentally draw three horizontal lines through the image you see in the viewfinder, dividing it into equal parts. You then add three vertical lines. Place your main subject into any of the points where the horizontal and vertical lines intersect.

In the first place, this moves your subject out of the center of the image, introducing an element of imbalance in the image. This adds interest to the photo, as the lack of symmetry creates visual tension. In addition, studies have shown that when people look at a photo, they first look at the areas where the imaginary lines intersect. If you place the most important parts of your image in these areas, there is a much better chance your subject will capture the attention of your viewers.

Of course the rule of thirds doesn't just apply to people. Most objects look more interesting when they are not horizontally or vertically centered. This applies to the horizon in a landscape, a lighthouse on the shore, or even a Christmas tree in your living room. Move these objects way from dead center and your images will immediately become more interesting.

3.9 No matter where the eye first lands in this image, it will quickly find one of the principal subjects. The wooden bridge is located at the intersection of the top and left lines, while the fountain is located along the vertical line of the right third. The bridge and fountain are also connected by the concrete stream, so the eye can't help seeing both elements.

Using direction to aid the viewer

Unless your subject is pointed directly at the camera, the direction your subject faces will cause viewers to look in the same direction. You can use this knowledge to set up your shots so you lead the viewer to see what you want to emphasize. If the subject leads the viewer's eye outside the image, they may move on without ever looking at it. You usually want your subject to look toward the center of your photo, so viewers will direct their attention away from the edges. If you allow them to reach the edge, their eyes may move further and you will have lost their attention.

Because western readers move their eyes from left to right, they also tend to "read" a photo the same way, moving from the left to the right. If you cleverly place your subject near the right edge, looking back toward the left, you can stop the viewer from casually sweeping across the image. When their eye reaches that person or object looking back toward the left, their brain wants to look back to the middle of the image. In effect you have trapped the reader inside the image. Hopefully, while they are there, they will see things they might have missed in a casual perusal of the photo.

3.10 Here the wide path is the lightest area of the image, so the eye is naturally dawn to it. Entering at the bottom, the eye roves along the path, across the bridge and past the structure on the left. Planning your shot so the viewer is led through your image is one of the fundamental elements of composition.

Lesses and Accessories

O ne of the best features of a dSLR is the ability to switch lenses for different subjects. With a simple twist of the wrist, you can dramatically change the camera's field of view, improve image quality, and increase low light capabilities.

There is a dizzying array of lenses available to fit the A-mount of the A300 series. If you are new to the dSLR world, you may find it difficult to figure out which lenses to add to your collection. The following section will explore your lens options and examine the factors you should consider when acquiring additional lenses.

Selecting Lenses to Complement Your A300 Series Camera

As the owner of an A300 series dSLR camera, you have a broad array of lenses available to you. A newcomer to the dSLR arena, Sony is still developing its lens lineup. Currently there are 24 lenses in the Alpha catalog, and Sony has indicated that many more lenses are on the way. If you cannot find an Alpha branded lens to match your requirements, you can explore the huge array of Minolta AF optics. If you still cannot find just the lens you need, don't overlook the quality glass from Tamron, Sigma, Vivitar, and other third-party manufacturers.

The lens brand is less important than the characteristics of the lens itself. All lens manufacturers produce a variety of optics, some excellent, some just okay, and a few no one likes to talk about. You should plan to acquire first-rate lenses, while avoiding the substandard specimens.

It can be tricky to determine just how well a particular lens will perform. Nearly every lens sounds good from the spec sheet, and just looking at the outside of the lens won't tell you much about what kind of images it will produce. Fortunately, there are several Internet sites that provide extensive reviews on available A-mount lenses. In Appendix A, you'll find a list of sites that offer user assessments of nearly any lens that will attach to the A300 and A350. Spend some time on these sites and you will have a good idea of which lenses to put on your shopping list.

While each photographer's needs will differ, the factors to consider when buying a lens are constant:

✦ **Sharpness.** The most important lens attribute, hands down, is sharpness. If a lens cannot produce sharp images, the other criteria are immaterial. Softness caused by unsharp lenses is very apparent in digital images. Once you know that a particular lens creates soft images, you will tend to avoid using it. Thus it is in your best interest to investigate how sharp a lens is before buying it.

The overall sharpness of a lens can be hard to determine. Some lenses exhibit different levels of sharpness depending which f-stop is selected. Some zoom lenses become sharper as the focal length is changed. Again, you should consult the online evaluations to discover which lenses are considered sharp at most focal lengths and aperture settings.

✦ **Chromic aberration.** Chromic aberration (CA) is an image flaw that shows up when a lens doesn't focus each color wavelength at exactly the same plane. The result

is narrow bands of color around the dark objects in a photo. The phenomenon is also known as purple fringing, although the color bands can appear in almost any color. When a lens focuses each color at different locations on the plane, bright spots may exhibit spectral dispersion "rainbow" effects toward the corners of the image. Fringing is usually more apparent in telephoto lenses.

Higher quality telephotos are less susceptible to CA then mediocre ones. In addition, Sony and other lens manufacturers offer apochromatic (APO) telephoto lenses, which are especially designed to eliminate fringing and CA. Investigate how well a lens handles CA before laying out cash for it.

✦ **Maximum aperture.** Experienced photographers always consider the maximum aperture when evaluating a lens. (Note that a wider aperture lens has a smaller f/# value!) A wider aperture allows you to use

4.1 Shot at twilight, this image displays chromatic aberration. The purple fringing is apparent even in the unenlarged sample, while the magnified circle clearly shows heavy aberration against the dark edges.

the lens in low light and to maintain a faster shutter speed. Smaller f-stops have a shallow depth of field and produce more out-of-focus backgrounds and foregrounds. In addition, autofocusing is quicker and more assured with a wider aperture. Not every photographer needs an extremely fast lens, however. If you shoot mostly in well-lit situations, you may elect to forgo the extra expense, weight, and bulk of a faster lens in favor of a slower, but lighter lens.

✦ **AF speed.** In a perfect world, all lenses would snap into focus in an instant. In the real world, some lenses take much longer to focus than others. Even more annoying is the tendency of certain lenses to shift the focus back and forth without locking in on the subject. Look for lenses that can focus quickly without "hunting."

✦ **Vignetting.** Most often seen when working with wide-angle lenses, vignetting causes the corners of an image to appear darker than the center. In addition to light fall off, vignetting can also cause the corners to become soft and unfocused. Avoid lenses with noticeable corner vignetting.

✦ **Distortion.** If a lens exhibits distortion, people and objects in your photos will look strange and mis-shapen. Most people are aware of a fish-eye lens's inclination to stretch objects into unnatural contortions. However, any lens can exhibit distortion. Wide-angle lenses often suffer from barrel distortion, which causes straight lines to bend in from the corners of the image, creating a bulge effect. Telephoto lenses may be afflicted with pincushion distortion, where straight lines bend out toward the corners of the image, making the image look squeezed in. With the exception of extremely wide optics, lens manufacturers are able to eradicate distortion in their better quality lenses. Don't accept lenses that display noticeable distortion.

✦ **Handling.** While handling is somewhat subjective, you will get more out of a lens if you are comfortable holding and adjusting it. While weight can be a consideration, overall balance is much more important. Are the controls clearly marked and easy to use? Is the manual focusing ring wide enough to be useful? Does the zoom function operate smoothly without sticking?

✦ **Bokeh.** Photographers use the term bokeh to describe the appearance of out of focus areas in an image. You want a lens that can produce a smooth, attractive bokeh, which you usually achieve by shooting with the lens aperture wide open or by being sure the diaphragm has a high number of blades. This is another subjective attribute, but certain lenses are highly sought after because of the bokeh they create.

4.2 The magnified circle in this image displays examples of bokeh. The unfocused branch and the area below it look smooth and soft, with no hard edges. Above the branch there is an out-of-focus flower with the suggestion of defined edges. Notice how the hard edges create a slightly distracting element, while the elements below fade smoothly into the background.

4.3 Fish-eye lenses create images with the ultimate barrel distortion. Even in non-fish-eye lenses, wide-angle lenses may still exhibit some degree of barrel distortion bulge.

The advantages of Super Steady Shot

One major advantage of the Sony Alpha camera line is that image stabilization (IS) occurs in the body, not the lens. Some camera makers build the IS feature into each lens. This means you have to buy specific IS lenses to take advantage of stabilization, and you have to buy the IS components over and over with each lens. With the Sony system, nearly any lens you attach to the camera, even those created before IS was practical, will be stabilized.

IS allows you to handhold your camera in lighting conditions where you simply couldn't get decent photos without it. As a general rule of thumb, to handhold a dSLR you need to use a shutter speed that is equal to or faster than the focal length of the lens. (For example, to get a steady shot with a 200mm lens, you would use 1/250 second or faster shutter speed.) That is fine in bright sunlight, but in dimmer light, you need to reduce the shutter speed to maintain a good exposure. The longer the lens, the quicker you will run out of a sufficient shutter speed to hold it steady when the light fades.

This is where Super Steady Shot (SSS) proves its worth. If the camera senses motion during an exposure, it actually shifts the sensor to compensate. The camera and lens may move or shake, but the sensor moves with the image, so the 'image does not blur. Sony claims (and reviews confirm) that the system will allow you hold a camera steady at speeds two or three stops below the minimum speed you would otherwise need. If you are shooting with a 200mm lens, it would normally require a minimum shutter speed of 1/250 second. With SSS turned on, you can reduce the shutter speed to 1/60 or even 1/30 second without worrying about camera shake.

When shooting with SSS, you will see a small graph icon in the lower-right corner of the viewfinder. The graph tells you when it's best to take advantage of SSS. Press the shutter button down halfway and watch the graph. When the bars of the graph become short, press the shutter the rest of the way to capture the image. Try to avoid shooting when the bars are at full height, as SSS may not be able to compensate at that moment. If you cannot get the bars down, try bracing yourself, or the camera, against a solid object.

It is important to note that IS only cancels camera vibration; it has no effect on moving subjects. The sensor inside your A300 or A350 can detect when you move, but it has no way to track a fleeting object. SSS will enable you to shoot at slower shutter speeds without camera shake, but if you are tracking a race car or other fast moving subject, you will still need a fast shutter speed to stop the action.

SSS allows you to shoot without a tripod in dim light. If you do use a tripod, however, Sony recommends you turn off SSS. Apparently the lack of any motion can confuse the system. Just remember to re-enable SSS after removing the camera from the tripod.

Understanding lens crop factor

When you start to think about acquiring lenses for your A300 series camera, it is important that you fully understand crop factor. Most photographers are familiar with the terms wide-angle and telephoto. You may have owned a 35mm film SLR in the

past and have a collection of Minolta Maxxum lenses, or you may intend to add some Sony Zeiss lenses to your collection. A 35mm film frame measures 24 × 36mm. The sensor in the A300 series is the size of an APS-C film camera: 17 × 23mm. Thus, the A300 sensor is roughly 55 percent the size of a 35mm frame. In effect you are "cropping" the image inside the camera.

This has a rather dramatic effect on the apparent focal length of your lenses. In a 35mm film system, anything with a focal length of 35mm or less is considered a wide angle, while 35 to 70mm is normal and anything above 70mm is a telephoto. This has been the standard in SLR photography for more than fifty years, so the focal lengths for wide, normal, and telephoto are ingrained in photographic lore.

Because of the smaller sensor size, however, the old focal length descriptions no longer apply. The sensor is only using a portion of the image the lens delivers, which magnifies the apparent focal length of the lens. The A300 series sensors actually magnify the focal length of the lens by a factor of 1.5. The true focal length remains the same, of course, but the angle of view will be magnified by one and a half times over what the same lens would display on a full frame 35mm camera.

The effect on apparent focal length should be obvious. A 35mm wide-angle lens now shows the view that a 42.5mm normal lens would in the film world. Your 50mm normal lens is the equivalent of a 75mm telephoto. A 200mm telephoto gives you the view that a 300mm super telephoto would on a 35mm camera.

4.4 The color image inside the white lines indicates the area of the APS-C sensor used in the A300 series, while the monochrome area represents a full-frame 35mm sensor.

To get the 35mm lens equivalent, you merely need to multiply the actual focal length by 1.5. Many photographers welcome this effect, because thanks to the crop factor all their lenses now have an enhanced telephoto view. Suddenly, the photographic world is filled with an overabundance of long telephoto lenses.

Unfortunately, on the other end of the scale, there is an extreme shortage of wide-angle lenses. Currently, the widest fixed length lens in the Sony catalog is the 16mm fisheye. On a film camera, this is an extremely wide lens, requiring you to use care not to get your feet in the image. With the crop factor, however, this exotic lens gives the effect of a much more pedestrian 29mm lens.

None of this field-of-view maneuvering affects the quality of the image. In fact, in many cases it may improve how well a lens performs because distortion and vignetting defects (which are most noticeable near the edges of an image) may be cropped away when the lens is used with an APS-C sensor.

Still, it is important to understand the crop factor effect. If someone offers you a deal on a great wide-angle lens, you may find the angle of view isn't all that wide. If you buy a moderate telephoto lens for portrait use, you may discover that on your camera the angle of view is much too extreme for a studio portrait. You have to understand that the old wide, normal, and telephoto descriptions don't apply to the A300 series (or any other dSLR with an APS-C sensor).

Sorting Through Your Lens Options

So which lenses should you add to your system? The answer depends on what type of photographer you are and what sort of images you intend to create. No single lens is appropriate for all occasions and all lighting situations. You need to determine which lenses you will need to make the type of photos you want. It is nice to have a selection of wide, normal, and telephoto lenses to choose from, but your particular style and circumstances will dictate which lenses you need. Many a photographer has invested in an expensive hunk of glass only to find that he seldom (if ever) uses it.

Don't buy a lens because you think it would be "cool" to own. Try to imagine how and when you might use a particular lens. How useful will the lens be to you? What sort of images will it allow you to create with it? Buy lenses that will improve your particular photographic pursuits.

Telephoto lenses

Most photographers like to have at least one telephoto in their bag. Telephotos allow you to photograph subjects from afar, so you can get details of your subject even when you are some distance away.

But telephoto lenses offer much more than a magnified field of view. Telephoto lenses can compress the depth of an image so that objects appear closer together than they actually are. While this can be a flaw in certain situations, most photographers find ways to use the compression attribute to add interest to their photos.

Another characteristic of telephoto lenses is narrow depth of field. Good photographers exploit this characteristic by using long lenses to isolate their subjects from the background. Distracting elements fade into a soft fuzzy background, while the sharply defined subject stands out and grabs attention.

4.5 The construction cranes in this image are actually far apart, but the telephoto lens compressed the distance so they look like they are right next to each other. Compare this image with figure 4.1 and notice the complete absence of chromatic aberration in the fine lines.

A 50mm lens actually qualifies as a low-power telephoto on the A300 series. This can be quite effective as a portrait lens. Portrait photographers always prefer a slight telephoto, as it eliminates facial distortion a wider lens might produce. Longer focal lengths (100mm to 500mm) are great for sports events, as a long lens can put you in the middle of the action. Wildlife photographers rely on extreme telephotos (400mm and up) to capture images of creatures that would be too elusive (or too dangerous) to approach with a shorter lens.

Telephoto lenses tend to be slower than other lenses. A maximum aperture of f/2.8 is considered quite fast for a telephoto, while maximum apertures of f/4 and f/5.6 are much more common. The smaller aperture and a long lens's tendency to exaggerate camera shake make telephotos less handy when the light begins to fade. This is where Super Steady Shot (SSS) again proves its worth, allowing you to shoot with a slow telephoto in dim light.

Even with SSS, however, telephotos prefer bright light. If you will be predominately shooting in low light conditions, you may find slow telephotos all but useless.

Normal lenses

Normal lenses attempt to replicate the field of view a person sees with the unaided eye. Unless you are a comic book superhero, you can't magnify your vision without the aid of binoculars or a telescope. At the same time, unless you have incredible peripheral vision, you can't see the world like a wide-angle lens. The lenses that approximate the view a typical person would see are known as normal lenses.

4.6 With a 210mm telephoto, the scene (top, left) looks like it was shot in a dense wooded area. Changing the focal length to 70mm (top, right) reveals the woods is actually a copse of trees surrounded by rolling grass. At 35mm (bottom, left), elements of civilization begin to appear. At 18mm (bottom, right), the entire scene reveals the trees are actually in a park, with a gazebo, sidewalks, and the edge of a power-line tower on the right. Notice how the apparent distance between the decorative shade trees (foreground) and the wooded area appears to be much greater when shot at 18mm than at 70mm.

The crop factor means that lenses in the 28mm to 35mm range qualify as normal lenses on the A300 series. These lenses are also among the fastest available optics, with maximum apertures of f/1.4 to f/1.8 being fairly common. This makes normal and mild telephotos excellent choices for existing light photography, when you are relying on the available illumination to make low-light images. Lenses in the normal range are often free of distortion, while both telephoto and wide-angle lenses are often compromised by distortion flaws. Most electronic flash units are designed to cover lenses in the normal range, while needing special panels to spread their light across a wide angle field.

Wide-angle lenses

Many photographers find wide-angle lenses to be more useful than any other type. They make horrible portrait lenses as they make noses look enormous and make caricatures out of faces, but they have many other uses. They allow you to include large subjects in a photo without the need to distance yourself from your target. Wide-angles are popular with architecture photographers as they can show a building in its entirety at close range. Even spacious rooms look cramped when photographed with a normal lens, but wide-angle lenses make a room appear open and inviting.

While telephotos compress distances, wide-angle lenses expand the apparent distance between objects. Using a wide-angle lens, a house with a tiny front yard can be made to look like a palatial estate with acres of property. Wide-angle lenses can also exaggerate the sky, making for stunning landscape shots.

Wide-angle lenses are the opposite of telephotos in that they provide more depth of field than longer lenses. When you want to have everything in your image, from foreground to background, in focus, a good wide-angle lens is your only option.

Another great use of wide-angle lenses is eliminating distracting elements in a scene. Consider a popular attraction visited by hundreds of people every day. With a normal lens, you might have to wait for hours to get a good photo without a crowd milling about in the foreground. Switch to a wide-angle lens, however, and you can move to the front of the crowd. If the lens is sufficiently wide, you can capture the entire subject, eliminating the people you would have caught with a longer lens. This same technique will allow you capture images without telephone wires, trees, signs, and other distractions you couldn't avoid with a longer lens.

Of course wide-angle lenses are more prone to distortion and vignetting than other lenses. Even moderate wide-angle lenses may show bulging distortion if the photographer doesn't choose the vantage point carefully. With a truly wide-angle lens, it is difficult to maintain straight vertical lines, especially near the edges. This is known as barrel distortion, and the closer the lens is placed the object, the worse the distortion may be. It takes more care to achieve good results with a wide-angle lens, but the results are well worth it.

Macro lenses

Although many lenses can record close-up images, true macro lenses are designed to capture subjects at actual size or larger. The ability to create actual size images of small objects opens up a new world to explore. When you make enlargements of a macro image, you see details that you would never have seen with your unaided eye.

While macro images are often used for scientific or investigative work, many photographers enjoy exploring creative ways to see new details with macro lenses. Insects, flowers, coins, stamps, and electronic components can be transformed from mundane to stunning with a good macro lens.

 See Chapter 6 for more information in shooting with a macro lens.

Most macro lenses can be used as a regular lens, allowing you to shoot typical photographs such as portraits, scenics, and the like. When you want to shoot in the macro mode, you either engage a macro switch or turn the zoom ring to the macro indicator. This permits you to photograph subjects at extremely close distances. When you want to return to shooting at longer distances, you need to disengage the Macro mode.

In good light, you may be able to handhold a macro shot, but the use of a solid tripod will ensure your macro images are razor sharp. Sony warns that SSS is not fully effective when shooting with a macro lens. The built-in flash can overexpose objects closer than 1 meter, so you should not use it with close-up macro images.

The A300 series has a macro setting on the mode dial, indicated by a flower. When using a macro lens, select the Macro mode rather than Auto or Program.

4.7 Macro lenses allow you to shoot at very close distances, enlarging details you would not see otherwise. Note the narrow depth of field throws everything except the leaf out of focus.

Zoom lenses

Not so long ago, multifocal length zoom lenses were considered toys. They did combine many different focal lengths into a single lens, but most zooms lacked sharpness and contrast. Professionals avoided zooms at all costs, preferring the razor sharp images they could achieve with single focal length *prime* lenses.

Today all that has changed. High quality zoom lenses are the equal of prime lenses, and you will find zoom lenses in the camera bags of most professional photographers.

Besides alleviating the need to purchase dozens of prime lenses, zoom lenses allow you to shoot in a variety of focal lengths without switching lenses. You can even combine wide, normal, and telephoto fields of view in a single lens.

Prime lenses

As the popularity of zoom lenses increases, you might think that single focal length prime lenses are in danger of becoming extinct. Prime lenses still offer some strong advantages that ensure their survival for the foreseeable future.

✦ **Speed.** Prime lenses are usually one to two stops faster than zoom lenses that include a comparable focal length. This isn't important to some photographers, but if you are shooting in low light or in conditions that require a fast shutter speed, prime lenses are well worth having in spite of their limitations.

✦ **Weight.** Zoom lenses are by nature heavy, as they require more elements and moving parts to achieve their goal of packing numerous focal lengths into a single package. Prime lenses only have a single focal length, so they can dispense with the weight of the zoom mechanism. Zoom lenses also need additional internal lens elements, which adds more weight.

✦ **Length.** Most of the time, the physical length of a lens (not the focal length) isn't critical. There are times, however, when a stubby lens is preferable to a physically long lens. Prime lenses are almost always shorter in length than zoom lenses.

Available Lenses for the A300 Series

With the exception of a few specialty optics and elderly third-party lenses, the A300 series will accept all A-mount lenses. If you are willing to consider pre-owned lenses, you can choose from millions of Minolta and third-party lenses, as well as the growing lens offerings from Sony. The fact that a particular lens fits your camera is no indicator of how well the lens will perform, however. This section will examine the variety of lenses available from Sony and Minolta and delve into what to look for when purchasing a lens.

Sony offers several different camera/lens packages for the A300 series. If you already own A-mount lenses, you can buy just the camera body, but you can get a bargain by buying either model with select bundled lenses.

Analyzing the A300 series kit lenses

The K versions of the A300 and A350 come with the highly regarded 18-70mm kit lens. With some manufacturers, the kit lens supplied in dSLR bundles is a low quality, limited-focal-length lens. The idea seems to be that you can buy the kit with a cheap starter lens, and when you upgrade your skills sufficiently, you will buy a "real" lens.

Such is not the case with the Sony 18-70mm zoom. It has good build quality, and though the mount is plastic, it is a study, light-weight lens. More importantly, it is fairly sharp, especially when you stop down the aperture.

With its variable f/3.5 to f/5.6 maximum aperture, it isn't a terribly fast lens. But it works well in sunlight and makes a good "walking around" lens. It is not a true macro lens, but with a minimum focusing distance of only 380mm, you can get close-up images that almost look like they were shot with a macro.

The lens range is quite good for a kit lens. The short 18mm focal length is equivalent to a 27mm wide-angle, which makes this lens the least expensive way to get a wide angle of view on the A300 series. At the long end, the crop factor makes the 70mm equivalent to a 105mm telephoto, which is good for portraits and mild close ups.

The lens lists for $199, but when you buy the K kit, the lens only costs $100 more than

the bare body. For the price, the SAL-1870 is a great bargain.

Sony also offers the X kit, which includes the 18-70 lens just described as well as the SAL-55200 55-200mm f/4-f/5.6 zoom.

Once again, because this is a kit lens, the mount and construction is plastic. This may make the lens feel somewhat cheap, but has the advantage that the lens is light and easy to handle.

The crop factor translates the equivalent lens range on this lens to 82.5 to 300mm — a nice complement to the other 27mm to 105mm (equivalent) lens in the package. The 950mm minimum focusing distance won't get you as close as the SAL-1870, but it is still good for a non-macro zoom of this range.

Whether you purchased your A300 series camera with the kit lenses or not, at some point you probably will want to add to your lens collection. There are many good options available to you, but you will need to do your homework.

Sony lenses

Even though Sony only entered the dSLR category in 2006, there are already 24 lenses in the lineup, and more are promised. The Sony inventory is roughly divided into four categories:

✦ **Carl Zeiss lenses.** Sony pulled off a major coup by enlisting Carl Zeiss to design their top-of-the-line lenses. If you are not familiar with Zeiss, imagine a major automotive company hiring Enzo Ferrari to design the engine for their latest sports car and you will get the idea. Zeiss lenses have an incredible reputation as quality optics.

4.8 The 18-70mm kit lens offers sharpness, close focusing, a focal length range that reaches from wide angle to moderate telephoto, and is lightweight.

4.9 Carl Zeiss lenses represent the zenith in the Sony A-mount lens lineup. Currently there are four available, with several more on the way.

At the time of this writing, there are four Zeiss lenses in the Sony catalog, two of which are zooms: the 16-80mm SAL1680Z and the brand new 24-70mm f/2.8 SSM SAL2470Z. The latter is the first Zeiss lens to incorporate Super Sonic wave Motor (SSM) technology. SSM provides quieter, more accurate autofocus and is incorporated in many of the better Sony lenses.

The Zeiss line also includes the very fast 85mm f/1.4 and 135mm f/1.8 prime lenses. Sony has promised there will be more Zeiss optics available in the near future.

✦ **G lenses.** Of course, you will pay a premium to have the Zeiss emblem

on your lens. If your budget won't accommodate a bag full of Zeiss optics, you might look to the Sony G series. Derived from the acclaimed Minolta G series, G lenses are professional grade, technical marvels. G actually stands for "Gold" but it might just as well stand for great!

Sony retained three of the best Minolta G lenses when it acquired Minolta's camera business and has recently added a 70-300 SSM G lens to its lineup. Two of the rebranded Minolta offerings are APO lenses, which are specifically designed to eliminate chromatic aberrations.

Just as with the Zeiss offerings, Sony has promised additional G lenses will join the lineup in the coming years.

✦ **DT lenses.** Of the current Sony lenses, six are classified as DT (Digital Technology) optics. This doesn't mean that these lenses are more suited for digital photography than any other Sony lenses, but DT lenses are designed only to cover the APS-C size sensor and cannot be used with 35mm size cameras. As an owner of a A300 or A350, this is immaterial, given all Sony lenses are compatible with the sensor in these cameras. However, Sony is currently at work on a dSLR with a full-frame (35mm size film frame) sensor. For many photographers, the A300 series cameras are more than sufficient for their needs, yet you need to think long term. If you want to take your photography to another level in the future, you need to consider carefully before buying a DT lens. Lenses usually last far longer than camera bodies.

If you upgrade to a full-frame Alpha in the future, you will probably end up selling your DT lenses to purchase higher-end optics.

✦ **Sony Alpha lenses.** Technically, all Sony A-mount lenses are considered part of the Alpha line. Sony doesn't have a specific designation for their affordable optics that don't fall into the G or DT ranges. Most of these lenses are updated versions of Minolta's vast prime lens inventory, so they will cover a full 35mm frame. The range extends from 16mm to 500mm, but there are some missing focal lengths in the current lineup. Hopefully Sony will extend the range with more Alpha lens offerings.

Minolta lenses

One of the real strengths of the Sony Alpha system is the wealth of Minolta A-mount autofocus lenses available on the used market. With millions of excellent but inexpensive A-mount lenses out in the wild, Sony Alpha users have a great selection of quality glass to choose from.

Minolta A-mount lenses work perfectly on the Sony Alpha lens mount because Minolta created the A-mount design more than twenty years ago. The Sony Alpha mount and the Minolta mount are identical, and lenses from either system will fit each other.

Minolta's reputation as a quality lens maker goes without saying. Long after other camera

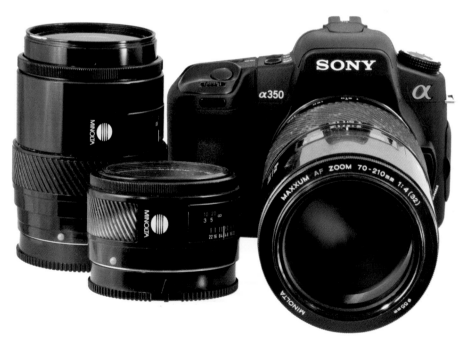

4.10 If you are willing to shop the second-hand market, there is a wealth of great Minolta lenses available at bargain prices. Minolta AF lenses work perfectly on the A300 series and there are some wonderful optics up for grabs if you seek them out.

manufacturers started farming out their glass-making operations, Minolta continued to pour and grind the glass elements for their lenses. High-end Minolta lenses are second to none and renowned for the colors and clarity.

Of course, not every Minolta lens is a world-class optic. In the waning years of film cameras, the SLR marketplace became extremely competitive. Minolta had to offer economy lenses as well as superb ones. Minolta sold many splendid lenses, numerous run-of-the-mill lenses, and a few clunkers. If you intend to augment your Sony lens collection with second-hand Minolta glass, you need to know which Minolta lenses are winners and which you should avoid. In Appendix A, you will find links to online Sony/Minolta communities that rate A-mount lenses. If you spend some time on these sites, you will quickly get an idea of which Minolta A-mount lenses are worth buying.

If you are seeking Minolta lenses for your Sony Alpha, you need to understand that only Minolta A-mount lenses will fit your camera. Minolta actually marketed three different SLR systems — four if you count Minolta's short-lived 110 SLR with interchangeable lenses. Only the A-mount auto focus system is compatible with the Alpha.

If you start seeking out used Minolta lenses, you will find numerous examples of Rokkor X lenses. Introduced in the late 1950s, the Rokkor lens line was produced into the new millennium. Sometimes identified as MC or MD lenses, second-hand Rokkor lenses are plentiful in camera stores, pawn shops, classified ads, and eBay auctions. Don't be misled. The manual focus Rokkor MC and MD lenses cannot be used on the Sony Alpha. There are adapters that will allow you to mate a Rokkor lens to an A-mount camera, but unless you have a large collection of old Rokkor optics, this isn't a great idea.

Even with an adapter, you will find plenty of limitations: No autofocus, limited or no automatic exposure, no TTL (through-the-lens) flash. Even SSS won't work unless you happen to find an adapter that includes an electronic chip to match the focal length of your lens. If you have a favorite Rokkor lens from years past, it might be worth looking for an adapter to make it work on your A300 series. Don't buy a MC/MD lens with the idea of adapting to your shiny new dSLR. It is not worth the compromise.

In 1985, Minolta stunned the camera world with an all-new lens mount designed to accommodate an autofocus (AF) system. There had been some limited AF attempts prior to this, but Minolta was the first to introduce a total auto focus system. It was a great advance, as evidenced by the fact that Sony is still using the mount nearly 25 years afterward. The older Rokkor mount did not offer sufficient space for the new AF system. Thus, the A-mount was born.

Sony has certified that almost all Minolta A-mount lenses will work on the Alpha. Some features on a few highly specialized lenses may not function, but the lens itself will be useable. See http://support.sony-europe.com/dime/digistill/alpha/compatibility/lens.aspx? for a compatibility chart.

Identifying the differences between the A-mount and Rokkor lenses is fairly straightforward. If the lens says Rokkor-X, MC, or MD on the face, it is not an A-mount lens. During the long run of the Rokkor system, however, some lenses were shipped without any Rokkor markings. It is still easy to tell the lenses apart. If there is a movable aperture ring, it is a Rokkor. The Rokkor lenses were completely mechanical. If you see electrical contacts on the rear of the lens, then you can be certain it is not a Rokkor lens.

4.11 It is easy to tell a Rokkor lens (left) from an Alpha compatible Minolta A-mount lens. The Rokkor lens has an adjustable aperture ring, while the A-mount lens has electrical contacts inside the mount.

Just to muddy the waters further, Minolta introduced a line of APS SLRs at the turn of the millennium. This was known as the Vectus line. The lenses designed for these cameras are AF electronic optics and look very similar to the A-mount. The mounts may look similar, but Vectus lenses cannot be used on an A-mount camera. If you locate a Minolta lens with the word Vectus or with a capital V in the model name, be forewarned, it is incompatible with the Sony Alpha system.

The Minolta Beercan

One of the most sought-after Minolta optics on the auction scene is the legendary 70-210mm f/4 beercan zoom.

The beercan, so named because of its straight sides and general resemblance to a can of malt liquor, is often spoken about in hushed tones by Minolta fans. It is incredibly sharp, and the sharpness extends to all focal lengths and lens openings. Its all-metal construction makes for a heavy lens, but it balances well on the A300 series. The beercan zoom lens also features a Macro mode, and the bokeh is considered to be equal to any lens in the Minolta line.

The beercan features a constant f/4 maximum aperture. This is important because Minolta sold a number of similar 70-210mm zooms with variable apertures. Many sellers try to portray these lesser lenses as beercans or "just like a beercan." Don't be fooled. The beercan is a constant f/4 maximum aperture lens and is superior to the pretenders.

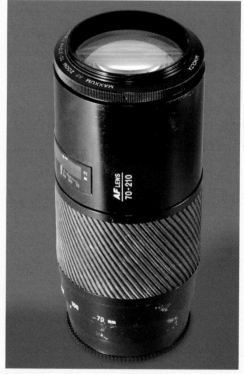

Battered and dinged, this 20-year-old beercan can still produce razor sharp images.

In addition to Sony and Minolta optics, a wide variety of aftermarket A-mount lenses are available. Companies such as Tamron, Sigma, Vivatar, and others started making A-mount variants soon after Minolta introduced the original A-mount cameras. You can find numerous examples of older aftermarket models on the used market.

Most of these third-party lenses will work well on the A300 series, but some of the older models require modifications to operate correctly. Unlike the Minolta lenses, Sony doesn't publish a compatibility chart for third-party optics. Always test a third-party A-mount lens before buying.

Should You Buy a Used Lens?

Should you consider a pre-owned lens? Most photographers take very good care of their equipment. In addition, lenses don't have a great deal of moving parts to wear out. True, modern lens, contain many electronic components, but compared to the complexities of a dSLR, lenses are fairly simple affairs. The majority of used A-mount lenses, even those dating to the mount's origin in 1985, are still capable of producing wonderful images.

However, this doesn't mean lenses never suffer age-related problems. There are millions of great A-mount lenses on the used market, but you still need to exercise caution when buying second-hand glass. If you don't, your great bargain just might turn out to be an expensive turkey.

What flaws should you look for when inspecting used optics? Damage from being dropped or scratches on the lens elements

4.12 To check for oily aperture blades, use a thin instrument to carefully move the stop down lever to fully open the diaphragm. When you release the lever, the aperture blades should snap closed instantly. Any hesitation in the closing of the diaphragm will cause photos taken with the lens to be overexposed.

are an obvious tip-off that the lens has problems. There are several other clues a particular lens should be avoided:

✦ **Fungus.** The number one killer of lenses is internal fungus. When lenses are stored in damp, humid conditions, fungal organisms may start growing on the inner elements. Once fungus invades a lens, it's usefulness as a photographic tool is pretty much over. Some photographers make the mistake of buying a lens with fungus growth thinking that a repair shop can remove the growth and they will gain a great bargain.

It seldom works that way. Fungus is a living thing, and like all living organisms, it needs to eat. It starts by devouring the special coatings all lens makers apply to their optics.

That would be bad enough, but over time, the microscopic little devils actually start to etch the glass surface. Once this happens, the lens is little more than a paperweight. Never buy a fungus-infested lens, even at a bargain price. It's not worth it.

✦ **Oily aperture blades.** All modern adjustable aperture lenses feature an automatic diaphragm. With this design, the aperture stays wide open while you focus and compose. When you press the shutter, the lens instantly stops down to whichever f/stop was chosen, then just as quickly returns to the wide open position. This provides a bright image in the viewfinder no matter which f/stop is selected.

Over time, oil from the internal bearings can seep out and coat the aperture blades with a thin film. You might think that oil would improve the action of the aperture, but such isn't the case. The viscosity of the oil causes the blades to stick to one another. When you fire the shutter, the aperture sticks open and you wind up with overexposed images.

It is easy to check the aperture operation of an A-mount lens. Unmount the lens from the camera and remove the front and rear caps. Hold the lens so you can see the rear element. When an Alpha mount lens is dismounted, the aperture closes down to the minimum aperture. There is a circular groove around the rear element. If you examine the groove in the area of electrical contacts, you will see an internal lever.

Using a pencil or other thin implement, carefully push the lever in a clockwise direction. This will open the aperture wide open. Release the lever and you should see the aperture snap back to the minimum aperture. If it hangs, or closes down sluggishly, chances are the lens suffers from an oily aperture.

A camera repair shop can remove the oil from the blades, but unless the source of the oil is eliminated, it will only be a short time until the problem returns. There are millions of lenses out there without a sticky aperture. If you find one afflicted with this problem, your best bet is to forget it and look for a healthy specimen.

✦ **AF problems.** You'll need to attach the lens to a working camera to determine how the AF works. Listen for noisy focus operation. If the focus seems to stick or moves roughly, it's a good indicator you should take a pass on the lens.

✦ **Grit in the zoom and focus rings.** If a lens is exposed to sand and dirt, grit may penetrate the helicord grooves and cause rough, unsmooth operation. This can be fixed, but it requires complete disassembly to remove the offending material. Why bother? Find a unit that works smoothly without a trip to the repair shop.

Tip **Pawn shops can be great places to locate used lenses and accessories. At a pawn shop, you can actually hold and examine the lens. Most reputable shops will give you a 24 to 48 hour period to try a lens, flash, or other accessory. If it doesn't work as expected, you can return it and get your money back.**

Extending Lens Reach with a Teleconverter

Teleconverters are optical devices designed to multiply a lens focal length. The teleconverter fits between the camera body and lens, increasing the focal length by whatever factor the teleconverter is designed to apply. Currently Sony offers 1.4x and 2x converters in the Alpha series. There are third-party converters that will triple the focal length of the lens.

Teleconverters used to be viewed with suspicion: a cheap, but low-quality compromise to add the effect of a longer lens. Just as zoom lenses have matured and become acceptable to professionals, today's teleconverters are recognized as high-grade tools.

In addition to turning your medium-length lens into a super telephoto, teleconverters offer several other benefits:

✦ **No increase in minimum focus distance.** While the lens focal length increases, the minimum focus distance stays constant, so your new giant telephoto can still focus fairly close.

✦ **Small and light weight.** Teleconverters don't take as much room in your camera bag as an entire lens. When you want to pack light, you can throw a teleconverter in your kit and avoid the weight of extra lenses. The converter allows the lenses you do bring to do double duty: They can be used at their normal focal range or multiplied with the converter.

✦ **Inexpensive.** The better teleconverters are not exactly cheap, but compared to the price of a good telephoto lens, pairing a teleconverter with an existing lens can give you an extreme telephoto at a bargain price.

Of course you do pay a penalty for all these features: converters extend the focal length while leaving the aperture the same as your lenses, causing the lens to loose 1 to 3 stops of maximum aperture. For example, a 2x teleconverter used on a 300mm f/4 lens results in a 600mm f/8 lens. And while most converters can deliver sharp images, overall optical quality with a lens and converter may suffer slightly. This image degradation appears mainly near the edge of a full-frame image, so it is often negligible for an APS-C sensor such as in the A300.

Note Make sure any third-party teleconverter you buy is fully compatible with the A300 series. Some converters that worked fine on the A100 and older Minolta dSLRs may only work in the Manual mode on the A300 series.

Don't confuse physical teleconverters with Sony's Smart Teleconverter option on the A300 series. The Smart Teleconverter digitally magnifies the image inside the camera, giving you the effect of a longer lens. The system is built into the A300 and A350; there is nothing else to purchase.

Cross-Reference See Chapter 2 for more on the Smart Teleconverter function.

Must-have Accessories for the A300 Series

While lenses are undoubtedly the most common accessories for the A300 series, Sony offers many other optional items that can help you improve your photographs.

Like everything else in photography, you need to consider carefully whether these accessories are necessary for your particular photographic pursuits. These optional components will be greatly appreciated by some photographers and considered nearly useless by others. Don't buy any piece of photographic hardware simply because it is available. Instead evaluate how a particular accessory could improve your shooting or make your life easier. Ask yourself how often you might use the item and if you think through your purchases carefully, you will probably end up with the equipment you need and avoid buying accessories that will spend all their time lying unused in your camera bag.

Vertical grip

Many owners of the Alpha A100 were disappointed that Sony did not design the A100 to accept a vertical grip. Thankfully, Sony has rectified that shortcoming with the A300 series (as well as their other dSLR models).

The A300 and A350 are compatible with the VG-B30AM vertical grip. This grip also fits the Alpha A200, so it offers good compatibility across Alpha models.

The grip attaches to the bottom of the A300 series and provides a second set of controls for shooting in the vertical position. The VG-B30AM can carry two NP-FM500H lithium batteries, for double the shooting time. Unlike some third-party grips, the VG-B30AM routes power and control lines through the battery door, so there are no external cables to clutter up the camera.

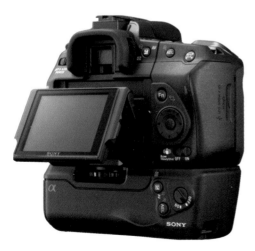

4.13 The VG-B30AM vertical grip makes it easy to hold the camera for portraits and other vertical subjects. In addition to offering comfortable vertical controls, the auxiliary grip can utilize two NP-FM500H batteries for extended shooting time.

GPS-CS1KASP GPS unit

Sony's GPS photo tagging unit is compatible with all Alpha dSLRs, as well as most Sony camcorders and digital cameras. About the size of an old 35mm film can, the GPS-CS1KASP will track where and when you shoot each photo. You can use this information in various ways.

The exact location and time of the shot is recorded, so you won't need to enter any extra keywords to know its location. You can search for images by the nearest GPS coordinate, so if you know a particular set of coordinates, you can quickly locate all your photos taken in that locale. If you use Google maps, you can even make your photos display as popups at the location where the photo was recorded.

Electronic cable releases

When you are shooting on a tripod, there is always a chance you will cause the camera to move when you trip the shutter. Sony offers two electronic cable releases that allow you to trigger the camera without touching the shutter button.

The RM-L1AM Alpha Remote Commander has a 5-meter-long cord, so you can trigger the camera from 16 feet away.

RM-S1AM Remote Commander has a much shorter, 20-inch cord, which is handier when working close to the camera as you don't have that long cable curling around your feet.

Both models have a three-position switch, which mimics the shutter button on the A300 series. When you press the button from Off to the middle position, it turns on the meter and AF systems, just as if you were holding the shutter button down halfway. Moving from the middle position to the third setting fires the camera.

You can also lock the Remote Commander in the On position. This allows you to take long time exposures with the camera set to the Bulb setting. The shutter will remain open until the release is unlocked.

Lighting Fundamentals

At some point, all photographers encounter situations where they need additional light. When the sun goes down or you need to shoot inside a dark building, there may not be sufficient illumination to capture your subject clearly. Even when there is an abundance of light, there may be harsh shadows or dynamic range problems that can only be eliminated by introducing extra light into the photo. When a photographer adds one or more light sources to an image, it is referred to as *artificial light.*

As an A300 series user, there are basically four types of artificial light that you will work with. These are reflected light, continuous (tungsten) light, portable electronic flash, and electronic studio strobe flash.

It is well beyond the scope of this book to explore lighting techniques in depth. You could spend a lifetime learning all there is to know about photographic lighting. This chapter is intended to cover only the basics, especially as they apply to the A300 and A350.

Reflected Light

Probably the least expensive and easiest form of artificial light to implement is adding some version of reflector. Reflectors can direct light from existing sources to fill shadows, balance the illumination in a photo, or enhance specific highlights.

Reflectors are relatively low-tech devices. You can buy fold-up reflectors that are easy to carry in your camera bag. These are great to have, but photographers are known to press almost anything into use as a reflector. White cardboard, aluminum foil, mirrors, bed sheets, painted walls: the list of creative

reflector solutions is endless. Professional photographers can afford the best equipment available, yet you often find them making use of homemade reflectors.

5.1 You can make a homemade reflector from all manner of materials. This sun shade for a car windshield has been reborn as easy-to-roll-up portable reflector.

If you want to start experimenting with reflectors, you might want to start with a couple of pieces of white foam core from your local office supply store. Foam core is inexpensive and lightweight, is easy to carry, and is easy for an assistant to hold in position.

As long as there is some sort of bright light source available, including sun light, you can position reflectors to redirect that light into areas that require additional illumination. You can observe what happens as you move the reflector nearer or farther to your subject. You can also experiment with different reflector angles to see how you can put reflected light just where you want it.

Even if you are working with actual artificial light sources, reflectors can still be quite useful. If you are shooting with a single light, a reflector can act as a second light source. You can create a very sophisticated lighting setup with only a single light and several reflectors.

Continuous Lighting

Continuous lighting has a number of advantages that make it popular with both amateur and professional photographers.

✦ **Continuous lighting is relatively inexpensive.** You can assemble a nice set of studio lights without dipping deep into your bank account. In the days of film photography, photographers needed to be extremely concerned about balancing the color temperature of studio lighting to the film stock being used.

The lighting had to match the film or the photos would suffer from color casts.

Thanks to the extensive white balance controls on the A300 series, you can use almost any lighting source and still balance the light to look natural. There is no longer a need to buy expensive daylight photographic lamps, given you can easily adjust the camera to match the lights being used.

Although there are still good reasons to own true photographic lighting equipment, you can get excellent results with ordinary tungsten lights. You can use aluminum clamp lights to create beautiful lighting for digital cameras.

✦ **You can see continuous lighting in action.** Unlike flash or strobe lights, you can see exactly what is happening with continuous lighting. If you move a light around, you can see exactly what that light is doing. You can detect any glare or shadows created by the lights. Working with continuous light is a great way to learn lighting techniques, because you see the effect of each light as you add it to your set.

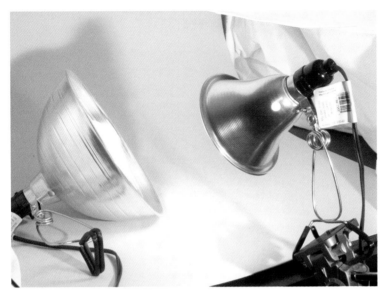

5.2 Inexpensive clamp lights can serve as excellent tungsten lighting receptacles, thanks to the ability of the A300 series to set custom white balance settings.

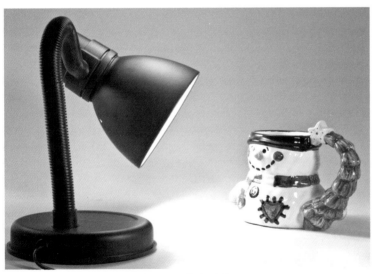

5.3 Equipped with spot lights, small desk lamps can serve as great lights for product photography. Make sure not to exceed the safe wattage for the lamp.

✦ **There is no need for any extra camera connections.** With continuous lighting, you can meter and shoot exactly the same way you do in direct sunlight. You don't have to be concerned with attaching the camera to the light source.

Of course, there are also some problems with continuous lighting.

✦ **Continuous lighting usually isn't very powerful.** If you are shooting products or other immovable objects, continuous lighting is more than adequate. You can simply use long shutter speeds to capture your images. On the other hand, if you will be shooting people or moving subjects, you will need extremely powerful lights to freeze motion with a fast shutter speed. In these situations, flash or strobe is a far superior option.

✦ **Continuous lighting can be very hot.** Hot tungsten lights can cause makeup to run, or even cause your models to perspire. Plastic objects can become soft and distorted from the heat of photo lights. Food photography is particularly challenging under tungsten light, as the heat can quickly cause the appearance of food to deteriorate.

✦ **You need an electrical outlet.** Because continuous lights require electrical power, it is not convenient to use them in areas that lack a convenient place to plug them in.

Electronic Flash

Electronic flash units are convenient and effective. Most photographers have at least one, and of course the A300 series features a built-in popup flash. Electronic flash offers many advantages over tungsten light.

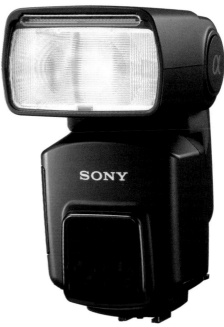

5.4 External electronic flash units are compact and easy to carry, yet they can provide excellent lighting for most photo subjects.

✦ **Electronic flash units are powerful.** Even modest flash units, such as the popup flash on the A300 series, can provide sufficient light to stop action at close range. More powerful external flashes can illuminate subjects that are more than 50 feet away.

✦ **The heat from electronic flash is negligible.** People may be temporally blinded by a powerful flash, but makeup and clothing will not be affected.

✦ **Electronic flash is portable.** Unless you are willing to haul a gas generator into the back country, it can be difficult to use studio lighting equipment out of range of the nearest electrical outlet. Flash units are light and self-contained, allowing you to bring daylight anywhere you travel.

✦ **Electronic flash is safer.** Using studio lights involves extension cords, power packs, and other 110-volt electrical peripherals. A portable flash unit needs only a few volts of battery power. This makes flash units inherently safer, particularly if you are shooting scenes that involve water.

✦ **Electronic flash can freeze motion.** Even the fastest shutter speed on the A300 series (1/4000 second) can't match the extremely short duration of most flash units. While the duration of a flash burst will vary with conditions, some units can achieve a minimum duration of only 1/20000 second. If you are shooting in dark conditions where there is little ambient light to show subject movement, you can capture incredible frozen motion scenes with electronic flash.

✦ **Dedicated flash units can be controlled by the camera's meter.** The A300 series can efficiently control compatible flash units, yielding excellent exposures in challenging lighting setups.

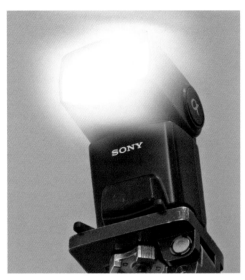

5.5 Although electronic flashes aren't as powerful as studio strobes, they can be used for a full range of studio lighting tasks.

Of course, nothing in photography is perfect, and electronic flash units have their own set of drawbacks.

✦ **Flash units must sync to the camera.** This requires a cable or wireless setup to fire the flash or flashes remotely. This extra gear doesn't come cheap.

✦ **Some flash units gobble batteries at an alarming rate.** Sony has done a fairly good job at creating battery conserving flash units. Despite this, you constantly need to keep your battery situation in mind when shooting a big event. On the plus side, most flash units rely on ordinary AA battery cells, so you can usually find a place to buy fresh cells if the need arises.

✦ **Electronic flash units require time to recycle.** Electronic flash units require long recycling times when shooting at full power. When you fire an electronic flash unit, it cannot fire again until it recharges itself. At low power, most flashes can recycle rapidly. There are even flash units that can keep up with the A300 series continuous frame rate for short durations. When you crank the power up to full, however, most flash units require extra time before they are ready to shoot again. This can be a minor annoyance if you are shooting still life subjects. When it comes to shooting people or moving objects, long recycling times can be a cause for major frustration.

✦ **Electronic flash only lasts for a fraction of a second.** Because you don't see the results until after the flash fires, it can be harder to set up a complex electronic flash set. You will usually need to evaluate the shot on your LCD monitor to see how well individual flash units are performing. The practice of moving the flash or flash units, then taking a test image to see the light pattern grows old quickly, especially when you are shooting with multiple flash units.

Studio Strobe Units

Studio strobes are the zenith in photographic lighting, making them the choice of most professionals and advanced amateurs. Strobes combine many of the better features of continuous lighting and electronic flash. Studio strobes have most of the advantages of smaller flash units, and add a number of major enhancements.

* **Studio strobes offer more power.** While electronic flash units are more than adequate for shooting small objects at close range, they pale (quite literally) when compared to a true studio strobe. A single flash unit can easily illuminate a single person, but the same unit will struggle when asked to light up a group of people. In contrast, a good studio strobe can cover a large group without a problem.

✦ **Extremely fast recycling.** For most studio strobes, recycling time is measured in milliseconds. You can shoot as often as you want without waiting for the strobe to recharge.

✦ **No battery concerns.** Unless you blow a fuse, power is not a concern for an AC powered studio strobe. Simply plug it in and shoot, without worrying about battery drain.

✦ **Strobes are designed for professional use.** Studio strobes are designed to meet the needs of professionals, so there are usually provisions for accessories and attachments. The units themselves will probably outlive your camera, making them an excellent long-term investment.

Before you start shopping for new strobe equipment, be aware of some disadvantages of studio strobes.

✦ **High electrical requirements.** Just as with continuous lighting, studio strobes usually require AC power, though some battery-pack units are available. Big name photographers may haul along a generator and several assistants to use their studio lights on location. Unless you are shooting for money, however, it can be quite expensive to shoot outside of a studio with studio lights.

✦ **High price tag.** Studio lights are probably more expensive than any other form of photographic lighting. While you can use almost any inexpensive tungsten equipment for continuous light shooting, there aren't many low cost studio strobes alternatives. This is one case where you do get what you pay for, and if you want good studio equipment you will pay a lot.

✦ **Studio strobes can tax your electrical system.** If you are shooting in a residential home or office, you may find the electrical outlets cannot handle high power strobes. Some professional photographers spend nearly as much time considering electrical needs as they do on composition and camera setup. This doesn't mean you can't find a reasonably priced, easy-to-use strobe unit, but as the power and capabilities of a strobe unit increase, so do the complexity and technical requirements.

Light Modifiers

Most photographers find it highly beneficial to add light modifiers to whichever form of lighting system they acquire. In most cases, light modifiers can soften or shape artificial light to make a photo more interesting. Some light modifiers are offered as an optional accessory for a particular piece of equipment, but most modifiers are general purpose affairs, adaptable to almost any light source. You can usually use the same modifier with tungsten, flash, and strobe lighting. Some modifiers can also be used with natural sunlight as well.

Softboxes

A softbox is an open face box with some sort of diffusion material attached to the front. The back of the box usually contains an opening for a light bulb, flash, or studio light. The light is contained and channeled by the box so it passes evenly through the

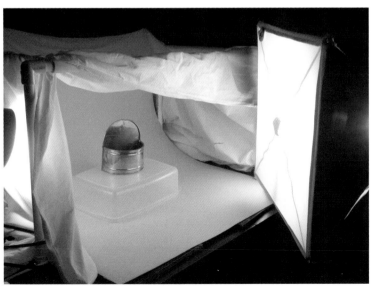

5.6 Softboxes can create large, soft light sources from flash, strobe, or tungsten bulbs.

diffusion material. The result is soft, very even lighting, especially when the box is close to the subject. Because the light is highly diffused, softboxes are excellent at eliminating harsh shadows. By positioning the softboxes at proper angles and distances from your subject, you still see shape and dimension in your images.

Some photographers use one or more softboxes as their only light source. On the other hand, many experienced photographers have found success using unmodified light sources as their main light, while using softboxes as fill lights. You can make your own softboxes, or buy the premade softboxes sold by numerous manufacturers.

Softboxes come in many sizes, from small units designed to fit on an electronic flash, to huge units you can walk into. In general, a larger box will produce a softer, more even spill of light. For general purpose photography, a good rule of thumb is that a softbox should be about the size of your subject, so you would need a larger box for a full body portrait than for just a head shot. Larger units diffuse light from a wider angle to the subject, softening texture with more even illumination. Sometimes you want to show texture, so you would need a smaller box, or a way to mask off the light from a large one.

Photo umbrellas

If you have ever visited a photo studio, you have undoubtedly seen the ubiquitous photo umbrella. For years photographers have relied on reflecting light into the inside of an umbrella to light portraits and product shots. Bouncing light off ceiling and walls has always been the preferred method for avoiding harsh light from direct flash or studio lights. But what if there is no convenient

wall and the ceiling is high or dark colored? What if you are outside and there is no ceiling at all?

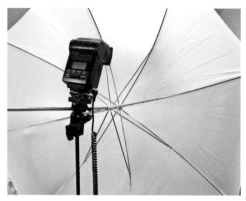

5.7 Shoot-through umbrellas share many characteristics with softboxes, creating soft, multidirectional light.

Enter the reflective umbrella. The open side of the umbrella is pointed at the subject, and a flash or light bulb is pointed inside the bowl of the umbrella. Light is reflected from all directions by the bowl, providing light that appears to evenly wrap around the subject. Umbrellas are simple to transport and use, so they have become extremely popular in professional and amateur studios.

Recently a new type of photo umbrella has come into vogue. The shoot through umbrella is used differently than the older reflective style. Shoot through umbrellas are made of thin, translucent material. The top of the umbrella is pointed at the subject, and the light source is pointed through the transparent umbrella. The result is somewhat like a large softbox, as the umbrella diffuses the illumination into a soft, multidirectional light source. Unlike a softbox, however, light will spill out of the open side of the umbrella, which can subtly alter the appearance of the image.

Some umbrella makers offer a convertible umbrella design. These units feature a removable reflector fabric skin that fits over a transparent umbrella. You can use the umbrella as reflective style modifier, or remove the reflective coat and shoot through the fabric skin.

Light tents

Another important modifier is the light tent, which encloses the entire subject in translucent fabric, leaving an opening for the lens to record the subject. Usually multiple lights are directed at the tent from various locations. The tent diffuses the lights and creates soft, even illumination.

You can make your own tent in the size you need, or you can purchase small, ready-made tent kits that are perfect for small product photography. The kits usually include a pair of tungsten lights. By placing one light on each side of the tent, the subject will be perfectly illuminated.

If you make you own tent, you want it to be large enough so the sides will not show in the photographs, yet not so large that the

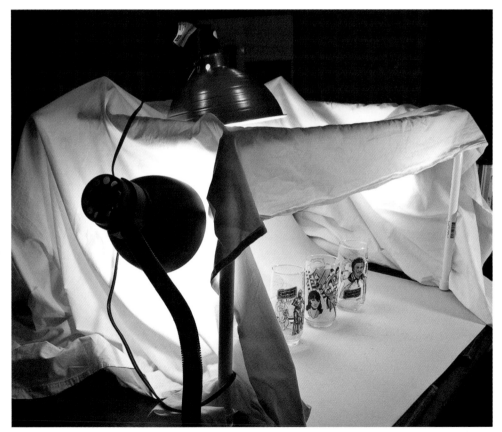

5.8 You can make a simple light tent for small objects from PVC pipe, wood, or even a cardboard box with holes cut in the sides. Drape the tent with fabric and shine lights through the fabric. Place your subject inside the tent and enjoy well-defined, shadowless light.

light sources are too far away to be effective.

Flash diffuser attachments

There are a nearly limitless number of attachments available to soften and direct light from an external flash. Some are designed to fit a specific flash, while others will attach to almost any flash unit. There are even third-party diffusers that will attach to the built-in popup flash on the A300 series.

All of these attachments do offer an improvement over the direct light from your flash. Usually, there is a tradeoff, as the light output will be somewhat reduced by the diffuser. In addition, you may have to exercise more manual control, because the camera may not know how to compensate for the modified light. In the end, however, almost all of these attachments will improve the quality of your flash photos.

Grids and barn doors

Sometimes you need to eliminate light rather than add more of it. For example, under direct light, highly polished surfaces can exhibit glare and distracting reflections. You might need to light most of the scene conventionally, but direct light away from areas that would cause reflected glare. Grids can be placed over a light source to point it in only a certain direction, preventing light from spilling on areas where if would be distracting.

Barn doors are even more powerful light controllers. Usually made of thin metal, the doors are hinged so they can flip back and fourth. Typically there will be four doors, one on each side of the light source. By opening and closing the doors, you can adjust the light from a full opening to a small slit. You

can also position one or more of the doors so that unwanted light is blocked from reaching your subject. This can be an excellent way to control where light falls, and can also be used to create a pin point light source to highlight details on your subject.

Using Artificial Light with the A300 Series

If the previous discussion of artificial lighting has whetted your appetite to delve further into lighting techniques, you need to be aware of some unique situations that apply to the A300 series. If you intend to work with artificial light with the A300 series, there are some roadblocks you will have to overcome.

The first of these is the Sony hotshoe design. The second is the lack of a PC sync port on the A300 series.

Sony/Minolta hotshoe

Make no mistake, the hotshoe used on the Sony Alpha digital single lens reflex (dSLR) is head and shoulders above anything else on the market. Even the most expensive models from Nikon and Canon come off second best when you compare their hotshoes to the one used on the A300 series.

Minolta was a big player in the dedicated flash arena, and the camera maker created many innovative solutions that advanced the state of the art in flash design.

The engineers at Minolta created a brand new hotshoe design. Unlike the old style shoe, the flash foot actually covers the hotshoe and locks in place with a small spring loaded peg. The flash is solidly attached to the camera by the locking peg. When you

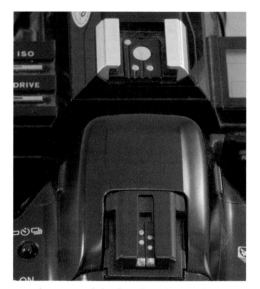

want to remove the flash, you simply press a button that retracts the peg and slide the flash off. It is far better than any other flash shoe design, and the good news is that Sony retained the Minolta design when they developed the Sony Alpha line.

While it is great to be able to enjoy the convenience of the Alpha hotshoe, there is a downside to the Sony/Minolta hotshoe. While Minolta was pushing the envelope in hotshoe design, the other camera makers collectively decided that the older, flawed design was good enough for their users. So every other dSLR on the market, apart from the Alpha and the now discontinued Minolta models, uses the old style shoe.

5.9 The Sony Alpha hotshoe is a major improvement over the old style hotshoe used by other camera makers.

5.10 These broken feet offer mute testimony to one of the design flaws of the older style hot shoe. Sooner or later, the same fate befalls most old style flash units.

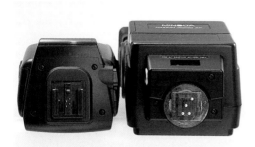

5.11 The Alpha flash shoe (left) itself is quite different than the older style shoe (right).

This isn't a problem if you stick to Sony or the newer models of Minolta flash equipment. If, however, you want to buy an aftermarket flash unit, you have to make sure it has an Alpha style hotshoe. There are also many aftermarket accessories made to attach to a camera's hotshoe. You may find yourself searching in vain for something compatible with the Alpha hotshoe, while users of other dSLR brands can pick and choose from accessories designed to fit the old style shoe.

You do have options if you want to use a flash unit or other accessory with the old style foot. Minolta designed an adapter that would mate an old style flash foot to the new hotshoe. Although these have become quite rare and hard to find, several vendors have started to produce aftermarket adapters to provide the same capability.

These adapters are inexpensive and easy to come by, but you do need to exercise some caution using them. Most of the aftermarket adapters do not use any internal voltage

suppression. Voltage suppression is important, because some small flash units can develop tremendously high trigger voltages. These voltages can damage the electronics inside a digital camera.

Don't let the concern about voltage deter you from using one of these adapters if you have a need to use some of the older flash equipment. Just make sure the flash or accessory doesn't have trigger voltage of more than six volts. It is generally considered that anything below six volts is safe to use without suppression.

If your equipment does exceed six volts of trigger voltage, or you just want to be extremely cautious, investigate the Wein Safe-Sync High Voltage Regulator. Available from most larger camera stores, the Wein device is specifically designed to prevent high trigger voltage from damaging your camera.

5.12 Inexpensive adapters will allow you to attach and fire old style flash units to the A300 series, but you have to be careful of using flash units with high trigger voltage.

Cross-Reference *You may be wondering how to determine the trigger voltage of your older flash equipment. In Appendix A, you will find a link to a Web site that lists the trigger voltage of most electronic flashes and studio strobe equipment. There are also instructions on how to measure the voltage of equipment not on the list. It is an excellent resource, especially if you want to work with non-Sony flash equipment on your A300 series.*

Off camera flash

While concern about the hotshoe design may be important to many users, some photographers seldom use the hotshoe, and if they do, it is for accessories, not a flash unit. Most professional photographers never mount a flash to the hotshoe, preferring to use off camera flash.

The hotshoe on virtually all dSLRs is located directly above the axis of the lens. In most photographic situations, this is the worst possible place to mount a flash.

Also, the closer the flash is to the axis of the lens, the greater the chance people and animals in your images will exhibit red-eye. The A300 series does have a red-eye reduction mode, but it only works with the built-in flash; it doesn't operate with hotshoe flash units.

Even if you can avoid red-eye, a hotshoe mounted flash is practically guaranteed to eliminate all the shadows in your subject. This might seem to be a desirable characteristic, but it leads to dull and unnatural photographs.

5.13 To use off camera flash with the A300 series, you need the Sony FA-CC1AM cable, which fits into the hotshoe and offers five feet of flash range.

Pay attention to people's faces when you interact with them. Most light comes from above, either from the sun or from overhead lighting. This overhead light usually creates soft shadows under the chin, under the nose, and in the eye sockets. These shadows usually aren't very pronounced and unless you look for them, you probably aren't aware they are there. Your brain always notices these shadows, however, and faces in photos with no shadows look somewhat strange.

In addition, shadows create the impression of a third dimension in a photograph. Even though a photo has no actual depth, shadows can create the impression of scale and texture.

Guess what happens to those shadows when you blast the light from your flash at a point a few inches above the lens? The flash wipes out all traces of the shadows, leaving your subject looking flat and unnatural.

You can buy a bracket to move the flash high and off to one side of your camera. While this can make a major improvement, many photographers simply balance and fire their camera with their right hands, while holding their flash units to the best location with their left hands.

5.14 You attach the other end of the FA-CC1AM cable to your portable flash unit. If your flash doesn't have a cable connector, you will need the FA-CS1AM adapter as well.

Because the A300 series does not have a PC port, you will need FA-CC1AM off camera cable to pull this off. This cable has a fitting that slides over the hotshoe, providing a method to sync the flash and the camera. The other end of the five foot cable attaches to Sony flash units with a cable connector. Not every Sony or Minolta flash is equipped with a connector. If you are using a model without a connector, you will need to add the FA-CS1AM off camera shoe.

This component has a connector and the equivalent of the Alpha hotshoe. Place the flash in the shoe and then attach the sync cord to the connector on the shoe. This allows you to use any unit with the Alpha shoe as an off camera flash.

With the flash on a cable, you can point the flash in any direction and illuminate your subject from almost any angle, adding drama to your images by illuminating your subject from above or from either side. It is simple to bounce the light off walls, ceilings, or reflectors, as well. There is probably no more versatile light than a flash unit on a remote cable.

If you are using a compatible Sony flash, the A300 series can still control the flash when it is off the camera, so you still will get great exposures with the off camera setup.

 If you want to use your flash unit on a bracket, you will still need the off camera cord setup to connect the flash to the camera.

Wired flash

If you want to work with studio strobes, or you want of use electronic flash in a studio setting, you will have to connect the lighting with some other specialized Sony components. The FA-ST1AM Sync Terminal adapter attaches to the hotshoe and provides a standard PC port connection for the A300 series. The FA-ST1AM has a built-in protection circuit, so you can safely use almost any studio light system that uses a standard PC sync cord.

5.15 This Sony sync terminal attaches to the hotshoe and allows you to attach studio strobes and other lighting equipment to the A300 series.

5.16 To set up the wireless flash system, choose the Wireless option from the Flash mode quick menu and then pair the flash to the camera.

Wireless flash

Connecting flash units to the camera with a cord is so last century. The A300 series can control any Sony branded Alpha flash unit wirelessly. This is yet another system created by Minolta, and some, but not all, Minolta flash units are also compatible with the Sony system.

Wireless-flash is nothing new; photographers have been using optical slave triggers for decades. With an optical slave system, the camera fires a single flash, which triggers any slave flash to fire at the same instant.

The Sony wireless flash system is far more sophisticated than the older optical slave system. The Sony system can actually send coded messages to the flash, pulsing the triggering light to control flash power and duration.

You can place one or more flash units anywhere in the line of sight of the camera, and trigger them with the built-in flash on the A300. This allows you to set up an excellent studio set up without wires.

Another big advantage to the Sony system is that you can set your flash units to a specific channel. Your flashes will only fire when a signal is sent over the correct channel. If you are in a situation where several other photographers are using flash, your flash units will only respond to signals from your camera.

Setting up the Sony wireless system is dead simple:

1. **Use the Fn button to enter the Flash mode menu.**

2. **Select Wireless flash from the menu.**

3. **Attach a compatible flash unit to the camera's hotshoe.**

4. **With the flash on, press the shutter release to set the channel and pair the flash to the camera.**

5. **Remove the flash and place it in the line of site of the camera.** If possible, point the red panel of the flash toward the camera. If your flash has bounce or swivel capabilities, you can usually direct the flash in the direction you want, while still pointing the body of the flash toward the camera.

6. **If you will be using additional remote flashes, repeat the procedure for each unit.**

7. **Raise the popup flash on the camera.**

8. **You can test your wireless setup by pressing the Auto Exposure Lock (AEL) button with the popup flash raised.**

9. **Compose and shoot.**

You will notice the popup flash will fire multiple times when shooting wirelessly. These extra flashes have nothing to do with illuminating the subject; rather this is how the A300 series tells the flash what to do immediately before the exposure.

> **Note** *You can only trigger the remote flash units with the built-in popup flash. Some Minolta film cameras can trigger the wireless system with shoe mounted flash units, but as this is written, the only way to trigger the Alpha wireless system is with the built-in popup flash.*

You might think that you could save money by using the old light activated slave triggers to fire a remote flash setup. This would be far cheaper than buying several Alpha compatible wireless flash units. Unfortunately,

before the actual exposure, the Sony Alpha always fires a preflash beam to establish exposure and wireless settings. This preflash will engage the old style optical triggers, causing them to fire too early to be effective. You cannot use the older optical slave triggers with any of the current models of the Sony Alpha.

Radio triggers

Although the Sony wireless flash system is excellent, it does have some limitations. The remote flashes have to be within the camera's line of sight, and close enough to the camera for the popup flash to trigger them.

What if you want to hide a remote flash inside a door frame or some other place where it cannot see the camera? What if you want to locate your remote flash units close to the subject and shoot from a couple of hundred feet away with a telephoto lens? This might be far beyond the range of the popup flash's ability to trigger the remote units.

Fear not, there is a solution, but it will involve another investment in technology. The answer is to use fm radio waves rather than light activated triggers. To use these triggers you generally attach a transmitter to the camera's hotshoe and a receiver unit to each flash foot.

Sony doesn't sell radio triggers, but there are many aftermarket units on the market. The trick is to find a way to make these triggers compatible with the Alpha hotshoe. Almost all of the triggers are designed to attach to the old style hotshoe, so they obviously will not work directly on the A300 series.

You will need an adapter to attach the trigger to the camera hotshoe, and you may need another adapter to connect the receiver unit to your remote flash unit. Then you have to hope the whole thing actually works as expected. Until someone develops a radio trigger system expressly for the Alpha's unique hotshoe, Alpha shooters will have to jury rig a do-it-yourself radio system with adapters. The result can be extremely satisfying, so don't overlook the idea of adding radio triggers to your system.

What to Look for in an External Flash Unit

There are many different flash units available in the Alpha mount, and it can be quite confusing deciding which unit will fit your needs. Obviously, you will want a flash that fits the Alpha mount and it is well worth paying more for a flash unit that is compatible with the Sony wireless system. There are several other features to consider if you are in the market for an external flash.

ADI and TTL dedicated flash compatibly

Although not strictly necessary, a flash that can be controlled by your A300 series camera will produce far more properly exposed shots than a manual flash unit. With a dedicated flash unit, the A300 can actually turn the flash off when the camera determines there has been sufficient amount of illumination.

The A300 series uses two types of flash metering: ADI and TTL. ADI (Advanced Distance Integration) is a Sony/Minolta exclusive, although many third-party flash units offer ADI in their Sony-compatible models. With the ADI system, certain lenses will use the information from their auto-focus confirmation to assist the camera in determining flash exposure. By knowing the exact distance to the subject, the camera can calculate accurate exposures when shooting highly reflective surfaces that might confuse the normal TTL flash metering.

ADI can be very accurate, but only works in specific situations. You will need to use a lens with a distance encoder, which eliminates many Sony lenses. Using light modifiers or bouncing the flash can cause the system to produce inaccurate exposures. Finally, the system cannot be used with off camera flash, because the camera can only determine the distance to the subject when the flash is mounted on the hotshoe.

The second system is TTL (Through-the-Lens) preflash metering. In this system, the camera fires a metering beam of light just before the actual exposure. The camera's meter uses this beam to calculate the proper exposure in the scene, then actually opens the shutter and fires a second flash beam based on the meter's calculations. The beams are usually fired so close together that users see only a single flash of light.

TTL is sometimes less accurate than ADI metering, but it works with all lenses and flash modifiers.

 Note *Although you can use the recording menu to select either ADI or TTL preflash, ADI will only operate if you have an ADI-compatible lens and flash unit. If conditions prevent ADI from getting an accurate exposure, the camera will automatically switch to TTL preflash metering. Because of this, you can safely leave your A300 series in the ADI mode, as it will switch to TTL if conditions warrant.*

High Speed Sync

All dSLR cameras have a maximum sync speed when shooting in the Flash mode. On the A300 series, that speed is 1/160 second (or slower). You cannot shoot at a faster shutter speed with a normal flash, because the shutter will not be fully open during the flash burst. This could lead to only part of the scene being illuminated by the flash unit.

This can cause problems when the ambient light is bright enough to register on the sensor. 1/160 second is not fast enough to freeze motion, but the flash cannot be synced to the camera at faster shutter speeds. This can be especially problematic when you want to use fill flash with moving subjects in bright daylight. Only part of the subject receives the fill light, resulting in a strange-looking image.

To understand High Speed Sync (HSS), you have to understand how the shutter works in the A300 series. Like most dSLRs, the exposure is controlled by a shutter curtain that passes across the sensor. There is no practical way to open and close a physical shutter devise at speeds as quick as 1/4000 second. Instead, the camera uses a traveling, two-curtain design. A curtain with a rectangular hole begins passing in front of

the film plane, allowing light to fall on the sensor. A second, closed curtain follows a controlled amount of time behind the first and blocks any further light from reaching the sensor. The combination of the open and solid curtains results in a slit traveling across the sensor. The faster the shutter speed, the quicker the second closed curtain will follow the first open curtain. In essence, the slit becomes narrower as shutter speeds get higher.

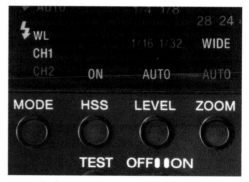

5.17 Flash units that support HSS generally have a switch to allow you to turn HSS off and on.

At high shutter speeds, the slit is never wide enough to allow a single quick burst of light to illuminate the entire sensor. Only when the shutter speed is 1/160 second or slower will the slit be wide enough for a single burst of light to illuminate the entire frame.

A normal flash unit emits a powerful, but very quick, burst of light. This is sufficient to light the subject, but unless the second curtain waits long enough for this light to reach the entire sensor before closing the shutter, only a portion of the sensor will see the flash when it fires.

HSS flash units can overcome this problem by firing several longer, but weaker, bursts of light. You might not notice the multiple

bursts, but because the additional light pulses span a longer duration, the traveling slit can illuminate the entire sensor. In the HSS mode, some flash units can sync at the 1/4000 second maximum shutter speed of the A300 series.

The 300 series supports HSS, so if you want to use this feature, you will need to look for a flash unit that offers HSS. To shoot in the HSS mode, you simply turn on the HSS mode on the flash. There is nothing to engage on the camera.

Bounce and swivel

Most high-end flash units offer bounce and swivel capabilities. Bouncing flash off a wall or ceiling can be a very effective way to eliminate harsh, direct lighting. The bounce light comes from the side or from above, re-creating the look of natural lighting. Of course, you need a convenient wall or ceiling, but the results are usually far superior to direct flash. Look for a flash unit that offers a full range of bounce abilities. Swivel is somewhat less important, but it still can be handy to have the ability to fire the flash to either side.

Remote battery packs

Many third-party flashes can be powered with battery packs. These typically hang by a shoulder strap and have a cord delivering power to the flash. Some flash brackets also contain rechargeable battery packs.

Battery packs can give you several times as many flashes as you would get from a set of AA batteries. In addition, you will usually enjoy much faster recycling times. You can only use a remote battery with a flash designed to accept external power. Currently

the only Sony-made flash to offer a remote battery pack is the HLV-F56AM, but there are several third-party manufacturers who offer remote battery power.

Sony Dedicated Flash Units

If you buy a Sony Alpha flash unit, you are guaranteed all the features previously discussed, with the exception of the remote battery pack. You also know the flash unit will work perfectly on the A300 series. After all, who should be better at developing compatible flashes for the Alpha than Sony?

5.18 The HLV-F42AM was introduced at the same time as the A300 series and offers external flash capabilities, including wireless flash and HSS.

Currently there are four flash models in the Alpha lineup, as well as two specialized ring lights.

The recently announced HLV-F58AM breaks new ground in the dSLR flash arena, as it offers a pivoting body in addition to the usual bounce and swivel capabilities. This means if you shoot in the vertical portrait mode, you can still bounce the flash with the flash head in the horizontal orientation. This can be very important with wide-angle lenses, so this flash is a welcome addition to the Sony line up.

5.19 Just introduced, the HLV-F58AM features a pivoting body as well as bounce and swivel positions. The pivot feature permits the user to use horizontal bounce flash when shooting vertically.

All the Sony flashes support wireless flash, so you can use the lower priced base units as wireless fill lights. The biggest difference in the Sony units is the guide number (the distance the flash can shoot at) and the presence of an external connector. If you want to use off camera flash with one of the units with the connector, you will have to buy the extra FA -CS1AM off camera shoe.

Using Older Minolta Flash Units with the A300 Series

Many, but not all, Minolta flash units are fully compatible with the Sony Alpha. In fact, the Minolta 5600HS (D) and the 3600HS (D) are basically the exact same flash as the Sony HLV-F56AM and HLV-F36AM, respectively. The only other Minolta flash that is fully compatible with the A300 series is the somewhat basic 2500(D). These three Minolta flashes should work as well on the Alpha series as any Sony flash.

5.20 Older Minolta flashes such as this AF4000 will only fire at full power, but there is a provision for users to adjust the power range to compensate. The AF4000 has the old style shoe, but does feature a Sony-compatible connector for off camera flash.

Of course, Minolta made numerous other flash units with the Alpha flash foot design. You might guess that these would work on the Alpha as well. They will fit and fire as expected, but there is a problem. Minolta changed the internal flash circuitry when the company designed the (D) series flashes. Only the (D) series can be fully controlled by the Sony Alpha and Minolta dSLRs. The older flashes can be controlled by equally old film cameras, but not by any dSLR.

If you shoot with one of the older flashes on the A300 series, the flash will always fire at full power, as there is no way for the camera to control the flash output. This practically guarantees that your images will be seriously overexposed, unless you are in a situation where the full power is required.

All is not lost, however. Some older Minolta flash units feature manual power output settings. In most of the cheaper flashes, the camera controls the power setting; there is

no provision for user adjustment. This worked fine with a compatible camera, but as explained earlier, the Sony Alpha cannot adjust the output, so the flash always fires at maximum power. The better Minolta flashes offer manual control of the flash power. With these flashes, the user can adjust the maximum power the flash will deliver. When you use one of these flashes on the A300 series, they will still fire at full power. Because you can control the maximum power setting, however, you can reduce full power to one-half, one-quarter, or one-eighth of the flash's maximum output.

This is not nearly as convenient as shooting with a fully dedicated flash, but you can get excellent images from these variable power flash units if you are willing to fiddle with the manual settings.

Otherwise, stick to the Minolta (D) series flashes which are fully controllable by the A300 series.

Shooting with the Alpha A300

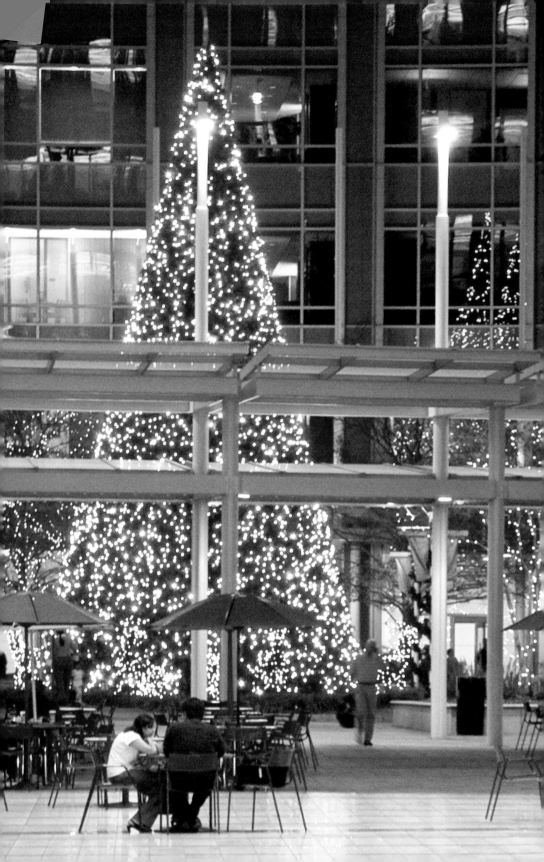

Photo Subjects

I n this section, you will move beyond mere theory and actually put your A300 series to work. The following assignments are designed to provide hands-on-learning in a wide variety photographic situations. As you progress through these exercises, you will gain confidence in your skills and gain new appreciation of the capabilities of your camera.

Each time you shoot a different subject or explore different lighting conditions, you will expand your photography expertise. As you master the following exercises, you will find yourself adapting the lessons learned to your own projects. So experiment, think everything through, and most of all, have fun.

Animal and Pet Photography

Animals are interesting and challenging subjects for photographers. Dogs and some domestic animals can be coaxed into posing for the camera, but most creatures could care less about a photographer's instructions. Wild and feral animals are even less controllable, as they are typically wary and shy of anyone pointing a camera at them. That means you have to seek out good animal photos; they seldom just happen.

Because animals are unpredictable, it is usually a good idea to leave some room for unexpected movement when you are framing active animals. Thanks to the high resolution sensors on the A300 and A350, you can always crop your images to fill the frame when you process the images on your computer.

Telephoto lenses are the mainstay of wildlife photographers, but they work equally well for pets. If you get too near your pet, you may distract them and they will run to you. If you shoot at longer distances with a telephoto, you can get excellent candid shots of your pet acting naturally.

6.1 Wilderness creatures, such as this timber wolf, are nearly impossible to photograph up close outside of zoos and nature preserves. Even in these locations, you'll need a fast lens, a fast shutter speed, and fast reflexes to catch the animals in motion.

Inspiration

A successful hunter studies his prey carefully so he knows where the animals can be found, how they will act, and what things attract them. As a hunter with a camera, you can employ these same techniques, even with your own pets. Watch how animals react to different stimuli. When you observe your pet acting cute or funny, try to repeat the conditions that provoked the animal's response; keep your camera at the ready.

Animals can be completely unpredictable. Many of the best animal images are captured by photographers who put themselves in a position to react immediately when they spot an animal acting in a funny, unusual, or interesting manner.

6.2 Not every animal is difficult to capture with a camera. There are few things more peaceful than a sleeping animal. Use a mild telephoto to get close without disturbing your pet's slumber.

Animal and pet photography practice

6.3 Bright sunlight caused the eyes to close down to narrow slits, imparting the impression that this cat knows things he isn't willing to share.

Table 6.1
Taking Animal and Pet Photographs

Setup	**Practice Picture:** Like many of the best animal photos, the cat picture in figure 6.3 is a candid grab shot. The cat wasn't the original subject, but quickly swinging the lens into position and shooting, I was able to produce this image that perfectly captures the personality of the animal. A second afterward, the cat ran off.
	On Your Own: You have to pay attention and be ready to react instantly when a great animal image presents itself. Zoom lenses, autofocus, and auto exposure settings can help you capture animal shots when there is no opportunity to set up the camera.
Lighting	**Practice Picture:** Afternoon sunlight.
	On Your Own: You can set up portrait lights to shoot domestic animals, but for grab shots like this, you will generally have to rely on whatever light is available.

continued

Table 6.1 *(continued)*

Lens	**Practice Picture:** Minolta 70-210 f/4, zoomed to 160mm.
	On Your Own: Like portraits of people, a mild telephoto will eliminate distortion, so a lens of 50mm (75mm with the crop factor) is probably the minimum focal length for photographing animals. You will often want a longer lens if you are shooting wild or shy creatures. Because animals react so quickly, you will want to shoot at a fast shutter speed, so the faster your lens, the better.
Camera Settings	**Practice Picture:** Program Aperture, Super Steady Shot, and autofocus on.
	On Your Own: Although you will normally want to take full control of your camera, in situations such as this, you will want to rely on automated settings to instantly capture the shot before it is gone.
Exposure	**Practice Picture:** ISO 250, f/4, 1/250 second.
	On Your Own: For a calm family pet, you may be able to shoot at any setting. For animals that are wary and elusive, you may need to shoot at higher ISO settings that allow you to use a shutter speed that stops the animal's motion.
Accessories	Lens hood.

Animal and pet photography tips

✦ **Always, always use caution around animals you don't know.** Even friendly looking pets can become aggressive, and non-domesticated animals can attack suddenly if they feel threatened.

✦ **Food can be a great motivator.** A savory treat can coax many animals to forget their shyness and cooperate. Some animals, however, will be so interested in whatever food you offer that they will jump on you, making it difficult to get an attractive composition.

✦ **Keep your camera ready.** All animal lovers can tell you tales about strange, funny, or unbelievable things they saw their pets doing. By the time they got their camera out, however, the moment had passed. Sometimes just the sound of the autofocus motors is enough to distract an animal from what it was doing, so always assume you will have only a single chance to capture a shot of an active animal.

Architectural Photography

Architectural photography allows you to capture houses, buildings, and structures of all sizes and materials. It might seem that photographing buildings would be simple; after all, structures do not move or blink. In actuality, architecture photography can be extremely demanding. You have to constantly be on the look out for lens distortion, while shadows and reflections can destroy your carefully composed shot. Interior photos can be particularly troubling, as the light from bright exterior windows often exceeds the camera's dynamic range.

6.4 A benefit of long lenses is there is usually little distortion, so the sides of structures look parallel.

Good architectural photography can make even a modest structure interesting, while careless snapshots of buildings often look bland and uninteresting. While careful composition is important to all photographic images, it is especially critical in architectural images. Planning the shot to avoid problems and to emphasize design aspects can make a huge difference in the successes of any architectural photograph.

While wide-angle lenses are a mainstay in architectural work, there are times when you can employ telephoto lenses to good advantage. If there is sufficient room to use a long lens, you can avoid the deformity sometimes caused by wide-angle lenses.

Inspiration

When you take on an architectural photography assignment, take time to evaluate the subject without your camera. Walk around the structure and envision the best angles to shoot from. Look for details that will add interest to your photographs. Plan where you will place your tripod and which angles will display the subject at it's best.

Wide-angle lenses are nearly a must for interior views, but lenses with an extreme angle of view typically create strange perspectives. The custom sink shown in figure 6.5 is marred by distortion.

You can repair minor distortions in a program like Adobe Photoshop. This is a free-form activity; you have to use your own judgment as to how much you want to modify the image until it looks right. I used the Transform tool to drag the top corners of the photo inward until the perspective of the cabinets looked correct. Although this fixes the cabinet problem, the entire image now looks too deep; everything is stretched up and down. Using the Transform tool stretches the image in the width and corrects the distortion, making the sink look round again.

6.5 The side cabinets appear to be falling away from the center counter, and the entire unit looks like it is leaning forward.

6.6 Notice the top corners do not fill the entire image frame. To fix this problem, crop away the parts of the image that do not meet at the top corners.

6.7 The final result has lost part of the image on the left and right sides, but the cabinets now look parallel and the sink isn't threatening to fall over. You can use this same technique with exterior images of buildings, which often exhibit distortion when you shoot upward at them.

Architectural photography practice

6.8 A cloudless sky and strong morning light combine to add drama to this distinctive custom home. The low shooting angle adds to the impressiveness of the three story structure. The trees and vegetation add to the sense of scale.

Table 6.2
Taking Architectural Photographs

Setup	**Practice Picture:** I photographed the custom home in figure 6.8 early in the morning to take advantage of the autumn sunlight. The angle of the sun eliminated the shadows except for those under the suspended deck.
	On Your Own: Always be aware of shadows when shooting architectural images. In the practice photo, the shadows actually help define the deck's dimensions, but cast shadows across windows or decorative trim will kill a good architectural photo.

Lighting	**Practice Picture:** Direct sunlight timed to illuminate the front of the house.
	On Your Own: You may need to use artificial lighting inside a building, but most exterior shots will be shot with direct sunlight. Because you can't simply flip a switch to get good sunlight, you may have to plan your shoot for a certain time of day. If the weather is poor, you may have to postpone the shoot until the weather clears.
Lens	**Practice Picture:** Minolta 16mm "fish eye."
	On Your Own: For most architectural applications, you will want a good wide-angle lens. Wide-angle lenses allow you to include the entire structure without having to move back an unacceptable distance. Wide angles also create apparent distance in a shot, making yards and rooms look larger.
Camera Settings	**Practice Picture:** Manual exposure, no Super Steady Shot, autofocus off.
	On Your Own: You can rely on the auto exposure of the A300 series, but setting the exposure manually will allow you to tailor the exposure to your preferences.
Exposure	**Practice Picture:** ISO 100, f/16 1/125 second.
	On Your Own: Unless you are trying to eliminate a distracting element, stopping down the lens to a small f/stop will enhance depth of field, making everything in the shot look properly focused. Because you will be shooting from a tripod and houses don't usually move, a slow shutter speed is acceptable.
Accessories	Tripod, cable release.

Architectural photography tips

✦ **In most cases, the wider focal length, the better.** This is particularly true indoors. A normal lens can make a spacious room look like a phone booth. Even moderate wide angle lenses will make a room appear cramped. It takes a true wide angle lens to make interior rooms appear inviting.

✦ **Remember the crop factor.** Because most lenses are designed for full frame cameras and your A300 series uses a smaller APS-C sensor, all lenses, including extreme wide angles, will have a magnified angle of view that is 1.5 times greater than when the lens is used on a full frame camera. That means the extremely wide Sony 16mm will only have the angle of view of a 24mm lens on a full frame camera. If you will be shooting many architectural projects, you will probably need a lens of 11mm or so to compensate for the crop factor magnification.

✦ **Windows can cause problems when shooting indoor scenes.** If you shoot indoor architectural scenes, sunlight streaming through outside windows can easily exceed the dynamic range of the sensor. If you set your exposure so the room

is properly lit, the windows may appear as strange white rectangles. There will be no detail in the window areas, so if there are scenic views outside the windows, they are not visible. In extreme cases, light streaming through the windows will give you uneven exposure by making one side of the room lighter than the other.

To correct this problem, you can either add studio lighting to bring the illumination of the room closer to natural sunlight, or you can wait for the outside light to weaken, creating less of a dynamic range problem. You could also create a second image with the proper exposure for the outer scene and strip the properly exposed windows into place on the main image of the room.

✦ **You can correct perspective problems with software.** View cameras are still very popular with professional architectural photographers, because they can tilt the lens in reference to the film plane, to correct perspective problems in a photograph. When you tilt a lens upward to shoot a tall building, the change in perspective creates the appearance that the building is tipping away from the camera. You can distort your images in a program such as Adobe Photoshop to correct this unwanted problem. Usually you can change the perspective to make the sides of buildings or rooms look parallel, which will go a long way toward making the building look the way it should.

Black and White Photography

Interest in black and white photos has surged in recent years. In a world where everyone is filling up memory cards with color images, black and white images stand out from the crowd. Only a few decades ago, most images were shot in black and white, and major magazines were filled with black and white photos. Today, even local newspapers use color images, and many photographers have never shot a black and white image in their lives.

It shouldn't be this way, as the black and white format has a lot to offer. In the first place, because people are used to seeing full color images a black and white photo

may gain extra attention. Secondly, certain subjects seem to look better in black and white. A well-done black and white portrait or architectural image can look elegant and refined, while similar color images may fail to elicit the same feeling. Finally, there are no shifts or color clashes in a black and white image. An image that might look garish in full color can take on a pleasant, soothing appearance when seen in black and white.

Fortunately, there is no need to choose between color or monotone images when you are shooting. In the days of film, you had to choose between one or the other format when you loaded your camera. Black and white prints made from color negatives usually had significant quality issues, and there was no convenient way to turn a black

6.9 A color image of these grave markers might appear too cheerful, but a toned black and white conveys respect and somberness without being morbid.

and white print into a color image. Because you are shooting digital, however, you can easily convert any color image into a black and white image. Black and white JPEG images have no color information, but the RAW format always retains the data the camera collected. That means you can turn a black and white RAW photo back into a color image in your favorite RAW converter.

If you convert RAW images into black and white on your computer, you can easily experiment with a wide array of tints and hues to elicit even more attention from your black and white images.

Because it is so easy to convert any photo to black and white, there is no reason to specifically shoot in the BW (black and white) mode. You can simply shoot normally and convert the images during your post processing. Because the A300 series is a full-

fledged dSLR (digital single lens reflex), you will not see any difference when you look through the viewfinder when you are in the BW mode. The mirror and ground glass will still display in color, just as when you loaded black and white film in a film SLR. The A300 series will, however, display black and white views on the LCD screen when shooting in the live preview mode.

Almost any graphic software program (including the Sony Image Data Converter program that shipped with your camera) can convert color images to black and white. Some programs simply discard the color information, but the better programs offer tonal adjustments that permit you to add tints and hues to customize the final look of your image.

If you are using a program like Photoshop, there are several ways to create black and white images. You can simply choose the

grayscale mode, or use the Desaturate command to eliminate any color information. An even better solution is to leave the image in the RGB (red, green, blue) mode and use the Hue, Saturation, and Brightness palette to eliminate some, but not all, of the color information. By varying the saturation of different channels, you can obtain eye-popping combinations that will stand out from a simple black and white image.

This exercise uses the presets in the Adobe Lightroom program to convert a color snap shot into a custom tone black and white

6.10 Black and white is an excellent choice for night photography, as color tones are usually muted and there are often areas of dark shadows. Notice how the pool of light around the race car directs the viewer's attention to the main subject.

image. If you do not own a copy of Lightroom, you can download the free trial from www.Adobe.com or you can approximate these steps with whichever graphics software you use.

Toning an image is an expression of your own creativity. Each photographer will have his or her idea of how the final image should look, so the amount of color tint you add to your image is completely up to your preferences.

Inspiration

Today, you have the choice of when to use color and when to use monochrome. Subjects with vibrant hues typically look better in full color, while less-brilliant subjects may look more dramatic in black and white.

Watch for subjects that will lend themselves to a monochrome treatment. Even if you show most of your images in color, you can shake things up by adding a few black and white images in your slide shows or albums.

6.11 This barn photo is a perfect candidate for black and white. The harsh shadows, weathered wood, and dilapidated roof create a feeling of age and loneliness, which the black and white treatment reinforces.

Black and white photography practice

6.12 The original color photo of this revolutionary war cannon was mildly interesting, but needed something to draw viewers' attention. Converting the photo to a tinted black and white image creates an antique appearance that has an appropriate historical feel.

Table 6.3
Taking Black and White Photographs

Setup	**Practice Picture:** The cannon image in figure 6.12 started as a full color RAW image. I convert it to a RGB black and white image that still displays a hint of the original colors.
	On Your Own: You can convert any image from color to black and white with graphics software. It is best to choose images with strong contrast and subjects that will look good in black and white. This cannon is a great candidate for black and white, whereas a beach sunset would not be.
Lighting	**Practice Picture:** Afternoon sunlight, aided by fill flash.
	On Your Own: You can use almost any lighting for a black and white photo. There is no need to be concerned with white balance, as any color casts will be discarded along with the rest of the color information.
Lens	**Practice Picture:** Sony 18-70mm lens set to a zoom range of 45mm.
	On Your Own: Almost any lens lends itself to black and white photos. Black and white was the only medium that early photographers had, and they experimented with lenses of all types and focal lengths.
Camera Settings	**Practice Picture:** RAW capture, Super Steady Shot, and autofocus on.
	On Your Own: You could use the BW mode on the A300 series, but shooting normally and converting to black and white in post processing is the recommended workflow.
Exposure	**Practice Picture:** ISO 400, f/9, 1/160 second.
	On Your Own: Start with any exposure that yields a good image. You may want to play with exposure compensation if you are seeking to evoke a specific feeling (for example, dense shadows or ethereal highlights).
Accessories	No special accessories were used for this image.

Black and white photography tips

✦ **Not every image looks good in black and white.** While most subjects can make interesting black and white photos, some photos grab our attention because of the vivid colors they contain.

✦ **Watch out for similar colors.** In a color image, all colors have a distinct appearance. In black and white, however, shades of red, blue, and green might look nearly the same. Thus, a high contrast color photo might turn into mush as the contrasting colors meld into each other.

✦ **Intermix color with black and white.** A fun technique is to create a photo that is mostly black and white with a portion popping out in full color. This is easy to do with layers in Photoshop. Duplicate the original color layer and convert that layer to black and white. Use whichever selection tools you are comfortable with to create a selection over the portion of the image you want to appear in color. Add a layer mask, choosing to hide the selection. The mask will hide the area in the selection, allowing the color image below to show through. The result will be a bright color area that appears to be overlaid on a black and white background.

Event Photography

Event photography is a broad term that can be applied to everything from weddings, to business meetings, to concerts. No matter where you live, there are probably several events occurring nearby. Carnivals, fairs, arts and craft shows — even the smallest town usually attracts at least one big event each year. Large cities will typically have several events planned each weekend.

Events are great places to expand your photography experience. There are usually colorful characters, especially if the event attracts people in historical or non-traditional costumes. If the event includes some sort of show or performance, this can yield some wonderfully interesting photos if you put yourself in the right place at the right time.

Although some events are private or closed to photographers, most event organizers welcome anyone willing to record images of their gathering. Many event coordinators overlook the need for photographs when planning the event, and smaller events may lack a budget to contract a photographer.

Such event planners usually gladly receive anyone with a camera, often providing the photographer with access to areas not available to the public.

6.13 No matter where you live or travel, you will find a huge variety of events occurring nearby. Reenactments are great places for interesting event photographs. A long lens gets up tight on the action and eliminates any evidence of modern society.

Inspiration

Your local newspaper is a good source of upcoming event announcements. You will also find signs and notices posted around your town. Public libraries are another good place to find event announcements. You will also find event listings on the internet. Don't overlook the local Chamber of Commerce, as it will usually have full information of any major event in the area.

You want to have as much advance knowledge of an event as possible. This will allow you to plan your own schedule so you have free time to shoot the event. A little pre-planning can make the difference between getting a collection of wonderful images or coming up empty-handed because you were otherwise engaged.

6.14 Crowds add impact to your event photos. You frequently want to isolate your event photos to eliminate the distraction of milling spectators, but always include at least some images showing the crowd, especially if the attendance is numerous.

Event photography practice

6.15 Annual events, such as this wooden boat show, always provide a great opportunity to capture interesting images. Watch your local events calendar and plan ahead.

Table 6.4
Taking Event Photographs

Setup	**Practice Picture:** Covering events such as the boat show in figure 6.16, has much in common with photo journalism. The goal is to tell a story from as many angles as possible. For this reason, there is usually no place for a tripod or involved studio lighting.
	On Your Own: Your event photography style will in some part be dictated by the event itself. Will the event be indoors or outdoors? Will it be held during the day or at night; or will it be an extended event lasting several days? Will the subjects be primarily people such as those at a concert? Or will the subjects be large and involved such as those doing a reenactment or subjects in a large display? Consider the breath and scope of the event before heading out into the field.

Lighting	**Practice Picture:** Afternoon sunlight.
	On Your Own: Your lighting will depend on the event subject. Additionally, artificial light such as electronic flash might not be permitted at some events. If the light is dim and you can't use flash, you may need to boost the ISO and shoot with a monopod. When there are crowds of people moving about, a full fledged tripod is difficult to set up and move around. Shooting existing light with a monopod may be your only option.
Lens	**Practice Picture:** Minolta 50mm f1.7 lens.
	On Your Own: Event shooting can require a large lens selection. You may want a wide angle to capture an entire scene, while a telephoto will allow you to get close to individual speakers, performers, and celebrities. Your best solution may be a selection of light lenses carried in an over the shoulder bag.
Camera Settings	**Practice Picture:** Aperture Priority program.
	On Your Own: Automatic settings are helpful for event shooting, as you will frequently be switching subjects and lighting conditions. You may need to use exposure compensation or manual exposure from time to time, but if you are trying to cover all aspects of an event, an automatic or semi-automatic setting will give you good exposures without wasting time.
Exposure	**Practice Picture:** ISO 100, f/11, 1/125 second. There wasn't any fast movement, so a moderate shutter speed of 1/125 second was fast enough to stop movement.
	On Your Own: For this shot in bright sunlight, the lens could be stopped down to increase sharpness and depth of field. Every event and every subject will differ however. At most events you will find yourself switching exposures frequently.
Accessories	None.

Event photography tips

✦ **Prepare to travel light.** At larger events, there is usually something happening all the time. You don't have the luxury of returning to your car for additional lenses and lighting equipment. Try to condense everything you need for the shoot into an easy-to-carry shoulder bag or backpack.

✦ **Take notes.** Always carry a pen and paper at an event. With so much going on, you will invariably forget things. Take notes so you will remember people's names, companies involved in the event, and statistics about the event itself.

✦ **Always be prepared.** Digital cameras are great, but without power or space on your memory card, they are just extra weight hanging around your neck. Always charge your battery before the event. Bring extra memory cards. If you will be using an external flash, bring extra batteries for that as well.

✦ **Try to arrive early and stay late.** Often the best photos from an event occur early on, when everyone is fresh and there is little in the way of a crowd. On the other hand, evidence that there is a large crowd can make photos look more dynamic and exciting. Get some good images before the crowds descend, but take additional images with the crowd in full attendance.

✦ **Vary your camera angles and position.** Few things are more boring than an event where every photo is taken from the same location. Move around, capture the event from as many different locations and perspectives as possible. Use different lenses, take vertical as well as horizontal images.

Flash Photography

Despite the advances in digital photography technologies, good flash photography still requires some knowledge and practice. You can usually get nice snapshots with a hotshoe mounted flash or with the popup flash on the A300 series. If you want to consistently create stunning flash images, however, you will need to learn how your flash and camera interact in specific lighting conditions. The best way to accomplish this is by taking flash images — lots of flash images. Figure out what is wrong with the bad shots and how you could have improved the good ones.

If you have the equipment available, experiment with off the camera flash techniques. Any good photographer will tell you that using a flash on the hotshoe reduces your chance of getting interesting photos. Shooting with a remote wireless flash, or with a flash unit fired with a PC sync cord, dramatically increases the quality of your flash images.

Inspiration

You don't have to spend a fortune or shoot with the very best equipment to get great flash photographs. If you are patient and creative, you can assemble the basics for well under a hundred dollars. An inexpensive flash, a way to move it off the camera, and perhaps a cheap or homemade light modifier should get you started. You may have to use your flash, your camera, or both in Manual mode to get the most out of this basic flash setup. That is all to the good, however. If you practice diligently with a simple kit, the experience and understanding you gain will let you master any flash situation, even if you move up to a more expensive, fully dedicated flash unit.

6.16 Animals get red eye, too! In this case, you might call it green-eye. You may see gold, blue, and purple eyes on animals as well. As with people, the best way to eliminate animal red-eye is to move the flash off the hotshoe.

Flash photography practice

6.17 Black animals, such as this Cocker Spaniel, are difficult to photograph, because their coats absorb so much light. Fill flash was used to additional light to make the dog's coat and eyes stand out.

Table 6.5
Taking Flash Photographs

Setup	**Practice Picture:** This was a complex shot with an A350 mounted on one tripod and a HLV-F42AM mounted on a second tripod about 75 degrees to the left. I stood to the left of the flash unit and triggered the camera with a remote cable release.
	On Your Own: You can use the built-in flash on the A300 series for fill flash, but as with any flash application, you will get better results with the flash off the camera.
Lighting	**Practice Picture:** Single wireless electronic flash mounted on a tripod and triggered by the built-in flash on the A300 series.
	On Your Own: Off-camera wireless flash is a great way to prefect you off-camera lighting skills. Experiment with placing the remote flash unit at different distances and angles from your subject. Analyze your images to determine which locations worked and which didn't. You will quickly develop a good sense of how and when to use fill flash.
Lens	**Practice Picture:** Sony 18-70mm zoomed to 30mm.
	On Your Own: Any lens your flash can cover properly is acceptable. Most flash units cannot cover the entire frame of an extreme wide angle, and create dark vignetting if the lens is too wide.
Camera Settings	**Practice Picture:** Shutter priority, Super Steady Shot Off (camera on a tripod). Camera set to wireless flash, flash unit set to HSS (High Speed Sync).
	On Your Own: To shoot off-camera flash, you will either need to use a hotshoe cable or use wireless flash. Both have their pros and cons, so experiment with what you have available, and expand your equipment as you increase your skill level.
Exposure	**Practice Picture:** ISO 100 f/5 1/200 second (HSS).
	On Your Own: You can use any setting that provides a good exposure for flash photography. If you are going to shoot at shutter speeds faster than 1/160 second with the A300 series, you will need to use a flash unit that features HSS. Given this was a daylight shot, HSS was required because the dog would undoubtedly move, creating blur.
Accessories	External flash cable of HSS and wireless connectivity, two tripods, long cable release.

Flash photography tips

✦ **Red-eye is a turn off.** Unless you are shooting images for a horror film, red eye can spoil otherwise excellent flash images. Sometimes you can fix red eye in software, but it is time-consuming and subtly changes the look of a person's eyes. The A300 series does offer a Red eye reduction mode, but it only works with the built-in flash unit. The best way to eliminate red eye is to move the flash off the camera's hotshoe so the flash is not aligned with the camera's lens.

✦ **Keep your subject away from walls.** New photographers love to line their subjects up against the nearest wall for portrait and group shots. If a flash is used, this almost always results in cast shadows behind the heads of the subjects. The closer the subject is to the wall, the darker the shadows will appear, to the extent that the tresses of dark haired subjects will merge with the shadows into an unappealing blob. Keep several feet between your subject and the nearest wall when shooting with a flash.

✦ **Watch your distance.** Most flash units, including the built-in flash on the A300 series, have a minimum flash to subject distance. If you fail to observe this minimum distance, you will usually wind up with drastically overexposed images with no detail in the highlights. If you must shoot with the flash closer than the minimum, experiment with different diffusers and modifiers that can cut the light output.

Flower and Garden Photography

Even non-gardeners enjoy flower photography. The riot of stunning colors, the appealing shapes and the endless variety make flower and garden photography a wonderful way to increase your collection of compelling images. You don't need to travel to a major botanical garden to find a subject to photograph either. You will usually find many interesting subjects in your own backyard, even if you don't have a formal garden. Even weeds, when photographed from the right angle, can serve as compelling subjects.

Although you can capture excellent garden images without any special equipment, a good macro or close-up lens will dramatically increase your options when shooting flowers. Moving in close on a leaf or petal can display features that few people ever see with their naked eyes. Someone may pass by a nondescript flower bed every day without giving it a second glance, but she becomes fascinated when you show her close-up images of the delicate construction of the individual plants.

You don't have to be a master gardener to capture great flower images, but like all forms of photography, it helps to know something about your subject. If you know a particular flower only opens up during a certain time of

6.18 Close-ups can create extraordinary flower and garden images. Even though the plant body is the same shade and tone as the background, the sharp details make it stand out well against the soft background.

day, you can plan a photo session around that knowledge. In the same way, some plants look dull and uninteresting for most of the year. For a brief time, however, that same plant may erupt into dazzling colorful blooms that quickly fade as the plant resumes its drab appearance. If you plan accordingly, you can record photos of the plant or flower in its full glory.

Inspiration

You can find subjects for flower and garden photography almost anywhere. State parks, decorative gardens, hiking trails, local farms, your neighbor's flower boxes — botanical subjects are everywhere.

Although you don't usually think of plants as being reflective, the fact is that light, pastel colors and smooth, hard fruit rinds both throw off a considerable amount of reflected light. In summer, you should plan your garden photography forays in the morning or evening, as noon sunlight will usually create glare. If you must shoot in the heat of the day, you have two choices. You can tent the plant with some sort of translucent material to soften harsh light. A piece of translucent material held between the plant and the sun will duplicate the effect of an overcast day, softening or eliminating shadows.

Your other option is to use electronic flash, set to lightly fill in the shadows and reduce

the tonal range differences. As always, off-camera flash usually produces superior results, but in a pinch you may get away with the popup flash.

In the course of photographing gardens, you will undoubtedly come upon other species of living things. Watch for birds, insects, reptiles, rabbits, squirrels, and other creatures that haunt gardens. You can often capture interesting images of these garden beings with flowers and vegetation as a background.

6.19 Water droplets catch the sun and add interest to the red textured leaf. Look for small details such as this to set your garden images apart from ordinary flower images.

Flower and garden photography practice

6.20 The light pastels of the flower petals contrast sharply with the out-of-focus, dark green background. A long lens with a wide aperture combine to make the subject pop off the background.

Table 6.6
Taking Flower and Garden Photographs

Setup	**Practice Picture:** I chose the subject for figure 6.21 because there were no other flowers around it, simplifying the task of making it stand out from the background.
	On Your Own: Because of the rich variety of colors and shapes, flowers can look good from almost any angle. Look for ways to use composition to isolate your subject from the background and other vegetation.
Lighting	**Practice Picture:** Afternoon sunlight.
	On Your Own: Electronic flash can often be helpful when shooting flowers, as the flash will fill in any shadows. Backlighting, either with a flash or with sunlight can be an excellent form of illumination for flowers, as translucent petals and leaves display new details when lit from behind.
Lens	**Practice Picture:** Minolta 70-210mm f/4 zoomed to 70mm.
	On Your Own: Long lenses, particularly those with macro capabilities, are excellent for flower photography. You can get close without uncomfortably contorting your body, and the long lens makes it easier to create an out-of-focus background.
Camera Settings	**Practice Picture:** RAW capture, Super Steady Shot on, manual focus.
	On Your Own: You can usually trust the camera's meter for flower photography, but by bracketing your exposures, you may obtain details and colors an auto shot would miss. If you are shooting close-ups or in the macro mode, you may prefer manual focusing to control the areas of sharpest focus,
Exposure	**Practice Picture:** ISO 100, f/5.6, 1/500 second.
	On Your Own: A low ISO will yield sharp images with no noise, so use the lowest practical ISO when shooting light pastel colors. A wide aperture will reduce depth of field, helping to isolate your subject. A fast shutter speed will reduce wind created movement.
Accessories	Lens hood.

Flower and garden photography tips

✦ **Choose a windless day.** Flowers and plants are usually fairly delicate. The slightest breeze can cause movement. No matter how sturdy your tripod, it won't prevent blurring as flowers and plants wave in the wind. You may be able to erect some sort of barrier to protect your subjects from the breeze, but a calm, windless day is preferable.

✦ **Try backlighting.** Because many flowers are translucent, you can achieve dramatic results by letting the sun or other light source illuminate your subject from behind. Because the light is actually shining through the petals and leaves, you will get extraordinary colors and textures.

✦ **Try bracketing your exposures.** If there are areas of dark foliage, your camera's meter may not produce the best tonal range. Bracketing may allow subtle tones to appear that would ordinarily be lost with a normal exposure.

✦ **Don't forget your macro lens.** Flowers are natural macro subjects. An overall shot of a colorful flower bed might be interesting, but filling the frame with a crisp, colorful individual flower can create a stunning image. Get close, make the subject as sharp as your lens will permit, and you will create memorable flower and garden images.

Food Photography

Everyone likes good food, and chefs will tell you they place nearly as much importance on the appearance of their signature dishes as they do on the taste. To appreciate the importance of great food photography, notice how you often get hungry after seeing images of colorful meals displayed on television and in magazine ads. The food in many exclusive restaurants is often no different than that offered in small family hangouts, but the appearance and ambience allows the upscale eatery to charge significantly more.

Inspiration

Unfortunately, food photographers have a short window of opportunity to capture images of great-looking meals. Some foods can look good for an extended time, but many items only look their best for a few minutes. You have to be ready to capture your image as soon as the dish is removed from the oven; or the freezer if you are shooting a frozen desert. This means you have to have everything set up ahead of time; there is no time to place lights or move the camera angle once the food is on the table. Prepare everything you can before placing the food on the set. If everything is

ready in advance, you will have a much longer period to shoot before the subject loses its fresh appearance.

6.21 Shooting downward into this dessert invites you to dive in and enjoy. Notice the angles used in food advertisements. Invariably, foods are portrayed in a manner that provokes your attention and your appetite.

If possible, avoid "hot" lights; electronic flash is a much better solution for this type of shooting. Even fairly low wattage lamps can quickly wilt and dry a great looking plate, to say nothing of what they will do to frozen things.

Don't overlook the setting itself. Just as five-star restaurants have found their patrons better enjoy their meals in first-class surroundings, the food in your photos will look much more appealing on a well-set table. Polished tableware, sparkling water in crystal glasses, and nicely folded cloth napkins will go a long way to make the food in your photos more attractive. Of course, if you are shooting a simple burger and fries, you may want to create a less formal setting, but you should still strive to establish a tempting environment for the culinary subject.

Food photography practice

6.22 You can't smell or taste the bread in this photo, but you can see the texture, and that texture makes it attractive. Side lighting created the impression of grain. Lighting from the front would have left the surface of the bread looking flat and unappealing.

Table 6.7
Taking Food Photographs

Setup	**Practice Picture:** I sliced a loaf of bread and placed it on a breadboard. Note part of the bread knife in the photo. After the composition and lighting was finalized, I spread butter on the slice closest to camera. I then completed the shot before the butter had a chance to melt.
	On Your Own: Take care of the little touches. The practice photo would be less successful without the breadboard, knife, and butter. Strive to make the food in your photos look like it is ready to eat.
Lighting	**Practice Picture:** Tungsten lights for fill, wireless flash unit bouncing off a reflector to create the side light for the texture.
	On Your Own: You can use some tungsten lighting, but your main lighting for food should be electronic flash or strobe. The heat from a tungsten main light would have quickly melted the butter in the practice photo.
Lens	**Practice Picture:** Sony 18-70mm zoomed to 60mm.
	On Your Own: As with product photography, you should avoid wide angle lenses, unless you want to distort your food items to give them an unnatural perspective. You will often see exaggerated perspective in food advertisements; if you like the look, by all means experiment with wide angle lenses.
Camera Settings	**Practice Picture:** Manual exposure, autofocus off, Super Steady Shot off (camera on a tripod), custom white balance, auto bracketing.
	On Your Own: Setting the exposure manually makes it easier to get the subtle appearance of food correct. In addition, the automatic bracketing of the A300 series was used to ensure that there would be a usable image when the photos were uploaded to a computer.
Exposure	**Practice Picture:** ISO 100, f/16, 1/5 second.
	On Your Own: Typically, food photography is a still life, so you can use whatever shutter speed is appropriate. A low ISO and a small aperture usually produce the results food photographers are looking for.
Accessories	Tripod, wireless, external flash unit, food props.

Food photography tips

✦ **Keep it fresh.** The food you display in your images needs to be fresh and ripe. The camera has a way of exaggerating any flaws in foods. If you want your images to show mouth-watering foods, start with an actual mouthwatering subject.

✦ **Use substitutes until you get the shot right.** If you are working with chilled or frozen foods, don't use the actual product to set up the shot. Use a substitute product to get the composition, lighting, and focus right. When you're confident that all your settings are the way you want them, you can then bring in the real thing and shoot while it still looks its best.

✦ **The food doesn't have to edible.** Professional food photographers employ all sorts of tricks to make food look good for the camera. The final images appear to be savory meals, but in reality the food might not be even edible. Mashed potatoes slathered in chocolate sauce make a good imitation of ice cream, but the subject won't melt. Painting a roast turkey with water-based varnish will make it unsafe to eat, but in the images it will look delicious. Don't be afraid to be creative. If the food in your images looks wonderful, it doesn't matter that you used various toxic or unappealing substances to fool the camera.

✦ **Light for texture.** Because viewers cannot actually taste or smell the food in your images, they have to rely on visual clues to determine if the food is appealing. The texture in a slice of bread, a hamburger, or a piece of Swiss cheese can make the item appear savory and inviting. Flat lighting kills texture, so explore various forms of side lighting to dramatize texture in your food items.

High Dynamic Range Photography

If you want to explore the cutting edge of digital photography, I recommend trying your hand at High Dynamic Range (HDR) photography. Basically, HDR photography attempts to drastically improve the tonal range in your photographs. It does this by combining several photos of different densities into a single image. In theory, the combined image will display the best tones from the various base images, showing much more detail in the shadows and highlights.

HDR photography has gotten a somewhat tarnished reputation because some users have exceeded the boundaries of good taste and created some horrendously ugly HDR examples. This is fairly typical of any new technology; when Adobe Photoshop first appeared, the photo world was inundated with overused filter tricks and radically altered perspectives. Eventually users tired of playing tricks with the program and learned to create stunning, artistic images that can take their viewer's breath away. HDR is no different. Many early adopters have pushed the envelope too far, but as more photographers start to experiment with the medium, the technology is enabling them to create lovely, thought-provoking images.

6.23 The original image, taken just before dusk, looks flat. Lighting the image to provide good contrast for the railway bridge will cause the vegetation to look washed out. Adjusting the image so the vegetation looks good will cause the bridge to become lost in the trees.

6.24 A series of five images were shot of the scene. The exposure was varied about one stop for each image in the series.

Inspiration

If you intend to dabble in HDR images, you will need a good tripod and an HDR software program. The basic idea is that you will take several images of the exact same scene, varying the exposure between each image so you record some images that show detail in the shadows and other images that reveal data in the highlights. You might think that using the auto bracketing on the A300 series would accomplish this, but the range really isn't suitable for this process.

You should vary the exposure by at least two stops in either direction from the normal exposure, and the auto bracket on the A300 series has a maximum range of only 0.7 f-stops. The best method is to shoot your first shot in Shutter Priority, then switch to Manual and change the shutter speed two stops over and under the normal exposure. You want to change the shutter speed, not the aperture, so you don't change the depth of field between images. You could also use the Exposure compensation menu, taking care that the camera maintains the same aperture.

There are many HDR applications available, at all price ranges. Adobe Photoshop CS3 can assemble an HDR image, but the stand-alone $99 Photomatix Pro is probably the most popular HDR application on the market. There are many free HDR applications offered as open source projects, and you can learn a considerable amount from creating HDR images in these free programs.

Don't expect instant success. Although a good HDR application can give you great results, it often takes some tweaking and experimenting to get everything right. Once you assemble a good HDR image, you may need to feed it into a tone-mapping application to make everything look the way you want. Some HDR applications include a tone-mapping program, while others require you to use a separate application.

You may not be happy with your first results, but as you gain experience with HDR, you will eventually create images with tonal ranges that far exceed anything you could expect from a single RAW or JPEG image.

6.25 When you load images into Photomatrix Pro, you can simply drag the image series to the input window.

6.26 Tonemapping an image in Photomatix Pro

HDR photography practice

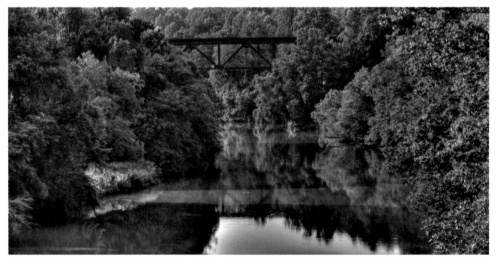

6.27 The final HDR image displays a range of tones that are beyond the capability of a normal JPEG to display. Notice how the bridge stands out from the background and the vegetation seems to glow with a three-dimensional quality.

Table 6.8
Creating HDR Photographs

Setup	**Practice Picture:** The slightly tonemapped image in figure 6.28 is an example of what can be accomplished with HDR photography. Notice how the vegetation seems to glow with color.
	On Your Own: Look for subjects where the tonal range exceeds the capability of your camera to capture properly. A tripod is preferred, but some applications will attempt to merge a series of handheld images. Take a series of at least three images, varying the exposure by at least two stops. Don't use the auto bracketing feature on the A300 series. It only offers a maximum of 0.7 stop variation.
Lighting	**Practice Picture:** Afternoon sunlight.
	On Your Own: Lighting isn't crucial to a HDR image. You will be overexposing and underexposing the image, so any lighting that provides good tones in at least one of the series will be fine.
Lens	**Practice Picture:** Sony 18-70mm zoomed to 55mm.
	On Your Own: No special lens is required for HDR images. Use whichever lens provides you with the angle of view you need.
Camera Settings	**Practice Picture:** Manual exposure, Super Steady Shot on.
	On Your Own: Manual exposure will allow you to significantly alter the exposure between shots. Take your first shot at the normal meter reading, then adjust the shutter speed by two stops over the normal exposure. Take a third shot at a shutter speed that will yield two stops underexposure. You may wish to take additional images to provide more overexposure and underexposure.
Exposure	**Practice Picture:** Base image: ISO 100, f/7.1, 1/200 second.
	On Your Own: Shoot at any exposure setting where you vary the exposure by at least two stops in each direction.
Accessories	Photomatix Pro software.

HDR photography tips

✦ **Adjust the shutter, not the aperture.** When changing the exposure manually, always adjust the shutter speed. If you change the apertures, you will change the depth of field, which may show up in the final image.

✦ **Watch out for movement in your image series.** If your subject moves, it may create strange artifacts in your final HDR image.

✦ **Use a tripod when you are first starting out.** Even if you are using an application that will merge handheld images, the learning curve for HDR is steep enough without adding other factors.

✦ **Experiment.** HDR is still an evolving technology. Try different subject and lighting conditions. Some subjects look much better in HDR than others. Find a process that works for you, then continue to explore new avenues where HDR could be useful.

Landscape and Nature Photography

Almost everyone enjoys nature photography. Viewers love scenic vistas, especially scenes of our fast disappearing wilderness areas. Other than people, landscapes are probably the most photographed subject in the world.

Although you can use a variety of lenses in landscape work, wide angle lenses can accent the vastness and majesty of any scenic view. Besides expanding the apparent width of the subject, wide angle lenses usually show wide expanses of the sky. If there are some dramatic cloud formations, the resulting photograph will arrest the attention of everyone seeing it.

6.28 Seascapes are good subjects for nature photography. Any large body of water can provide visually appealing images, particularly if there are natural elements such as hills, beaches, forests, and the like. The freighter in this image is a great asset. Without it, the image would be just a pretty snapshot.

Inspiration

The most important thing when photographing landscapes is to carefully select your vantage point. Look for anything that might spoil the resulting photo; moving the camera slightly to avoid a telephone pole or road sign can make a dramatic difference in the final image.

The other major factor is lighting. It would be extremely difficult, if not impossible, to light a wide landscape with an artificial light source. As a result, landscape photos are almost always taken with natural light. If the sky is washed out and overcast, or the sun creates harsh shadow on a far off mountain range, the only solution is to wait for the light to change. You may have to wait hours or, in extreme cases, days to get exactly the light you want. Generally, the best light is at dawn or at dusk, so you may need to plan to visit your preferred location at odd hours.

6.29 Sometimes a mix of natural and man-made elements can combine to create an interesting photograph. These stone pillars contrast nicely with the fall foliage and waterfall. The table in the background suggests this would be an excellent place for a picnic.

Landscape and nature photography practice

6.30 This golf course scene would be dull and uninteresting without the addition of the stone bridge in the foreground. Seek out details that can add interest to your landscape scenes. A monotonous flat horizon with no foreground elements makes for an uninspiring photo.

Table 6.9
Taking Landscape and Nature Photographs

Setup	**Practice Picture:** The golf course photo in figure 6.31 works as a landscape thanks to the wide expanse of sky and the combination of well-trimmed fairways and natural rough areas. The bridge commands the viewer's attention; without it, this would be a less than memorable photo.
	On Your Own: Seek out vistas that include foreground features. People, houses, and trees can add a sense of scale to your landscapes. Without something to judge the relative size of natural elements, the viewer has no idea how large those elements are in real life.
Lighting	**Practice Picture:** Bright morning sunlight.
	On Your Own: Good landscape photos require patience. You have to wait for the right kind of light to appear. A dull, overcast sky would have killed this image. In addition, if the sun was coming from a different angle, there would have been unappealing shadows on the near side of the bridge. Sometimes you will have to wait for hours for the right light, but the results are worth it.
Lens	**Practice Picture:** Minolta 24mm f/28.
	On Your Own: Wide-angle lenses offer several advantages when shooting landscapes. They allow you to capture an entire scene and they add drama to images by including sweeping expanses of sky. Because wide-angle lenses exaggerate distances, they make landscapes look more grand and majestic. Occasionally you may find a use for longer lenses when shooting natural scenes, but the wide-angle is the lens of choice for most landscapes.
Camera Settings	**Practice Picture:** Aperture priority, Super Steady Shot off (camera on a tripod).
	On Your Own: You may need to experiment with exposure compensation, because so much sky could cause the meter to render the foreground too dark. You might be able to handhold the camera for scenes like this, but a tripod will hold the camera rock steady, making the image appear sharper.
Exposure	**Practice Picture:** ISO 100, f/16, 1/125 second.
	On Your Own: You want the cleanest highlights possible in your landscapes, so select the ISO 100 setting on the A300 series. With the camera on a tripod and a largely immovable subject, you are free to stop down the lens and let the camera select the appropriate shutter speed.
Accessories	Tripod, cable release.

Landscape and Nature photography tips

✦ **Use your sharpest lenses.** Find the sharpest aperture setting on your best wide-angle lens and use that when shooting landscapes. Usually lens are sharper when stopped down, and you want a small aperture for depth of field anyway.

✦ **Take care composing your land-scapes.** Only a small change in perspective can make a tremendous difference in the final landscape.

✦ **Wear comfortable shoes and clothing.** You may find yourself walking long distances to achieve the composition you want, so dress for hiking.

✦ **Consider adding a circular polar-izer to your kit.** Many filters can be added in post processing, but the effects of a polarizer need to be obtained at the time of shooting. A polarizer can darken the blue of skies and eliminate reflections in water. A good circular polarizer is the surest way to improve the look of your landscapes.

Macro Photography

Modern macro photography is simple and easy to do, and the required equipment is relatively easy to come by. Yet, most photographers never seem to get beyond an occasional experimental macro shot now and then.

If you take the time to learn about true macro photography, it is safe to say you will become enamored with extreme close-up photography. You can capture scenes and details that few people ever see, and when you blow up your images into large prints, you may find you have something extraordinary.

Inspiration

Of course, good macro photography usually doesn't just happen. Occasionally, you may get a great macro shot by just hand-holding your camera, but usually you need a tripod and extra lighting to get something special.

There are many macro lenses on the market, but lens makers sometime take liberties with the term. A macro lens isn't just a close-up lens. A true macro will record a 1:1 image (of a small subject) on the camera's sensor. Obviously, if the image is life-size on the sensor, it will become huge when you blow up the image to normal viewing sizes.

It takes a good lens to actually record a true macro, but if you don't own an actual macro lens, there are ways to work around the problem without buying a new lens.

Close-up filters can allow you to get very close to a subject and are probably the cheapest way to get close without a true macro. An even better solution is a reversing ring used with an old manual focus lens. You screw the ring to the filter threads of

6.31 With the right light and lens, you can handhold your macro shots. This little gecko probably wouldn't have waited around while a tripod was set up. He was curious enough to stick in one place for a series of handheld close ups.

your main lens, and then attach the manual focus lens by its filter threads so the extra lens is actually backwards. This setup can provide some extreme close-ups, although you should not expect to use autofocusing.

Other options include extension tubes and bellows arrangements. If you really are interested in extreme macro shooting, you can explore the range of equipment available. For the purpose of this book, it will be assumed you are using a common macro lens.

6.32 If you don't have a dedicated macro lens, you can get excellent results with a reversing ring and an old manual exposure lens. Here a reversing ring is used to attach an old Rokkor manual lens to the filter threads on a Minolta 50mm AF lens. Note that the Rokkor lens is attached backwards. This rig can focus at distances of less than 1/2 inch.

Macro photography practice

6.33 Coins are a favorite macro subject. Side lighting was used to exaggerate the engraving and designs of these silver dollars.

Table 6.10
Taking Macro Photographs

Setup	**Practice Picture:** I arranged the silver dollars in figure 6.34 on a piece of green construction paper placed on the floor. I placed an A350 on a tripod with the lens pointing directly down at the coins.
	On Your Own: Locate a suitable subject and determine how you can hold it steady while you shoot it. The coins laid on the floor were obviously rock steady, but some macro subjects, such as living bugs, have a tendency to move.
Lighting	**Practice Picture:** A softbox with a tungsten spotlight was paced low to the right of the cons, and a second tungsten light was pointed down from overhead to light the highlights of the coins.
	On Your Own: Lighting for macro images is similar to product lighting. Outdoors you may use no lighting at all, while in the studio you may use a variety of continuous or flash lighting, Don't use the built-in flash on the A300 series, as it will generally overexpose at macro distances.
Lens	**Practice Picture:** Minolta 70-210mm f/4 in the macro mode, zoomed to 150mm.
	On Your Own: There are a variety of ways to get close to your subject, including macro lenses, reversing rings, close-up filters, and more. Use whatever you have available and develop your technique.
Camera Settings	**Practice Picture:** Aperture Priority, Super Steady Shot off (camera on a tripod), manual focus.
	On Your Own: Aperture Priority is a good choice for macro work, as you can change the exposure with the shutter speed and not effect the depth of field. Manual focus was selected to avoid the camera's tendency to refocus between each exposure.
Exposure	**Practice Picture:** ISO 400, f/4, 1/60 second.
	On Your Own: Practice with a variety of exposure values when shooting macro images. A higher ISO can keep the shutter speed from becoming objectionably long. In the case of the practice photo, there was no need for great depth of field because all the detail was on the same plane. For some macro shots, however, depth of field becomes critical.
Accessories	Tripod, cable release, softbox, tungsten lights.

Macro photography tips

✦ **The built-in flash isn't built for macro work.** Don't expect to use the popup flash on your A300 series to illuminate your macro shots. The flash isn't designed to be used at ranges closer than 1 meter (3.3 feet). At close ranges, the built-in flash will horribly overexpose most subjects. Use off-camera flash or continuous lighting.

✦ **Use a tripod.** Sony says that Super Steady Shot isn't fully effective for macro work. If you can shoot with a sufficiently fast shutter speed, you can shoot some macro subjects handheld. Most of the time, however, a good tripod will produce much sharper macro images.

✦ **Watch out for dust, dirt, and scratches.** You will probably be amazed how much dust, dirt, and crud your macro shots will reveal. A macro lens magnifies everything about your subject, including the

flaws. Use a soft brush and a blower to clean your subjects just before you shoot them. If you skip this step, you will likely be disappointed with how your subjects look in your finished close-up images.

✦ **Remember that side lighting produces texture.** Using a straight-on light source, or copy-stand setup will fill in shadows on your subject. Sometimes that may be the light you are looking for, but this kind of lighting can make it difficult to see fine details in your subject. If you place your main light so it shines from the side, you will exaggerate surface details. Imagine you want to shoot the inscription on a piece of jewelry. By lighting from the side, the surface will be bright and shiny, but the inscription will stand out because light didn't reach inside the engraved area. The same technique works for coins, small parts, and insects.

Night Photography

When it becomes dark, most photographers either put away their camera or bring out an electronic flash unit. Yet, some of the most compelling and interesting photos can involve (literally) shooting in the dark.

Night photography usually involves shooting long exposures with the camera mounted on a tripod. With the 3200 ISO and Super Steady Shot capabilities of the A300 series, you may be able to take handheld, short exposures at night, but for most night subjects, a tripod and longer exposures will yield better results.

6.34 If you are relying on existing light for night images, you may face a variety of color temperatures and exposure values. In this old-fashioned store, a cool white light illuminates the porch area. The light on the upper floor is dimmer and warmer, causing the siding to look yellow. The light on the end of the porch bathes the snow and surrounding area with a greenish light.

Inspiration

Although photographers refer to this as night photography, you obviously aren't taking photos of the night itself. Rather you will be shooting buildings and natural artifacts as they appear after dark. Often the subject will have some extra light of its own, such as a neon sign or a lit window. Even without extra light, however, long exposures can practically turn night into day.

You seldom want to go to the trouble of taking a photo at night and making it look like it was taken in broad daylight. What would be the point? By adjusting the exposure so it is evident that it is a night scene, but the main subject is distinct and easy to make out, you create an image that is quite different than one shot in the light of day.

6.35 A tripod can hold your camera rock steady, but neither a tripod or Super Steady Shot has any effect on subject movement. In this case, the flags and boats were moving slightly during the exposure. The resulting blurring is acceptable, adding a touch of action to the image.

Night photography practice

6.36 A sturdy tripod and a cable release was used to capture this night image of this church, relying on the church's own outdoor lighting.

Table 6.11
Taking Night Photographs

Setup	**Practice Picture:** Any well-lit structure, such as the Ontario church in figure 6.36, can provide dramatic night images. Taking images like this goes well beyond taking snap shots, as you will need to use a tripod and carefully meter your exposure.
	On Your Own: Many company headquarters, political offices, and tourist attractions are lit up at night. Find a well-lit structure and plan a strategy to capture it at night. It may help to scout the area in the daylight, and then return to shoot after dark.
Lighting	**Practice Picture:** Existing light designed to light the church for visitors.
	On Your Own: Look for buildings that are lit evenly, without "hot" areas. It would be difficult and expensive to light a structure of this size, so in most cases, you will want to rely on the light that is already there.

continued

Table 6.11 *(continued)*

Lens	**Practice Picture:** Minolta 50mm f/1.7. A normal lens reduces the distortion a wide-angle lens might create. Because the lighting on the scene was already in place, there was no problem shooting from a distance. **On Your Own:** If you are shooting a nicely lit structure, most lenses will suffice. You can shoot close with a wide angle, or if there are no interfering obstacles, you can move back and shoot with a telephoto. The speed of the lens is relatively unimportant, as well. You will be shooting on a tripod, so there is no problem taking long exposures. In addition, you will probably want to stop down the lens to increase depth of field.
Camera Settings	**Practice Picture:** Manual exposure, Super Steady Shot off (camera on a tripod). **On Your Own:** Manual exposure offers the most flexibility for scenes such as this. The meter in the A300 series might be able to read the scene correctly, but the amount of dark areas could cause the camera to overexpose the subject, blowing out the highlights and desaturating the dark background.
Exposure	**Practice Picture:** ISO 200, f/8, 1/60 second. To get the approximate exposure, the camera was moved close to completely fill the frame with the church. A meter reading was taken and the camera set on Manual so the exposure would not change. Then the camera was moved back to an area that showed the composition in the practice photo. Because the exposure was set in Manual, the camera could be moved to many locations without changing the exposure. **On Your Own:** If you can meter at close range, do so. If you cannot get close enough to your subject to fill the frame while metering, you can switch to spot metering and get a good indication of what the correct exposure should be. It is a good idea to bracket your night exposures in any case; subtle details may be revealed with minor exposure changes.
Accessories	Tripod, cable release, cross screen special effect filter.

Night photography tips

✦ **All darkness is not created equal.** You will find great differences in the sky tones when shooting after dark. The phase of the moon, the current weather, and the proximity to other light sources can all effect how the sky looks at night. In large urban areas, there is so much stray light that the sky seldom gets totally dark. In such cases, you may have to stop the lens down to make the night look the way you expect.

✦ **A full moon can be a photographer's friend.** Sometimes moonlight can be so bright that it washes everything with a beautiful, even glow. You can capture interesting ethereal images with such light. Watch the phases of the moon to determine the amount of light you can expect on certain nights. If you are looking for a dramatic, nighttime image, a full moon may not be what you want.

✦ **Bring a flashlight.** Wandering around in the dark, looking for a place to set up your tripod can be dangerous and frustrating. Bring a flashlight to make your movement easier.

✦ **Night silhouettes can be dramatic too.** Although you usually think of shooting lighted subjects at night, if there is some light in the sky, you can expose so buildings, statues, and other objects become black silhouettes against a rich blue sky.

✦ **Auto white balance is less effective at night.** There are so many different kinds of lights used after dark, and the actual lighted area may be so small that your camera's auto white balance won't be able to deal with the subject properly. Your subject may look too yellow or too red. You can try to establish a custom white balance, but your best bet may be to shoot RAW and adjust the white balance in post processing.

✦ **Lighted subjects require less exposure than you might think.** Although you will usually need to shoot longer than normal exposures at night, the actual exposure for a lighted structure may not be much different than late afternoon. If the lighting is good, you can capture the subject with a relatively normal shutter speed and let the background go dark.

Panoramic Photography

The digital age has made it possible for everyone to create true panoramic images. Panoramic images are created by mounting the camera on a tripod and taking a series of overlapping images while rotating the camera around a fixed point. The end result is anywhere from three to twelve images, with each image overlapping the next one in the series by 25–30 degrees.

After the shoot, the images are imported into a stitching program. The software will assemble the images into a single wide image, using the features in the individual images to understand how to align everything.

6.37 Realtors, custom builders, hotels, and travel attractions use 360 degree "virtual tours" to display their offerings on the Web. With Quicktime VR, Internet viewers control the speed and direction of movement and can zoom in and out.

Inspiration

Whether you want to create a virtual tour for a Web site or create an interesting wall hanging, stitching multiple photos into a panoramic image is a fun exercise that can produce a one-of-a-kind image.

Be on the lookout for vistas that might lend themselves to an eye-catching panorama. Remember not all panoramas have to be a full 360 degrees. A 180-degree or 90-degree panorama might be better than a wider image where part of the panorama is relatively uninteresting.

6.38 You can create your own virtual tours by stitching a series of overlapping images into a single JPEG image. In this case, a portion of the images that make up the image in figure 6.41 are ready for export to a hard disk. The resulting JPEG images will be stitched together to form a single image.

6.39 Stitching software is prone to making errors if you aren't careful to provide enough images and if those images weren't taken on a similar axis. When Real Stitcher produced this misaligned result, all that was required was to manually rearrange the base images and regenerate a new panorama.

Panoramic photography practice

6.40 This 360-degree panorama was created from 25 vertical images. A vertical orientation was chosen because the subject was a two-story tall great room. When made into a Quicktime VR presentation, the extra height lets viewers pan up and down as well as move the image in a 360-degree rotation.

Table 6.12
Creating Panoramic Images

Setup	**Practice Picture:** I created the image in figure 6.40 by using Real Stitched to stitch together 25 images into a single JPEG.
	On Your Own: You don't need 25 images for most panorama images. A series of five might be sufficient for a 180-degree view, while you will probably need ten or more for a full 360-degree presentation. More images usually create better results, as the software will have more data to work with.
Lighting	**Practice Picture:** Natural sunlight from the overhead windows provided all the light required for this scene.
	On Your Own: The light needs to be even or parts of your panoramic scene will be darker than others. If you are shooting outdoors, the light will usually be constant. Indoor rooms, however, frequently have widely different light values in different areas. Sometimes you can wait for light coming in from doors and windows to change, making the scene more even. Otherwise, you will need to use artificial light to give the entire room similar illumination.

Lens	**Practice Picture:** Minolta 16mm f/2.8.
	On Your Own: Generally panoramic images look better when wide-angle lenses are used to create the base images. You might be able use longer lenses to make panoramas of very large subjects such as the Grand Canyon. Smaller subjects, including the interior room in the practice image, require the widest lens you can find.
Camera Settings	**Practice Picture:** Manual exposure, autofocus, and Super Steady Shot off.
	On Your Own: Shooting with a manual exposure is preferred, because there will be less variance in lighting. In the practice photo, there are several bright areas that could cause the meter to produce uneven readings. By shooting in Manual, all the images in the series will be taken at similar values.
Exposure	**Practice Picture:** ISO 200, f/8, 1/30 second.
	On Your Own: Because you will be using a tripod, you can stop down the lens and use the resulting depth of field to make the overall image look in focus.
Accessories	Tripod, cable release.

Panoramic photography tips

✦ **You don't need a special bracket.** You can buy special brackets designed to give you the perfect amount of overlap when shooting your base images. These can be helpful if you are making numerous panoramas. You can create excellent results with only a good tripod.

✦ **Avoid ball head tripods.** Ball head tripods are popular with many photographers, because you can adjust the head in any direction with just a single control. For panoramas, however, you want a tripod that can rotate in only a single direction without flopping up and down.

✦ **Watch your horizon.** If the camera isn't level when you rotate it, you will wind up with a crooked panorama that will be disconcerting to your viewers.

✦ **Use a program like Adobe Lightroom to rename your images.** Most stitching programs make use of numerals in the file name to identify which order the images should be loaded. Use a software program to give each photo in the series a name followed by a consecutive number.

✦ **Panoramas can be useful for more than the Internet.** Although the majority of panoramas wind up on the Web as virtual tours, their usefulness doesn't end there. You can frame a wide, narrow image that will attract viewers' interest, especially if it represents a 360-degree view in a single photo.

✦ **Expect to make some mistakes.** Panorama making isn't an exact science. You'll probably be disappointed with your first few efforts. With a little perseverance, however, you will soon be creating panoramas you are proud of.

Portrait Photography

A good portrait can reveal volumes about the subject. Expressions, clothing, accessories, and surroundings all tell a story about the person being photographed.

Many photographers assume that they need a fully stocked studio to create good portraits. In fact, you can make great portraits with just a lens and camera. Of course, lighting equipment and studio backgrounds can make the task of capturing someone's likeness easier, but extra equipment isn't strictly necessary.

While you can get decent results with available light, artificial light sources can counteract shadows, separate your subject from the background, and accentuate the best features of your subject.

6.41 A good portrait can reveal far more than facial features. It can reveal someone's personality.

Ordinary electronic flash units can take the place of studio lighting equipment in most portrait situations. If you are shooting a group, you may need the high performance output of a studio strobe, but for one- or two-person portraits, an electronic flash will suffice nicely.

Inspiration

If you are new to studio lighting, you should resist the urge to use more than a single light source for your portraits. Professionals may use numerous lights, but they know how to place their lights to get the results they want. If you are just starting out, it is far better to start with a single light and learn how to light your subjects. If you start with multiple lights, you may find it difficult to balance the lights properly.

Few people look good when lit by an unadorned flash or tungsten light source. A softbox or shoot-through umbrella will diffuse the light and create soft, evening illumination on your subject.

If you are going to move past simple available light, a minimum outfit would consist of a electronic flash unit or tungsten light diffused thorough an umbrella or a homemade softbox. If you are shooting with a flash unit, you will need to use either wireless flash or a cable attached to the hotshoe.

The popup flash on the A300 series is not a good choice for portraiture. As a matter of fact, neither is any hotshoe-mounted flash unit. As you learned in Chapter 5, off camera flash is generally far superior to using the flash on the hotshoe.

Once you have the lighting worked out, you can turn your attention to the lens. In general, a medium telephoto is the preferred choice for portraiture. Lenses with a narrower field of view tend to distort the faces of your subject. A 50mm prime lens, which is equivalent to 75m with the crop factor, is probably the minimum focal lens you should choose for portrait work. A focal length of around 60–70mm is probably ideal, although some photographers like to shoot portraits with even longer lenses.

Don't be afraid to take charge of your models during a photo shoot. Your models cannot see what you are seeing through the viewfinder. Your subjects are relying on you to direct them. Tell them which direction to look, what type of expression to wear, what emotions to display.

6.42 Strive to put your subject at ease. You are much more likely to get a good portrait when your subject is discussing his favorite pastime.

Portrait photography practice

6.43 The trick behind great portraits is to make everything look natural, as if you just happened on the scene. In reality, this shot required advance planning and careful lighting setup.

Table 6.13
Taking Portrait Photographs

Setup	**Practice Picture:** The boy requested to pose with his dog. The result is a relaxed, fun image that is far more revealing than an ordinary studio portrait.
	On Your Own: Consider adding props that tell something about the subject. Include sports equipment, hobbies, awards, and uniforms. Show the subject's true personality.
Lighting	**Practice Picture:** Electronic flash fired through a shot-through umbrella
	On Your Own: Assemble a lighting kit to fit your needs. Electronic flash is preferable, but you can also use tungsten clamp-on lights if you are shooting indoors. Photo umbrellas are inexpensive and easy to carry. You can also construct a softbox out of cardboard or foam core, using translucent fabric for the face.
Lens	**Practice Picture:** Sony 18-70mm, zoomed to 20mm.
	On Your Own: Choose your sharpest mild telephoto lens. You can use the Sony 18-70mm kit lens, zoomed to a range of 50-70mm. Any focal length above 50mm should work well.
Camera Settings	**Practice Picture:** RAW capture, Aperture Priority, Super Steady Shot off autofocus off.
	On Your Own: Aperture priority allows you to adjust the depth of field so you can throw the background and foreground into soft focus. You could use autofocus, but placing the camera in the Manual focus mode will give you better control over what is in and out of focus. As always, when shooting from a tripod turn SSS off.
Exposure	**Practice Picture:** ISO 100, f/5.6, 1/160 second. Typically, portraits require longer focal lengths. In this image, however, a wider focal length works because there are multiple subjects and they are far enough from the camera to avoid distortion.
	On Your Own: Generally you want your lowest ISO for portraiture, to eliminate any noise in the final image. Adjust the aperture to give you a good exposure with your lighting equipment. If you want to use a faster shutter speed than the 1/160 sec maximum sync of the A300 series, you could use HSS.
Accessories	Tripod, shoot-through umbrella, light stand, cable release, off camera cable.

Portrait photography tips

✦ **Don't place your subject near a wall.** You will wind up with harsh shadows behind your model's head. With light hair, the effect is distracting, but with dark hair, your subject's hair will blend into the shadows.

✦ **Use a reflector to simulate a second light.** If you add a reflector to a single-light setup, you can actually create the effect of a two-light setup. Place the reflector to bounce your main light into shadow areas to give the appearance of a second light.

✦ **Inspect your model's clothing and hair before you shoot.** Your model usually can't see herself when she's in front of the camera. It is your job to make sure everything looks right. Watch for stray hair, twisted collars, gaping shirt fronts, and the like.

✦ **Try to put your subject at ease.** Many people are nervous when they have a formal portrait taken. Instead of just telling them to smile, get a conversation going. Find out what they are interested in and talk about that. If you can get them to talk about something they are passionate about, they will become animated and lose their apprehension. The resting photos will be better.

✦ **Use bounce flash if your studio equipment us unavailable.** If you don't have an off-camera flash with you, you can bounce the light from your hotshoe flash. If there isn't a convenient ceiling, you can rig a white card to bounce the light onto your subject. In most cases, however, off-camera flash will yield superior results.

Product Photography

Small product photography can be an art form, as it requires careful lighting to eliminate shadows and isolate the product from the background. Knowing how to light a small product is a handy skill for any photographer to master. You will need a basic understanding of studio lighting, because you typically want the product to be well-lit, razor sharp, and isolated from the background. If you have no studio lighting experience, product photography is a great place to start. You can teach yourself a great amount about lighting and studio setups by shooting small products. The knowledge you gain while capturing product images can be applied to almost any studio shot, so it is well worth your time to learn to do it right.

Inspiration

The A300 series is well-suited to capturing small product images. Generally, you want to shoot with a mild telephoto to eliminate any distortion caused by a wide-angle lens. If you have the 18-70mm kit lens, you could use it stopped down at the longer focal range. Another good choice is the Sony 50mm prime lens, which because of the crop factor, will give the angle of view of 75mm on a full frame sensor. With the

exception of extreme telephotos, any Sony lens with a focal length above 50mm will serve well in this capacity.

You can use continuous lights, electronic flash, or studio strobes if you have them available. This exercise is designed around simple tungsten lighting, because continuous lighting is the easiest lighting to learn. Even if you have strobe or electronic flash units available, you might want to use tungsten lighting for this practice exercise. Successfully lighting a set with tungsten lighting can significantly advance your understanding of studio lighting techniques.

6.44 Don't be afraid to take things apart and show the inner workings when shooting product photos. People want to see what's inside and how things work.

Product photography practice

6.45 Transparent glassware is always challenging to photograph. It takes careful arrangement of the lights to avoid glare and still separate the edges of the glass from the background. In this case, the design on the front of this collector glass had to be maintained as well.

Table 6.14
Taking Product Photographs

Setup	**Practice Picture:** I placed the glass on a plastic platform inside a homemade light tent. The background has a slight gray tone to help set off the glass.
	On Your Own: Select a small product that can be shot on a tabletop. If possible, lift it above the table on a translucent platform. The platform on the practice photo was a large white plastic food container.
Lighting	**Practice Picture:** I used a total of four tungsten lights inside aluminum reflectors for this image. I suspended a large spot light over the light tent, aimed to avoid the glass and evenly light the background. I aimed a small flood light through the right side of the light tent to illuminate the glass from behind, and placed another small flood light to shine through the left side of the tent and provide light to the left side of the glass. The final light was a 75-watt spotlight that I placed inside a softbox, and placed to the right side of the lens, aimed directly at the glass.
	On Your Own: You don't have to spend a fortune to obtain results like this. You can start out with several clamp lights with ordinary tungsten bulbs. Create a tent with translucent material and experiment with moving the lights and subject around to achieve different lighting effects.
Lens	**Practice Picture:** Sony 18-70mm lens zoomed to 50mm.
	On Your Own: Avoid wide angle lenses for product work because they will cause a distorted perspective. Any mild telephoto (50mm and up with the crop factor) will work well, as long as it can deliver sharp images.
Camera Settings	**Practice Picture:** Manual exposure, autofocus off, Super Steady Shot off (camera on tripod), tungsten white balance, automatic bracketing.
	On Your Own: It is faster to set the camera to the Manual exposure mode and use the live preview to select the exposure. With the camera in Manual, you can use the control dial to alter the shutter speed and see the change on the LCD.
Exposure	**Practice Picture:** ISO 100, f/16, 1/8 second.
	On Your Own: Use the lowest practical ISO and stop the lens down to its sharpest aperture. You are shooting a still life with the camera on a tripod, so the shutter speed is of little concern.
Accessories	Tripod, clamp lights, softbox, homemade light tent.

Product photography tips

✦ **Keep it clean.** You will be surprised how much dust and grime can show up on a product. Unless you want to spend hours touching up spots in Photoshop, carefully clean your products before you shoot them.

✦ **Use custom white balance when mixing light sources.** If you are intermingling different temperature lights, or adding a touch of electronic flash to light a predominately tungsten setup, you'll save time by taking a few minutes to establish a custom white balance for your A300 series.

✦ **Watch out for glare and color shifts.** Your eyes respond so well to shifts in lighting that you may not even notice that the top of the product is receiving more light than the lower parts. In the final images, however, the top will appear light or even a shade of white. It is important to eliminate shadows, but if you spend all your efforts on killing the shadows without lighting the highlights properly, you will still be disappointed with the results.

Seasonal Photography

Holidays are a great time for photographs. It is a rare opportunity to capture images of far-flung family members gathered together around the festive table. In addition, homes and businesses are often draped with wonderful decorations, offering colorful scenes that are perfect for digital photography.

Inspiration

Christmas is, of course, the most decorated holiday. In the United States, it is rare to find a home without at least some decoration. Brightly lit trees, fat men in red suits, stars, and manger scenes provide a smorgasbord of photo opportunities. Halloween probably comes in second with its own gaudy mix of pumpkins, witches, and monsters. Thanksgiving, New Year's, 4th of July, and St . Patrick's Day also provide fodder for the creative photographer. Don't overlook parades, a source of great photos year round.

6.46 Closeups can make familiar decorations fresh again. This metal snowman wouldn't attract much attention if the entire figure was included in the image. Everyone has seen too many snowmen to find another one interesting.

For the photographer, holidays offer a wealth of colored lights after-dark. These lighted decorations can provide dramatic images if you are willing to put in the effort to capture them.

In the daylight, holiday extravaganzas are easy to shoot. After-dark, however, your skill as a photographer will be tested. It is not especially difficult to capture lighted decorations after-dark, but you will need to plan ahead and have a good understanding of how to expose for the lights at night.

You may be able to handhold your camera for some night decorations, but to maximize sharpness and provide good depth of field, a tripod is mandatory. With the camera on a tripod, you are free to capture long exposures without fear of camera vibration.

You cannot always rely on the meter in your A300 series for after-dark holiday photos. The meter will try to lighten the scene, when you actually want everything except the lights themselves to be dark. You may have to experiment to get the proper exposure. With some careful bracketing, you will end up with exciting images that everyone will enjoy.

6.47 Christmas displays lend themselves to fantasy image manipulation. Surprisingly the monochrome silver tree in the center outshines the color version of the same image on either side.

Seasonal photography practice

6.48 This grinning Jack-O-Lantern was photographed with a long exposure and lit with an ordinary flashlight.

Table 6.15
Taking Seasonal Photographs

Setup	**Practice Picture:** The pumpkin face was an experiment with long exposures. I placed the pumpkin in a darkened room, and I put an inexpensive book light inside the pumpkin, aimed toward the back to light the inside evenly. I set the camera for a long exposure to give plenty of time to "paint" the exterior. After pressing the shutter, I pointed the beam of a flashlight at the pumpkin and rapidly moved it around to add light to the scene. Because there was no other light in the room, I could take my time and paint the Jack-O-Lantern evenly.
	On Your Own: You can use this technique for many nighttime holiday photos, but obviously Halloween is an appropriate choice. You could even use this technique on a person wearing a costume.
Lighting	**Practice Picture:** Book light inside the pumpkin, flashlight to paint the light, no room light.
	On Your Own: The key is to place your subject in a room with no ambient light. This will give you plenty of time to experiment with light from your hand-held flashlight. Keep the flashlight moving during the exposure, to prevent overexposure in areas of your image.
Lens	**Practice Picture:** Sony 18-70mm, zoomed to 60mm.
	On Your Own: Any lens will work for this type of image. Select a lens that is appropriate for your subject.
Camera Settings	**Practice Picture:** Manual exposure, Manual focus, SSS off.
	On Your Own: Setting the camera to Manual will give you the most flexibility, since you can't meter on a shot like this. Locking down the focus manually eliminated the chance that the camera would shift the focus point.
Exposure	**Practice Picture:** ISO 100, f/16, 30 sec.
	On Your Own: Use a low ISO so you can use a long exposure. Thirty seconds gave me plenty of time to paint my subject.
Accessories	Tripod, cable release, flashlight, book light.

Seasonal photography tips

✦ **Be ready to shoot people in cosutume.** Holidays are magical. People adopt a different persona when they are in costume, so it's fun to capture images showing someone's "other" side.

✦ **Give yourself some photographic assignments.** You may find it hard to pick up your camera when you are stuffed with turkey and everyone else is sprawled in front of the television watching football. If, before dinner, you assign yourself the task of going outside and shooting holiday displays, you are much more likely to carry through.

✦ **Make sure you wind up in some of the photos.** At a family gathering, active photographers are so busy shooting they seldom appear in any of the photos. Put your A300 series in the Auto mode and hand it off to someone to shoot some candid images. An even better plan is to set the camera up with the self timer and take a group shot of everyone, including you. Unless you are proactive in this manner, you may become an invisible person; you never show up in any holiday images.

✦ **Keep your camera with you during the holiday season.** I missed a great image when a local neighborhood celebrated Christmas Eve with thousands of luminaries set in rows along a long winding road. It would have been a wonderful series of images, but my camera was safe at home.

Special Effects Photography

Every photographer dabbles in creating special effects from time to time. Effects can involve custom filters, auxiliary lenses, trick lighting, and the like. With the event of program like Adobe Photoshop, it is easier to produce many effects with software. Some effects, however, can only be produced in the camera.

Inspiration

You will usually get better results if you plan your effects ahead of time, rather than just popping a filter on your lens when you want to be more creative. Think through the effect you want to create and decide what equipment you will need to accomplish it. Then find an appropriate subject and setting.

6.49 This spire was photographed with a multifaceted filter that created several overlapping exposures of the same subject. This sort of special effect needs to be used sparingly, but with the right subject the results can be visually pleasing.

Like all artistic endeavors, your favorite special effects won't appeal to all your viewers. Some people may love your creative effects, while they will leave other viewers cold. If you intend to experiment with special effects, be prepared to deal with some rejection. It simply comes with the territory.

6.50 A cross-screen filter was used to add a bit if whimsy to this hard working railroad ferry boat. It is largely a matter of personal taste whether you consider the effect wonderful or somewhat cheesy.

Special effects photography practice

6.51 A homemade filter was used to create these strange-looking snowflakes on a Christmas tree. Nearly any shape can be designed into a custom filter.

Table 6.16
Taking Special Effects Photographs

Setup	**Practice Picture:** The snowflakes displayed in figure 6.51 create a one-of-a-kind appearance. I cut an image of a snowflake into a piece of black construction paper, and pressed the paper onto the surface of an old filter. With the filter attached to a wide-open lens, I aimed the camera at the lighted tree and the cutout produced the effect shown here.
	On Your Own: When you have decided on the design of your special effect, cut a silhouette into piece of black construction paper with a sharp knife or razor blade. The flakes in the practice picture are probably too large; as a starting point, make your element no larger than 50 percent of your filter size. Press the paper into an old filter and attach it to your lens.
Lighting	**Practice Picture:** Ordinary tungsten room lighting for the background, with large, old-fashioned Christmas bulbs on the tree to produce the effect.
	On Your Own: You will need a subject with numerous pinpoint light sources. Christmas lights are excellent, as are bridges, street lights, buildings, and the like. You will need to shoot in the dark, so the light sources can be seen against the background.
Lens	**Practice Picture:** Minolta 50mm, f/1.7.
	On Your Own: For this trick to work, you will need a wide-open aperture that will throw the light points out of focus. If your lens won't stop down below f/2.0, you might not be able to make the lights sufficiently unfocussed for the effect to work very well.
Camera Settings	**Practice Picture:** Manual exposure, Manual focus, Super Steady Shot off (camera mounted on a tripod).
	On Your Own: The Automatic settings on the A300 series will probably spoil the effect by trying to make everything look normal. If you take full control of the camera settings, you will get much better results. Use Manual focus to make sure the pin points of light are out of focus.
Exposure	**Practice Picture:** ISO 200, f/1.7, 1/4 second.
	On Your Own: You may need to experiment with the exposure. You want the background to be dark, which will cause the light points to "pop." Use the maximum aperture of your lens to ensure the effect works.
Accessories	Screw-in filter that matches the filter threads of the lens, black construction paper, sharp knife, tripod.

Special effects photography tips

✦ **Don't overuse an effect.** Unless you are a working photographer, and your clients ask for variations of effects they see on your portfolio, you should avoid using effect filters too often. The first time someone sees your effect, he may be overwhelmed by your creativity. If he sees the same effect used several times, however, it starts to lose its impact.

✦ **Many of the best effects are homemade.** To make your images truly special, try to create effects that don't look like any of those made by any other photographer. If you buy a specialty filter, you know that thousands of other photographers are using the same filter. You can create an effect that no one else has, and your images will stand out as yours alone. Look for non-photographic elements that you can use over the lens or your subject to create a special look.

✦ **Not all effects are appropriate for all subjects.** Try to match your effects to the subject. A techno effect might not go so well with a historical figure, while an effect that works well with a city skyline might fail miserably on a rural landscape.

Sports and Action Photography

The A300 series is well suited to capturing sports photography. Because of the Live View system, the viewfinder is smaller than most APS-C dSLRs, and the burst mode is on the slow side. Despite those facts, a photographer with a good eye can capture great action images with the A300 series.

The secret of action photography is anticipating when and where the action will take place. This usually means you need to have at least a rudimentary idea of how the game, contest, or match is played. A good baseball photographer will guess that the runner may be thrown out at third base and will be ready to shoot the action. A race car photographer will know where cars are likely to run off the track and will set up to catch the action in that area.

6.52 Modern sports equipment is often dressed in vibrant colors and shapes. Had this image been shot upward from the bottom of the hill, the impact would have been lessened by the washed out, overcast sky.

Inspiration

If you want to cover a particular sport, try to learn all you can about the sport, the teams, and the venue where the event is played. A mediocre photographer who has a complete understanding of a sport will often out shoot a great photographer with no experience in that particular type of competition. Knowledge is key, so do your homework before heading out to the ball field, racetrack, or tennis courts.

Equipment may vary for different types of action, but the preferred lens for most sports photographers is the fast telephoto. You may not be able to get close to the action taking place, and even if you could, it might not be safe to get closer. You want a fast lens, because it will allow you to stop motion with a fast shutter speed. This is particularly important in an indoor sport like basketball, where the light may be dim, but the action is fast enough to require a high shutter speed.

6.53 Water sports have their own set of challenges for the photographer. Watch out for glare on the water or subject. Your subject will not only move forward, but up and down as well. If you are shooting from a boat, you will have to contend with your own movement, too. A fast lens and an equally fast shutter speed are your best recourse to capturing waterborne action.

Use the Shutter Priority mode when you are shooting fast action. You can set the shutter speed and be assured that it will not change if the overall light dims. If the exposure changes and the camera is in Shutter Priority mode, the camera will vary the lens aperture to correct the exposure, while the shutter speed will remain constant.

While a fast shutter speed is often mandatory when shooting action, don't feel you have to shoot at the 1/4000 second top speed offered on the A300 series. The fact is anything above 1/500 second will easily stop motion for any spectator sport, including auto racing.

Sports and action photography practice

6.54 Composition is critical to action photos. Notice the space in front of the fast moving sand racers. When shooting moving objects, you need to allow space in front of the person, animal, or vehicle to "move." If you crop too tightly to the moving subject, viewers will have the uncomfortable feeling that the subject is about to crash into the edge of the photo.

Table 6.17
Taking Sports and Action Photographs

Setup	**Practice Picture:** Almost any spectator sport, such as the sand race in figure 6.54, can provide exciting action shots. Although I used a fast shutter speed to freeze the motion, the clouds of sand behind the vehicles convey the speed and excitement of the race.
	On Your Own: Look for vantage points that allow you to impart the action involved in the sport or activity. Become familiar with the sport so you can anticipate the action and thus be prepared to shoot at the critical moment.
Lighting	**Practice Picture:** Outdoor sunlight.
	On Your Own: Many sports are played outdoors in daylight, so you will rely on existing light to capture the action. Some sports are scheduled indoors or at night, and will require electronic flash or very high ISO settings.
Lens	**Practice Picture:** Minolta 50mm f/1.7.
	On Your Own: Fast telephoto lenses are the preferred optics for action, because you can get close and use a fast shutter. Because I composed to show two vehicles and the people in the background, a shorter lens worked well for the image in figure 6.54. At many sports venues, you won't be allowed to get very close to the action. At these events, you will have to make do with long lenses and creative composition.
Camera Settings	**Practice Picture:** Shutter Priority, Manual focus.
	On Your Own: Shutter Priority is the preferred mode for action photos because you can be assured the shutter speed will not change with varying camera angles and lighting conditions.
Exposure	**Practice Picture:** ISO 200, f/8, 1/500 sec.
	On Your Own: In general, a shutter speed of 1/500 or faster will stop the action in any sport. Bright sunlight permitted a fairly low ISO to be used in the practice picture, but action photography is one medium where you can get away with higher ISO settings. A minor increase in noise levels is less important than catching the action at the right instant.
Accessories	Lens hood, UV filter (to protect the lens against sand).

Sports and action photography tips

✦ **Safety First.** Never become so deeply involved in capturing an action sequence that you ignore your own safety. Always have an escape route planned if things get out of control. Whether it is a hard charging linebacker or a spinning race car, you risk serious injury or worse if you cannot get out of the way. Remember that fast vehicles involved in a crash often catapult wreckage in a wide area. Keep an eye out for protected areas where you can shelter if things turn hostile.

✦ **Use the continuous shooting mode.** Even though the burst rate on the A300 series isn't extremely fast, it is still much faster than taking photos in the single shot mode. Don't simply hold down the button in the continuous mode and hope for the best. Instead pick your shot, trying to capture the drama of the moment. You can then use the continuous advance to capture additional frames.

✦ **Consider pre-focusing when appropriate.** Autofocus can be a great asset, but when you are shooting certain types of action shots, it can actually get in the way. If the camera cannot get a lock on the subject, it may prevent you from taking an image. If there are several contestants competing closely together, the camera may focus on the wrong target.

If you are fairly certain where you plan to shoot, you can turn autofocus off and pre-focus on that area. The camera won't need to take time to focus and you will know that anything you photograph in the selected area will be in razor-sharp focus.

Improve Your Action Photos by Panning

Often, there is very little difference between a quick moving subject photographed with a fast shutter speed and one that isn't moving at all. The fast shutter speed eliminates the evidence of motion, leaving the equivalent of a still life.

You can reintroduce the feeling of motion by panning with your subject. To pan, you reduce the shutter speed and attempt to move the lens at the same speed as your subject. The idea is to blur the foreground and background, while still capturing a clear image of your subject. Done correctly, the fuzzy surroundings leave no doubt your subject is in motion.

The problem is that to get a good pan, you probably will have to take dozens of bad ones. If you try hard enough, however, you will occasionally get — an incredible image that is bursting with action. That single image will make all the poor ones worth the effort.

Turn off Super Steady Shot and select an appropriate shutter speed. Usually you can get effective pans with speeds in the 1/8 to 1/60 second range. If your subject is traveling very fast, you my even find 1/125 produces interesting blurring of the background.

Although you can pan with any lens, telephotos tend to produce better pans because you are farther away from the moving subject. It is easier to track your subject when it is farther away from the camera, because objects appear to move slower the farther away they are.

Start panning well before the point where you trip the shutter. You might be able to use continuous autofocus, but a better solution is to shift into manual and pre-focus on the spot where you intend to take the picture.

When you are smoothly tracking your subject, press the shutter and continue to follow the subject with the lens. This isn't as easy as it many seem, because when you click the shutter, the mirror inside the camera will flip up and the viewfinder will be black for the duration of the exposure. After the mirror flips down, continue to track the subject for a moment. This will give you a nice, smooth action.

Typically, the background and foreground will be blurred. Part of your subject may be blurred as well. If you are shooting a running person, the arms and legs may blur because they are moving at a different rate and different direction than the torso. This usually adds to the effectiveness of the photo.

Travel Photography

Every photographer likes to take travel photos. In addition to providing a record of places you have been and things you have seen, sharing your travel photos with others can let them to vicariously participate in your outings.

Like most photographic endeavors, you'll have greater success with travel photography if you prepare ahead of time. Pack a small, easy to carry bag for your camera and most-used accessories. If you want to bring additional equipment, pack it another bag that you can leave in a secure place while you are out exploring. Your primary bag should be light and offer quick access to your camera.

Inspiration

Wherever you travel, you will always find something different or interesting. No matter the size of the city or town, there is always something unique to see and photograph. Museums, gardens, buildings, scenic vistas; every place has something special.

6.55 Lighthouses are always popular travel subjects, as this example of the lighthouse at Lake Superior's Whitefish Point demonstrates. Always be on the lookout for distinctive structures or natural features when you travel.

When you find a worthy subject, take your time and find the best angles or vantage points. If you are shooting in an area far from your home, you may never return to the area you are visiting, so you will only have one chance to get a good set of photos.

6.56 There is no doubt where this photo was taken. The viewer knows it is the entrance to the Mystic Seaport Museum. Notice how the stairway invites the viewers' eyes into the alcove.

Travel photography practice

6.57 Your intent with travel photography is to show the viewer scenes and places from a particular area. This photo was taken on the Mystic River in Connecticut.

Table 6.18
Taking Travel Photographs

Setup	**Practice Picture:** To get the idyllic composition in figure 6.57, both the small boat and the sunlight had to be just in the right spot. Sail boats travel slowly, so the shot was set up well ahead of time and the exposure was made when the boat arrived in the frame.
	On Your Own: The secret to setting your travel photos apart from ordinary snap shots is careful composition and the patience to wait for all the elements to come together.
Lighting	**Practice Picture:** Afternoon sunlight.
	On Your Own: Lighting for travel photos can involve everything from no additional lighting to a full studio production. Because you are traveling, however, you will usually want to keep the lighting simple. Like landscape photography, you may have to wait for the right kind of natural light.

continued

Table 6.18 *(continued)*

Lens	**Practice Picture:** Minolta 24mm f/2.8. The wide-angle lens exaggerates the length of the larger boat and makes the smaller boat look further away.
	On Your Own: No matter how many lenses you bring on a travel shoot, you usually find yourself wishing you had more. Wide-angle lenses are usually more useful than other lenses because you can include entire buildings and entire rooms that you couldn't shoot with longer optics.
Camera Settings	**Practice Picture:** Aperture Priority, Super Steady Shot off (camera on a tripod).
	On Your Own: You will appreciate the ability of Super Steady Shot to let you take longer exposures when traveling without a tripod. Consider bracketing to make sure you get a good exposure.
Exposure	**Practice Picture:** ISO 200, f/8, 1/125 second.
	On Your Own: Typically you will want a lower ISO for your travel photos given you may enlarge them or show them on a larger television screen.
Accessories	Tripod, cable release.

Travel photography tips

✦ **Don't forget to shoot photos of signs and information placards while traveling.** Signs can be interesting in their own right, particularly if they contain witty sayings or specialized information about the locale. In addition, signs can serve as reminders. Weeks, months, or decades after you visited a particular place, you may come across a batch of photos and wonder where and when you took them. If you included some images of welcome signs or markers, you will have a visual indicator clearly indicating the photo's setting.

✦ **Exercise care when you are traveling with your camera.** Expensive cameras can catch the eyes of thieves, so be careful not to leave your camera bag unattended. Consider checking your bag at the front desk rather than leaving your camera unattended in a hotel room.

✦ **Take care of your equipment.** Never leave your camera in a hot car; other than moisture, high heat is your camera's worst enemy.

Weather Photography

When the weather turns nasty, many photographers put away their camera and wait until the sun returns. Unfortunately, they are missing out on some incredible photographs. Rain, snow, and wind can create one-of-a kind events that a wise photographer will take the opportunity to capture.

No one is suggesting you risk life and limb by venturing out in a storm just to create an image. You need to use common sense and stay in a sheltered place during a dangerous storm. When the storm passes, however, or when you are just experiencing rain or snow

6.58 Ice storms can be dangerous and destructive, but they can also be quite lovely. A late spring storm transformed the branches of this dogwood tree into a magical ice sculpture.

without high winds, you may want to collect some images that show your world from a different perspective.

Inspiration

After protecting yourself with rain or cold weather gear, your next concern needs to be your camera. The A300 series is not weather sealed, so you will need to safeguard your camera from grit and moisture. There are specially made rain and snow covers available that can protect any dLSR from the elements. You can also take the DIY approach and modify a heavy trash bag so you can view and shoot without exposing your camera to a hostile environment. Whatever you decide, do not neglect some form of protection. The A300 series is packed with electronics and it only takes a little moisture to cause a camera to short circuit.

You also need to consider the temperature. Sony advises that the safe operating temperature range of the A300 series cameras is 32 to 104 degrees Fahrenheit (0 to 40 degrees Celsius). Sony also includes the warning that shooting in extremely cold or hot situations is not recommended.

Condensation is another concern when shooting outdoors in cold weather. When you bring a very cold camera into a warm building, it is quickly covered with condensation. This can be as damaging as moisture from rain or snow. Sony recommends sealing the camera in a tightly closed plastic bag before bringing the camera indoors from the cold. You have to seal the camera in plastic while still in the cold area; condensation will form immediately when the chilled camera is exposed to room temperatures. Leave the camera in the bag for at least an hour so the condensation will evaporate.

6.59 The meter in A300 series handles snow conditions well. Even so, you might want to use a half stop or so of exposure compensation. All meters are calibrated for an average gray tone. When the meter encounters a scene that is mostly pure white, it tends to overexpose everything trying to make the scene an average gray.

6.60 Although you don't see the rain, the umbrella and flat lighting are good indications it's unpleasant outside. Notice that the composition indicates the man walks alone.

Why go to all this trouble just to shoot in bad weather? You will discover photo opportunities you never knew existed. Shooting in inclement weather can offer reflections in rain puddles, frozen fog over a mountain top, icicles hanging from rooftops, and raging streams covering bridges and roads. Don't overlook people's reaction to a wet or cold environment. Consider the possibilities: a woman trying to maintain control of an umbrella as she walks against the wind, children jumping in puddles, a man endeavoring to scrape snow from his windshield. Unnatural weather conditions give you the chance to visit a strange, but short-lived world, without leaving home.

Weather photography practice

6.61 Don't put your camera away in inclement weather conditions. Take advantage of reflections and shadows you wouldn't encounter in normal sunlight.

Table 6.19
Taking Weather Photographs

Setup	**Practice Picture:** The photo in figure 6.61 takes advantage of the reflection of car headlights in the rain-covered pavement. Although you don't see the individual rain drops, the overall tone of the image, the fact that all the cars have lights on, and the obvious wet pavement all indicate that this is a rain shot. **On Your Own:** Look for situations that communicate the effect of weather on your subjects. In addition to rain, high winds, ice, and snow can demonstrate the caprices of weather.
Lighting	**Practice Picture:** Overcast sunlight. **On Your Own:** Artificial light can hinder many weather shots. Rain drops and snow flakes will reflect light back into camera, creating strange, out-of-focus highlights. Because natural light becomes dimmer during a storm, a well-lit subject may look unnatural. Typically, overcast lighting will be even with low contrast — perfect for shooting with existing light.
Lens	**Practice Picture:** Minolta 70-210 f/4, zoomed to 210mm. **On Your Own:** You can use any lens to shoot the extremes of weather, but long telephotos will let you shoot from locations where you remain warm and dry, while your subjects face cold and wet conditions.
Camera Settings	**Practice Picture:** RAW capture, Aperture Priority, Super Steady Shot and autofocus on. **On Your Own:** Although you will normally want to take full control of your camera, in situations such as this you will want to rely on automated settings to instantly capture the shot before it is gone.
Exposure	**Practice Picture:** ISO 400, f/4, 1/200 second. **On Your Own:** A high ISO will increase your options when shooting in the typically dim light experienced in poor weather. Because rain or snow already cause some image degradation, introducing additional noise won't have much of an effect.
Accessories	Plastic over camera, dry cloth to wipe lens and camera.

Weather photography tips

✦ **Tell the story.** Watch for interesting ways to demonstrate the effect of storms or adverse weather. A fire hydrant buried in snow or a swimming pool covered with ice can be interesting indicators of severe weather. Close-ups of withered plants can testify to severe heat and drought. Look for contrasting elements, such as a surfboard half buried in snow and ice.

✦ **Use reflections.** Ice and rain can create wonderful reflections in roads, fields, and waterways. Keep an eye out for ways to exploit these reflections in your weather photos.

✦ **Don't overlook people.** People's reaction to weather is often more interesting than the weather itself. Watch for the man grimacing while he shovels out his driveway, or the laughter and excitement of kids sledding on the local hill.

✦ **Know your local area.** If you know that certain streams always seem to flood in the spring, or an area is prone to wind damage each year, you can use this knowledge to capture great images.

Creating a Digital Workflow

The camera and lens are only the first components involved in producing great digital images. After the pixels have been saved to a memory card, the photo usually has to go through several post-processing steps to reach its full potential. Even if the original capture is technically perfect, the image needs to be stored and archived so it can be available in the future.

The steps required to process, archive, catalog, and edit digital images is commonly referred to as a workflow. Establishing an efficient photographic workflow is extremely important, especially if you shoot a large amount of images. Without a well-planned workflow, you will end up with a hodgepodge collection of photos, scattered across hard drives, memory cards, DVDs, and CDs; with no easy way to locate the image you want. Editing and retouching will become a chore rather than a creative exercise. When post-processing and cataloging get out of hand, the task may become so monumental that the photographer will start leaving the camera in a drawer rather than add to the mountain of drudgery he or she has accumulated.

Fortunately, a number of software solutions exist to automate the tedium of post-processing and put fun and creativity back into the digital workflow. Every photographer will approach his or her workflow differently, and there is an incredible array of tools available to fit your particular preferences. With so many choices available, it is in your best interest to investigate and demo many different software packages to discover which ones you are most comfortable working with.

Transferring Images to Your Computer

You could just store your images on a memory card and take the card to a processor to have prints made. Memory cards, however, are not designed for long-term storage and it would become expensive to continually buy additional cards when you want to take more photos.

For editing and archival storage, the best solution is transferring images to a computer. There are three methods you can use to transfer your photos to your computer's hard drive.

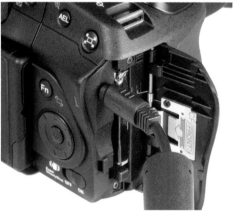

7.1 The USB connection on the Sony A300 series is located behind the door for the Compact Flash slot. Connect the other end of the supplied cable to your computer and you will be good to go as long as the battery holds out.

Copying photos with a USB cable

Sony includes a USB cable with the A300 series. You can connect the camera to the computer with the cable and copy images from the camera to the computer. It is easy and doesn't require any additional hardware or software. It is slow, however, and requires that your camera be on during the transfer. If the battery dies during the upload, the transfer will fail and it could ruin the images on the memory card.

Copying photos wirelessly

At least one company is shipping a wireless Secure Digital (SD) memory card that allows you to copy photos wirelessly from a digital camera to the Internet. While the A300 series does not offer a SD memory slot, there are adapters that allow SD cards to be used in a Compact Flash card slot. There are several hurdles still to be overcome with this new technology: Not all SD-to-CD adapters work with the wireless card and the wireless card itself doesn't support RAW file transfer. Still, as technology continues to evolve, so the time may soon come when you can easily transfer images from your camera directly to your hard drive through a wireless access point. As this is written, however, it is more science fiction than fact.

7.2 Card readers are the best way to transfer image files to your computer. Most readers use a self-powered USB connection, although FireWire readers are also available. Most card readers do not require any additional software to operate.

Copying files with a card reader

The fastest and most reliable way to transfer your images to your computer is with a card reader. Card readers are inexpensive, compact, and easy to use. Although a Compact Flash reader is all you really need to read files from the A300 series, most readers have slots for many different memory card formats. The majority of readers are USB 2.0 compatible. If your computer has a FireWire interface, it might be worthwhile to invest in a FireWire card reader to obtain the faster transfer rate.

The Advantages of a RAW Workflow

The A300 series can record in two basic formats: RAW and JPEG. If you cannot make up your mind, there is also a RAW & JPEG option that will record one RAW and one JPEG for each image you take.

Both RAW and JPEG have highly vocal proponents who sneer at those who don't shoot in their preferred format. But each format offers advantages, depending on the situation and final use of the image.

Working with JPEG

JPEG images are highly compressed, which means they have a much smaller file size than RAW files. JPEGs are the standard for photos on the Web, so when you shoot JPEG, the image is ready to use on photo sharing sites right from the camera. Almost any software package that can import graphics can recognize a JPEG. If you shoot in continuous mode with the A300 series, you will get a faster frame rate shooting JPEG than with RAW.

With all that JPEGs have going for them, why would anyone want to shoot in the RAW format? Two words: image quality.

Don't misunderstand, a RAW file by itself is not a higher quality image. There isn't some magical transformation that makes RAW files superior to JPEGs. When you start color correcting your images, however, you will quickly find that RAW-generated images consistently look better than JPEG images. RAW files simply have more data to work with.

One point that many find confusing is that a RAW file contains the sensor data, pixel by pixel, but it has not been rendered into an actual image. The current camera settings are applied to RAW data from the sensor to provide a base that will be used to render an image. All RAW converters will not render the same RAW file in the same way, so the RAW file will always be open to reinterpretation by another processor, possibly with very different results.

When you shoot in the JPEG mode, the camera uses the basic settings you selected and creates an image from the data the camera recorded. After it has distilled the recorded information into an image matching your settings, it discards the unneeded data. One reason JPEG images can be so small is that the format naturally tosses out any data it doesn't need.

Advantages of RAW

A RAW file, on the other hand, retains all the pixel information the camera recorded during an exposure. All the data is saved, even if it is not needed in the current version of the image. A prime example of this is a black-and-white RAW file. Shoot a black-and-white JPEG and that is all you will ever have. The image is made of shades of gray because the JPEG discarded all the color information.

If you happen to shoot a black-and-white RAW file, however, the RAW format still maintains all the color information. The image will look and print in shades of gray. The color is still there, however, and just changing to the RGB mode in a conversion program will instantly replenish the image's original colors.

In a real world scenario, the fact that RAW files maintain all that data makes it possible to tweak RAW-generated images to display detail that cannot be matched by JPEGs captured in your camera.

Imagine an outdoor scene taken at noon on a bright, cloudless day. The intense light coming from high overhead creates dense shadows underneath the subjects in your photos. If you shoot in JPEG and attempt to lighten up the shadow areas in post-processing, the shadows will become an unnatural pasty-looking gray. There is no detail in the shadows, because the original JPEG recorded the area as completely black and discarded any tonal information in those areas. You are left with a choice: dense black shadows or unnatural-looking shadow areas with no discernible detail. Neither image is likely to foster your reputation as a photographer.

If the same scene was shot in RAW, however, the camera probably recorded some details in the dark areas. When you lighten the shadows in the RAW processor, you start to see hidden details, much the way the human eye would. You are able to salvage the image because the RAW format preserved all the detail the sensor captured.

Because RAW files contain all the data just as the camera sensor captured it, you can instantly adjust the white balance to whatever looks natural. You simply adjust the Temperature and Tint settings in your RAW processor, and the image is rendered with the new settings. In a JPEG image, the white

balance is not retained in the image file. If the balance isn't correct, you can attempt to adjust it in software, but given the JPEG doesn't retain unneeded tones, the image might require extensive retouching to come close to looking natural.

This shouldn't be interpreted to suggest that RAW is simply a Band-Aid that allows you to repair poorly exposed images. An overexposed image is still going to have blown highlights, and even excellent images can be subtly improved by amplifying details and tones that a JEPG image would have discarded.

Of course, once you've adjusted the image in the RAW conversion software, you then have to export it in a usable format: typically TIFF for high quality editing or JPEG for the Web or final print. Thus you may still end up with a JPEG when you have finished, but the extra step of editing the RAW file on your computer results in a much nicer looking JPEG.

Each digital camera brand records in its own RAW format, and it is not uncommon to find different models from one manufacturer producing slightly different RAW files. Images made with the Alpha A300 and A350 will have a .arw file extension.

RAW conversion software for the Sony A300 series

Because a RAW file is not usable by itself, you will need software to allow you to edit the RAW file and export it to a useable format. Fortunately, you have many excellent choices when establishing RAW workflow.

The CD that accompanied your A300 series includes Image Data Lightbox SR and Image Data Converter SR. Image Data Lightbox allows you to preview a "collection" of RAW files, while Image Data Converter provides the tools you will need to edit and convert a RAW file into a useable format.

7.3 Viewing RAW files with Sony's Image Data Lightbox SR application.

Image Data Lightbox SR is primarily a viewing application that allows you to open RAW, TIFF, and JPEG images for viewing and ranking. The Lightbox application has no editing capabilities and it doesn't save individual files, although you can save a collection of images so you can open the same batch of images at a later date.

Image Data Converter SR offers a full range of editing options. It is designed for RAW editing; you can import JPEG and TIFF files, but the editing operations for these formats are limited to rotating the image and adjusting the tone curve.

For RAW files, however, Image Data Lightbox offers a host of editing options. You can adjust the hue, saturation, exposure, brightness, contrast, white balance, and more. There are also tools for sharpening and removing image noise. You can apply "Creative Styles" similar to the way you can select specific styles when shooting. As you would expect, there are also options to convert images to black and white and sepia.

Cropping is also available in Image Data Converter, but it is pretty rudimentary; you select an area on screen and choose Trim to Selection from the edit menu. This is the biggest weakness of the program as there is no way to restrict the aspect ratio of the trimming operation, nor is there a way to adjust the resolution of the final image.

7.4 All Sony A300 series cameras ship with the Image Data Converter application. It works well as a RAW converter and offers noise reduction, sharpening, and a full range of tonal editing tools. When it comes to speed and efficiency, however, it lags behind some of the aftermarket RAW converters.

The Sony software may offer you everything you need, and given it comes with the camera, there is nothing else to acquire. It also provides excellent results. After all, who knows more about Sony's RAW format than Sony?

Before you invest too much time learning to use the Sony suite of software, you should look at what else is available.

Third-Party Converters for RAW Images

Now that your photos are on your computer, it's time to take a look at some third-party converters. But why should you invest in a third-party application when you already own the software from Sony? Actually, there are several good reasons:

✦ **Improved camera compatibility.** Third-party RAW converters attempt to recognize every digital camera format on the planet, while the Sony software only recognizes Sony's proprietary ARW format. If you acquire another brand of camera or a family member picks up a non-Sony model, you can maintain a single image library for all your RAW files.

✦ **Superior interface.** The interface on the Sony software is not as efficient as some of the other products.

✦ **More tools and options.** You will have access to a host of editing tools and plug-ins that are not available in RAW Data Converter or Image Data Lightbox.

✦ **Software compatibility.** Many third-party applications are tightly integrated with pixel editing software such as Adobe Photoshop.

✦ **Cropping and resizing control.** Cropping and image resolution adjustment in most third-party apps is far superior to the Sony software.

✦ **Active communities.** The more popular third-party applications have energetic communities who offer free tips and advice as well as plug-ins, automated presets, and even video training sessions.

The two most popular RAW converters on the market are Photoshop Lightroom from Adobe and Apple's Aperture. These programs go way beyond converting RAW files, as they offer robust cataloging and the ability to generate Web galleries, slide shows, and customized printing. Both programs are popular with professional photographers as well as advanced amateurs.

Adobe Photoshop Lightroom

Not to be confused with Adobe's Photoshop graphic editing program, Lightroom (www. adobe.com/products/photoshoplightroom/) is aimed directly at photographers and offers a smorgasbord of image-correction tools. Lightroom ships on a single CD that contains both the Windows and Macintosh version of the software, so any copy will run on both platforms. Besides a first-class RAW conversion engine, Lightroom also offers a mind-boggling array of tools for printing and creating slide shows and Web galleries.

Adobe calls Lightroom a nondestructive image editor, because the program's innovative design actually stores all the changes to a RAW file in a database. No matter how many changes you apply to your original image, the RAW file remains untouched. The instructions for editing the image are saved as text in the database. Onscreen, you see the effect of your edits, but the program is actually just saving a recipe of your changes.

Adobe's solution to RAW conversion is to use a RAW processor plug-in to open files in any Adobe application. Adobe Camera Raw (ACR) is used to render images by Photoshop, Bridge, or Lightroom. Adjustments made to the RAW processing settings for a file are saved in a kind of sidecar text file, allowing any of the other ACR-savvy applications to open the RAW file with the same settings.

7.5 Adobe Photoshop Lightroom features a brilliantly designed interface and all the tools you would expect from a first-rate RAW converter.

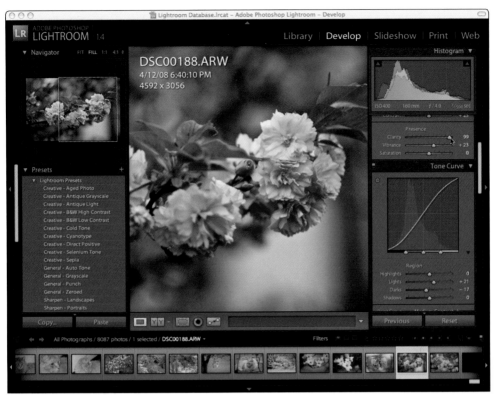

7.6 The Lightroom-specific Clarity tool offers photographers a new way to enhance the look of their images.

When you choose to output a final TIFF or JPEG, the software consults the database and applies the changes to the exported image. Because all the edits are saved as text, this saves a considerable amount of space on your hard drive.

Lightroom version 1.4 or above is required to open RAW files from the Alpha 300 series.

Aperture

Aperture (www.apple.com/aperture/) only runs on the Macintosh platform and it requires a powerful Mac at that. The program will not open on anything less than a PowerPC G5 and is happiest with an Intel Mac Pro or Macbook Pro. If your system meets Aperture's stringent specs, however, Aperture offers a stellar array of editing tools. It boasts more processing features than iPhoto, and is compatible with third-party plug-ins to expand its editing capability. Like Lightroom, edits are nondestructive, allowing for multiple image versions to reference the same RAW file. Some plugins also allow for minor pixel-editing on the rendered version.

To edit A300 or A350 RAW files, you will need at least Aperture 2 with Mac OS X v10.4.11 Tiger or Mac OS X v10.5.2 Leopard.

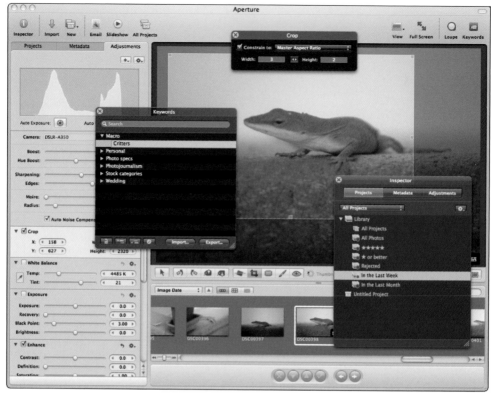

7.7 Aperture is Apple's professional grade RAW file processor. What does a computer manufacturer know about photography? Quite a lot, if Aperture is any indication. The tools and capabilities are second to none, but you will need a powerful Mac to take advantage of the program.

iPhoto

The latest version of Apple's iPhoto (www. apple.com/ilife/iphoto/) can also convert RAW images from the A300 series. Although not as powerful as Aperture, iPhoto can serve as a capable catalog and RAW conversion tool, especially if your photo library isn't overly large.

Silky Pix Developer Studio

Another option for editing RAW files is the cross-platform Silky Pix Developer Studio (www.isl.co.ip/SILKYPIX). Not as full featured as Aperture or Lightroom, it still handles RAW photos extremely well. If you don't need all the extras, Silky Pix could be all the editor you need. There are many other RAW converters available.

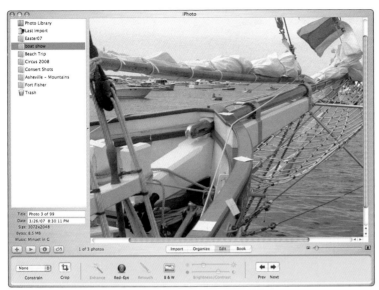

7.8 iPhoto, another Apple application, ships with Apple's iLife suite of programs. From its humble beginnings as a catalog tool, iPhoto has grown into a capable RAW workflow tool.

Archiving and Cataloging Images

Once you have images on your computer's hard drive and you've selected the converter application of your choice, it is time to catalog and archive your images. If you make it a point to catalog them as soon as you import them to the computer, the task will be fairly painless. If you wait and attempt to catalog months of digital imports, the task may become overwhelming. It may seem dull and unnecessary to catalog each collection of images when you first import them, but if you make it a regular practice, you'll maintain an organized collection that will allow you to find any image with a minimum amount of searching. If disaster strikes and your hard drive crashes, you won't loose sleep over it because your images will be safely backed up.

Maintaining a manual catalog of your images could consume so many hours that you wouldn't have time to shoot any new photos. That is why you need an automated or semiautomated solution. Good cataloging software will enable you to quickly import and rate your images as well as create keywords for them and store them. The ability to batch assign keywords is vital, as it will save hours while cataloging and provide an easy way to locate the photos in your ever-growing collection.

If you haven't yet started to catalog your image collection, there are several options available to you.

Microsoft Expression Media

Microsoft has acquired the cataloging software formerly known as iView Media Pro and rebranded it as part of the Microsoft Expression family. Available for both Windows and Mac, Expression Media (www.microsoft.com/expression/products/overview.aspx?key=media) reads all popular graphic formats and can even archive PDF files. It has some limited graphic editing capabilities, but its main strength is storing and cataloging. Expression Media offers a drag and drop interface that makes it easy to add keywords and categories to images.

Google's Picasa

Picasa (http://picasa.google.com/) is Google's free imaging cataloging desktop client. Currently Picasa is only available for Window PCs, however there is a beta version for Linux offered in the experimental section of the Google Labs Web site (http://picasa.google.com/linux/). There are rumors of a Mac version being developed as well, but Google has not said so publicly.

Picasa offers an interesting twist on cataloging. Picasa runs in the background, continuously searching your hard drive for new images. When it locates a new file, it automatically adds it to the library. It can also catalog images from removable media such as DVDs and CDs. Because Picasa adds files

7.9 Google supplies the handy Picasa catalog software for free. Picasa offers plenty of features and can automatically catalog TIFF, JPEG, and GIF images. At the time of this writing, there is no support for the A300 series RAW files.

to the library without supervision, your complete image catalog is always up-to-date. You can manually add keywords to help you locate images, but Picasa does all the heavy lifting by itself.

Picasa offers limited RAW conversion options, but at this time that doesn't extend to the RAW files generated by the A300 and A350. Until Google bakes support for the ARW format into Picasa, you will only be able to catalog your TIFF, JPEG, and GIF images.

Apple iPhoto and Aperture

iPhoto (http://apple.com/ilife/iphoto/), only available for the Mac, has evolved far beyond its origins as a simple catalog application. iPhoto now boasts a full range of image editing tools, and can even convert RAW files. It is still an excellent catalog tool, and recent upgrades have dramatically improved iPhoto's speed and reliability.

Aperture 2.0 (http://apple.com/aperture) is also only available for the Mac, and was specifically designed to meet professional RAW workflow needs. Unlimited keywording and search options make organizing files across multiple drives a snap. You can also create multiple versions of an image without having to actually save multiple copies of the original RAW file. Aperture offers an automated built-in back-up utility that stores your entire library in a format called a Vault.

Adobe Bridge and Photoshop Lightroom

If you purchase any of the Adobe creative products, you are given a copy of Bridge CS3 (www.adobe.com/products/creativesuite/bridge/). Bridge allows you to organize, rate, and key image files and other files. RAW files are opened using the Adobe Camera Raw (ACR) engine (there will be more on ACR later in this chapter), and the processing settings can be accessed by other Adobe products.

7.10 The CD that accompanied your A300 series camera includes the Windows-only Picture Motion Browser, which offers tools for viewing, organizing, retouching, printing, and e-mailing images.

Where Bridge stops, Adobe Photoshop Lightroom (www.adobe.com/productsphoto shoplightroom/) takes over, providing full keywording support and additional photo editing tools, as well as saving multiple versions of the same RAW file.

Sony's Picture Motion Browser

Windows users have access to Sony's Picture Motion cataloging program. Picture Motion ships on the CD that came with your Alpha Series camera. The Picture Motion browser allows you to import and organize a catalog of your A300 or A350 images. The software also allows you to repair red-eye, e-mail photos, and make CD data disks from your images.

In addition to the previously mentioned programs, dozens of third-party software are designed to organize and store digital images. While these are probably the most popular, you may prefer one of the others. Whichever you choose, make sure you select a package that can grow with your photo collection. If you diligently catalog images with one package for several years, then elect to switch to cataloging software that offers more features, what happens to your existing library? Will you have to manually import years of data into the new program? Or will you have to maintain two libraries, one with your old data and one with your new images? Choose wisely so you won't face this dilemma as time goes on.

Storage Medium Options

Once you have selected software to catalog your images, you should consider how you will store and back up your collection. A digital photography library requires extensive storage capacity, and if you are currently stashing your images on your computer's internal hard drive, it is only a matter of time until you run out of disk space.

Some photographers attempt to maintain their photo collection on CD or DVD. Writing all those images to an optical disk can be a time-consuming task. You also have to be diligent about marking and storing the removable medium so you can find it again. This makes CD and DVD archiving less than an ideal solution.

The good news is that today's external hard disks have dramatically increased in capacity while at the same time plummeted in price. Adding an eternal hard drive is a simple matter and can provide an excellent storage solution for your media library. As your library expands, you can add more and larger hard drives.

If you choose to go this route, make sure your computer supports either USB 2.0 or FireWire. USB 1.0 simply isn't fast enough to deal efficiently with the size of files generated by the A300 or A350.

7.11 Prices for external hard drives have dropped drastically in recent years, while storage capacity has soared into multiple terabytes of available disk space. These drives are a great place to store and back up your images.

The latest form of storage and backup involves transferring your files to an online storage facility. Online storage sites are springing up everywhere on the Internet. Some are free, while others charge a fee based on the megabytes or gigabytes you store with them.

There are several advantages to online storage. The storage company is responsible for maintaining and backing up the information you store with them, so you don't have to worry about the integrity of your library. Many of the storage companies offer software to upload images in the background, so you can transfer files while you are busy doing something else. If some disaster destroys your personal computer, your images are still safe on the online site.

Of course, online storage is not perfect. It can take a long time to transfer large images to or from the online site.

However you decide to store your images, spend some time planning the best way to organize and name your folder structure. Your memory can be fickle and if you just label your folders with names like "dog show" or "Christmas," it is easy to loose track of what is exactly in these folders. Are they photos from last Christmas, or of a Christmas long ago? What if you attended more than one dog show? How do you find the folder with the images you want?

A good solution is to name the folder with a numerical date format such as 032208, where the numbers are the month, day, and year the photos were taken. This can be combined with a description, such as 122507_Christmas.

Dedicated Sharpening and Noise Reduction Applications

You've gotten the administerial chores out of the way — you've chosen which format to shoot in, your images are on your hard drive, you've selected your converting software, and you've figured out how you want to catalog and store your images. Now you can enjoy the creativity of fine-tuning your images.

While all the previously mentioned programs contain tools for sharpening and noise reduction, many photographers include dedicated sharpening and noise elimination applications in their workflow.

Nik Multimedia Sharpener Pro is probably the best-known sharpening application, but there are several others available. Almost all digital images can stand a controlled amount of sharpening. Unfortunately, it is very easy to oversharpen an image. This produces strange artifacts and destroys the integrity of the image. For this reason, many photographers avoid sharpening altogether. This is a mistake, because, properly applied, software sharpening can improve almost any image.

Noise is the bane of many digital photographers, and a number of software solutions to reduce noise are available. Neat Image bills their software as the best noise reduction program available, but the fans of the popular Noise Ninja, Nik Multimedia DFine, and the cleverly named Grain Surgery disagree. These programs use various algorithms in an attempt to remove noise artifacts. All can be successful to a degree, but there are some images that are beyond salvage. If you shoot at a high ISO setting, noise reduction software is a must.

Pixel Image Editing Applications

The final piece of the workflow puzzle is pixel image editing. Programs such as Aperture and Lightroom allow you to apply overall corrections, such as adjusting overall contrast and tone. Pixel editing allows you to edit or retouch individual portions of the image. This can involve something as minor as cloning away small imperfections to replacing entire backgrounds and merging several photos into a single image.

Not every image will require this degree of manipulation, of course, but photo editing software can often salvage poor photos and make good photos into great photos. Using photo editing software, you can correct perspective, remove blemishes, remove telephone wires, repair reflections, and far more. The degree of photo manipulation you can achieve is only limited by your talent and creativity. Naturally, your choice of editing software plays a part in this equation, as well.

Adobe Photoshop

The undisputed leader in the graphic software arena is Adobe Photoshop (www.adobe.com/ products/photoshop/photoshop/). When it comes to image editing, no other desktop software package offers the power and capability of Photoshop. Adobe's flagship software is the editing tool of choice for professional photographers, movie studios, graphic arts houses, and Web designers.

Photoshop's strength lies in its easy-to-use interface, its full range of editing tools, and its plug-in architecture that provides a method to add additional tools and capabilities. In addition, there is an army of enthusiastic users who are continually pushing the graphic editing envelope.

Photoshop is also a very capable RAW editor, as Adobe bundles the Adobe Camera RAW (ACR) plug-in with the application. ACR can open most RAW files and you have the collective might of Photoshop's editing tool inventory to tweak your RAW files.

Photoshop is often portrayed as overly complicated and hard to learn. There is no denying the learning curve can be extensive, yet photographers have a real advantage over most potential users. The techniques that you need to become a good photographer are the same ones needed to master Photoshop. So dedicated photographers have a much easier time becoming proficient in the program.

7.12 If you can stand the high price tag, Photoshop can be a one-tool workflow application. Graphic editing, retouching, RAW conversion, sharpening, cropping, resizing — Photoshop does it all and does it all well.

The biggest obstacle to becoming a Photoshop maestro isn't mastering the tools; it is the price of admission. They invented the term "sticker-shock" to describe new photographers' reactions to Photoshop's price tag. It is definitely a professional application and the asking price reflects that.

Adobe Photoshop Elements

Fortunately there are alternatives. Adobe, realizing that not everyone can afford Photoshop, offers Photoshop Elements (www.adobe.com/products/photoshopelwin/), an editing program available for a much more affordable sum. While Elements can do many of the same things that its big brother can, Elements is not a stripped-down version of Photoshop. The interface is different, many of the tools operate in slightly different ways, and of course, many of the more powerful tools are missing from Elements.

Still, Elements is worth a look, particularly if you do not delve into pixel editing on a regular basis. Elements ships with its own version of ACR, so you can open and edit RAW files. There are not as many options for color correcting and manipulating images as with Photoshop, but most of the tools are there if you are willing to dig into the program.

The GIMP

Surprisingly, the closest thing to a real competitor to Photoshop is a free open-source application called the GIMP (www.gimp.org/). GIMP stands for GNU Image Manipulation Program. You can download it from a variety of Internet sites and versions are available for Windows, Macintosh, and Linux.

The GIMP offers many of the tools available in Photoshop; however, the interface is not as polished as the Adobe product. The GIMP can even do some things that Photoshop can't, although many tasks, such as layer masking, is more difficult in the GIMP. Because it doesn't cost any money to "kick the tires" on the GIMP, it is worth your while to download it and try it out.

Developing a workflow may not seem as exciting as shooting in the field, and buying software will probably never have the same thrill as acquiring a new lens. Once you dive deeper into the intricacies of software editing and manipulation, however, you will find that post-processing offers just as much of a creative outlet as handling your camera. Your images will look better as well, because you are in charge of the entire process from capture to output. You will quickly find that your workflow is a vital part of any digital photography process.

7.13 The GIMP is a free open-source image editor that runs on almost any computer platform available. The interface lacks Photoshop's professionalism, and some of the tools are rough around the edges. For the price, however, the GIMP is a surprisingly powerful image editor.

Sony Alpha Resources

Sometimes you just need a little more information. This appendix serves as a resource guide for your more specific questions.

Specialty and Used Camera Dealers

If your camera's been around for awhile, or if it's a custom piece you may not find just anywhere, check out the following resources to narrow the search for your answers.

Alpha Lens Rental

(651) 755-6786

www.alphalensrental.com

A welcome addition to the A-mount scene is Alpha Lens Rental. Located in Minnesota, Alpha Lens Rental offers a wide selection of Sony and Minolta lens rentals by mail within the United States. Users of other major camera lines have had access to lens rentals, but until now it was a difficult proposition to find a source for A-mount rentals. Renting is a great solution when you know you will be attending a one-of-a-kind event and want an exotic lens such as a Minolta 300mm f/2.8 APO G HS to shoot with.

Gadget Infinity

http://gadgetinfinity.com/

Gadget infinity is a Hong Kong merchant that specializes in hard-to-find photographic equipment. Here you will find third-party flash triggers, lens adapters, wireless shutter releases,

AA1. The Minolta 300mm f/2.8 APO G HS lens.

AC adapters, flash adapters, ring lights, and much more. The company sells aftermarket equipment for all brands of cameras, but owners of Sony Alpha digital single lens reflex (dSLR) cameras will find a nice selection of affordable gear that can't be found anywhere else.

KEH Camera

www.keh.com

KEH claims to be the world's largest used camera store, and their inventory is online in a searchable database. They stock all brands and types of secondhand photo equipment, including used A-mount lenses, flashes, filters, and accessories. They also carry tripods, lighting equipment, cases, and other used items. Everything is graded with KEH's sliding scale, which starts at New and progresses through Like New, Excellent, Bargain, and Ugly.

Adorama

(888) 805-4900

www.adorama.com

Adorama is a large camera sales outlet located in New York. In addition to all brands of new equipment, they also have an extensive inventory of used cameras, lenses, flashes, and accessories. It's worth a visit if you're looking to add used Minolta or Sony lenses to your kit.

B&H Photo

(800) 952-3386

www.bhphotovideo.com

Another major New York photo retailer that also offers new and used equipment online, B&H stocks tons of professional equipment for still and video photographers. The Web

site is somewhat difficult to navigate, but the prices and selection make a visit worthwhile.

Seagr112's Maxxum/ Sony photo gear

http://stores.ebay.com/Seagr112s-Maxxum-Sony-Photo-Gear

Naturally, you will find many used Minolta lenses and equipment on eBay. The eBay store run by Seagr112 will be of special interest to Sony Alpha owners, however. This online store deals only with new and used A-mount lenses, flashes, and accessories. Most of the offerings are mint, in-the-box merchandise. If you are looking for second-hand lenses in excellent condition, search for Seagr112 in the stores section on eBay.

Support and Technical Information

When you need advice from an expert on your specific photographic issue, take a look at some of these sites to help get you on your way.

Sony eSupport

http://esupport.sony.com

Sony provides an online support site for owners of all their products, including the Alpha A300 and A350. After registering your product, you can get e-mail support, browse the Sony knowledge base, and be notified of product updates.

You will also be able to consult the official Sony-Minolta lens compatibility chart, which details the Minolta lenses that Sony certifies will work successfully on the Alpha dSLR models.

Sony Australia Alpha dSLR Centre

http://dslr.sony.com.au/SonyAlpha/

Sony is a global organization, and each major geographical division has their own Web site. You will find Alpha support information on all the sites, but the Sony Australia site has moved to the top of the pack with an exceptional flash Web site. In addition to the usual sales material, the Australian site is chock full of articles, photo tutorials, and images taken on location with Sony Alpha cameras. No matter where you live, you will find the Sony Australia site is worth bookmarking for frequent visits. Hopefully the other Sony sites will evolve in the same way the Australia site has.

Minolta Maxxum Dynax AF Lens Service Repair Manual Mini CD

www.pbase.com/pganzel/image/54644996

Pete Ganzel offers 693 pages of Minolta A-mount lens repair information on CD. Thirty A-mount lenses and two teleconverters are represented on the disc, which includes diagrams and parts information in PDF format. If you want to try your hand at repairing a Minolta A-mount lens, or if you want to explore DIY lens modifying, Ganzel's disk is a must.

Flash trigger voltage report

www.botzilla.com/photo/strobeVolts.html

Kevin Bjorke has assembled an extensive list of flash unit trigger voltages. Although the list is aimed at Canon EOS users, the trigger voltage information is useful to any user who wants to use older, non-Sony strobes on their Sony Alpha. There are hundreds of portable flash units and studio strobes listed, each with a maximum trigger voltage and a suggestion of whether they are safe to use on modern electronic cameras. If you intend to use any flash other than those made by Sony or the Minolta D units, you owe it to yourself to consult this list first.

A-mount Lens and Flash Information

To find out what lenses are out there or for the specs of a newly acquired flash unit, start out your search with these sites.

The Dyxum A-mount lens database

www.dyxum.com/lenses/index.asp

www.dyxum.com/flashes/index.asp

This database is probably the best A-mount lens resource available. Here you will find a comprehensive list of nearly every A-mount lens ever made, all reviewed in detail. Unlike many of the other A-mount review sites, the Dyxum site covers third-party optics as well as OEM lenses. You can compare optics from Tamron, Sigma, and Vivitar, and many others with Sony and Minolta glass. If you want to see what owners think about the performance of a particular A-mount lens, the Dyxum site should be your first stop. You will also find user reviews of Sony/Minolta flashes and accessories.

Fotographie – Mike Hohner

www.mhohner.de/sony-minolta/lenses.php?lg=e

www.mhohner.de/sony-minolta/flashes.php

Mike Hohner has assembled an incredible Web site that every Sony Alpha user should know about. There aren't many reviews, but there are photos and full specifications of nearly every lens, flash unit, and SLR camera made by Sony or Minolta. Hohner's site makes it easy to compare different lenses to one another, so if you are considering buying a Sony or Minolta brand lens, it is well worth your time to compare it to others of a similar focal length on Hohner's site. There are also a number of articles discussing how to get the most out of Sony and Minolta cameras.

Maxxum Eyes

www.maxxumeyes.com

This Web site is dedicated to Minolta and Sony prime lenses. The site doesn't provide reviews or specifications. Instead, it has compiled links to online reviews of A-mount prime lenses. Find a lens you are interested in, and you will be presented with numerous links to online reviews of that particular lens.

Photography Review

www.photographyreview.com/mfr/konica-minolta

Photography Review reviews lenses for all popular dSLRs. The A-mount section is fairly comprehensive, although many of the featured lenses are accompanied by generic "photo not available" images.

Photozone

www.photozone.de

Another site that reviews all makes of cameras and lenses, Photozone offers very detailed reports on a variety of Sony and Minolta A-mount lenses. Photozone takes a little different approach to reviews, as there are no user reviews. Instead, each lens they profile is accompanied by distortion and resolution charts, as well as a number of sample images. Not every A-mount lens is included, but they have most of the current Sony lenses as well as some Minolta and Sigma A-mount offerings. This is definitely a site worth visiting if you are considering adding additional lenses to your kit.

Sony/Minolta Forums and Discussion Groups

There is a wealth of online discussion groups of interest to A300 series owners. These groups allow users to trade information, share experiences, critique each other's photos, and generally hang out online with other Alpha enthusiasts. Finding the group that is right for you, however, can be problematic.

Some groups are friendly and easygoing, but many of the bigger forums can be a bit intimidating. Many popular forums are attractive venues for people who criticize a particular brand of camera. They toss out wildly inaccurate rumors and half-truths, running down a particular camera while praising their favorite brand. Be wary of anyone who insists that there is only one camera brand worth owning. There is no such thing as a "junk" dSLR; the dSLR market is so competitive that no manufacturer can afford to produce second-class merchandise.

Dynax Digital

www.dynaxdigital.com/

The Dynax Digital site offers in-depth discussions on all Sony Alpha and Minolta dSLRs. In addition to general Sony Alpha forums, there is a specific section for discussion of Alpha A300 and A350 matters.

dPreview (Digital Photography Review)

www.dpreview.com

The dpreview site has news and reviews, but it is best known for its highly active user forums. Choose Sony SLR Talk from the Discussion Forum menu on the left to enter the Sony Alpha forum threads. Users might also find A-mount lens and flash unit information in the Konica Minolta SLR Talk section.

Steve's Digicams

http://forums.steves-digicams.com/forums/

Steve's Digicams began covering the digital camera scene when 1mp sensors were considered a big deal. The site still offers news and in-depth reviews, but many readers

overlook the discussion forums. There is a combined Konica Minolta/Sony Alpha dSLR forum that will appeal to A300 series users.

Photoclub Alpha

www.photoclubalpha.com/

David Kilpatrick's UK-based Sony/Minolta based site covers all the bases, offering a blog; forums; a subscription print magazine, Photoworld; and Minolta-branded merchandise. In addition, you will find news, tips, and reviews about Sony and Minolta SLR equipment. While the site has an obvious British slant, any Alpha dSLR owner will find a wealth of interesting information here.

Flickr

http://flickr.com/groups/sony_alpha/discuss/

There are more than 600 Sony Alpha groups on Flickr. To find them, just search for Sony Alpha under groups from the Flickr home page. Many of the groups are small and dedicated to a single country; but others, like the Sony Alpha dSLR group, have thousands of members. Although the A300 series is still quite new, several dedicated A300 and A350 Flickr groups have started to spring up and you can expect more in the future. While many of the groups simply use Flickr to display their best images, the larger groups also have strong discussion groups. The Flickr discussion threads seem to be friendlier and more easy-going than some of the hard core digital camera groups.

Yahoo! Groups

http://groups.yahoo.com

It seems that Yahoo! has a group for everything, so naturally there are many Sony Alpha groups located in the Yahoo! Groups pages. Simply search for Sony Alpha from the Groups page to locate them.

Google Groups

http://groups.google.com/

There aren't as many Sony Alpha groups available in the Google Groups project as there are in the Yahoo! Groups pages, but you will find some interesting discussions and the number of groups is growing.

Blogs

If you're just looking for the latest in the Alpha world, you might want to check out or even subscribe to a few blogs.

AlphaMount World

www.alphamountworld.com

This interesting A-mount blog features reviews, articles, and forums, all dedicated to A-mount cameras, lenses, and equipment.

Alphatracks

http://alphatracks.com

This is my own blog, which covers the full gamut of Sony and Minolta dSLRs. The content consists of news and opinions about Sony and Minolta SLR cameras. About 90 percent of the topics revolve around the

Sony Alpha, but older film Minoltas claim the other ten percent. Readers of this book are encouraged to stop by and say "Hello"!

Sony-Alpha.org

www.sony-alpha.org/

This blog covers OEM and third-party lenses, flashes, and accessories for Sony Alpha dSLRs. Naturally, Sony Alpha cameras receive attention as well. Many of the reviews appear to be little more than press releases, but A300 series owners may find some interesting aftermarket Alpha accessories profiled.

Sonolta.com

www.sonolta.com/

Every Alpha owner should know about Don P. Northup's Sonolta Web site. The name represents a clever merging of the Sony and Minolta brands. Sonolta is more of an extensive A-mount photo blog, but the images are incredible. Most of the images are taken with the Alpha A100 or the Alpha A700. A300 series users will be inspired when they see what the A mount lenses are truly capable of.

Troubleshooting

The A300 and A350 are well-designed digital single lens reflex (dSLR) cameras without any appreciable reliability flaws. Properly taken care of, both cameras should stand up well to heavy use. If something does go wrong, however, you may find that it is fairly easy to return your camera to usefulness. Naturally, a Sony service center will have to perform major repairs, but you can often rectify simpler troubles with just a basic understanding of what has gone wrong. At the same time, it is far better to prevent problems than have to mend them. This section will help you keep your A300 series hale and hearty.

Keeping Your Compact Flash Cards Healthy

The A300 series cameras use Compact Flash (CF) cards as a mass storage medium. Some cameras are finicky about card brand and capacity, but the Alpha dSLRs seem to tolerate most CF cards as well as microdrives. A properly cared for Compact Flash card will probably outlive both you and your camera — the CF Association claims the typical CF card can be used for more than 100 years and not suffer dilution of data.

This doesn't mean that CF cards are invulnerable to problems. Few things can cause more dread to a photographer than inserting a card full of photos into a computer and seeing the chilling words Card Read Error. It happens more than most photographers would like to believe.

The good news is most CF problems aren't fatal to your images. Unless the card is physically damaged, it is unlikely the data will be completely wiped out. Like all electronic storage devices, a CF card distributes information across the storage media and maintains a directory to remember where the

In This Appendix

Keeping your Compact Flash cards healthy

Upgrading your camera's firmware

Preventing sensor dust

Resetting to the default settings

Battery basics

AB.1 The pins on a CF card are spaced close together in neat rows. If you attempt to insert or remove the card while the camera is on, an electrical arc could damage the card, your data, or even the camera. Always turn the camera off when working with memory cards.

data is stored. When an undamaged card cannot be read, the culprit is usually a corrupt directory. The images are still there, but without a directory, your computer cannot access them. This also applies to deleted images. The deleted image is removed from the directory but will remain in place on the card until another image overwrites the area where it is stored.

If you should encounter a card read failure, do not panic. There is a good chance you can use recovery software to find and restore your images. There are many applications available that you can employ in an attempt to regain your images.

Because the directory is damaged or corrupt, the typical recovery application doesn't use the directory. Instead the application will scan the media looking for beginning and end bits of all the files it can locate. This operation is usually takes much more time than reading the images from the directory, especially on large cards with many stored images. The wait is well worthwhile if the software is able to recover important images that would otherwise be lost forever.

There are dozens of recovery applications available. The ones listed here are only a few of the applications that claim to recover data from CF cards. Most image recovery applications are available as a demo that demonstrates whether they are able to recover images from a faulty card. The files

recovered with a demo are usually watermarked or crippled in some way, but if the demo works you know it is worth buying a full copy to regain your images.

Of course, it is better to eliminate memory card problems before you have to resort to recovery software. Because CF cards are solid-state devices, there are no moving parts to go bad. When trouble arises, usually either the camera or user is responsible. Here are some tips to help prevent data loss:

✦ **Avoid filling your cards to capacity.** Some cameras can loose track of data and overwrite images when the card gets full. The A300 series doesn't appear to have this problem. Still it is a good idea never to completely fill a CF card. When the card starts to fill up, leave some free space and switch to fresh card.

✦ **Do not erase files from the card on your computer.** Always erase and format your cards with your camera. Once you have transferred the images to the computer and you are sure they are backed up, return the card to the camera and delete the images or format the card. Although most computer file systems should be compatible with your A300 series, by deleting files with the camera, you eliminate any file irregularities between the camera and computer.

AB.2 You will find dozens of image recovery programs, such as the one shown here, available to help you recover your images if a memory card becomes corrupt.

✦ **Turn the camera off when inserting or removing cards.** Never insert or remove the CF card from your A300 series while the camera is turned on. Doing so could cause the card to be unreadable, and in some cases the camera itself could be damaged.

Table AB.1 displays a partial list of file recovery software.

Even if you have never had a problem with a memory card to date, it is a good idea to add one of these applications to your software library. If the worst should happen, it is nice to have a recovery program installed and waiting: you may never need it, but if you ever do, you'll be happy you thought ahead.

Table AB.1
File Recovery Software

Software	URL	Platform
Camera Salvage	www.subrosasoft.com/OSXSoftware/index.php?main_page=product_info&cPath=201&products_id=3	Mac OS X
CardRaider	http://ecamm.com/mac/cardraider/	Mac OS X
Digital Picture Recovery	www.dtidata.com/digital-picture-recovery.html	Mac OS X
		Windows
Media Recover	www.mediarecover.com/software.html	Mac OS X
		Windows
PhotoRescue	www.datarescue.com/photorescue/	Mac OS X
		Windows
PhotoRescue Pro	www.objectrescue.com/products/photorescuepro/	Windows
ProDataDoctor	www.datadoctor.org.in/undelete-partition/memory-card.html	Windows

Upgrading Your Camera's Firmware

All digital dSLRs use internal software to control the functions of the camera. This software is known as firmware and it provides a simple way for a camera maker to fix bugs and add new features to an existing camera. Typically the process involves downloading an installer file from the Internet to your computer. You then write the installer to a memory card and place the card in your camera. Activating a special sequence of controls will cause the installer to begin the upgrade process.

Checking the firmware on your camera

It is simple to check the firmware version on your A300 series camera. Press the MENU button, then press the DISP button. The camera model will be displayed along with the firmware version.

The A300 and A350 are both so new that as this is written, the firmware is still at version 1.0. Most dSLRs see a regular progression of firmware updates during their production life, so you can expect that at some point Sony will update the firmware on one or both of the cameras in the A300 series.

You should register your camera at sonystyle.com so you can be advised of any firmware upgrades.

Use extreme care when installing new firmware

If and when you need to update the firmware, always use a freshly charged battery or an AC power adapter. If the camera is powered down before the firmware upgrade is completed, the camera may be left in an unstable state. There have even been cases where cameras would not function after a faulty firmware upgrade.

AB.3 Pressing the MENU button and the DISP button displays the firmware version.

This isn't intended to scare you away from updating your camera's firmware. Having the latest firmware is almost always a good idea and may be necessary to use new accessories with your camera. Take your time, read the instructions, and make sure your camera won't lose power during the upgrade.

Preventing Sensor Dust

The Achilles' heel of any dSLR is dust, specifically dust that winds up on the camera's sensor. In a film SLR, film moved through the camera, so in the unlikely event that dust adhered to the film, it would only affect a single frame. With a dSLR, however, the sensor stays in place and passively records the image signal, pixel by pixel. If dust finds its way on to the sensor, it will leave its mark on every image you shoot.

Like the other dSLRs in the Sony Alpha family, the A300 series attempts to keep the sensor clean by shaking it vigorously when the camera is powered up. This may help dislodge larger particles, but smaller dust particles have a nasty habit of sticking to whatever they land on. Find something that has dust adhering to it and shake it. You may remove some or even most of the dust, but the more stubborn particles will remain. In addition, because your sensor is an electronic devise, it develops a static electric field that can attract and retain dust mites.

The best method of keeping your sensor clean is to prevent dust from entering your camera. Keep a body cap or lens on your camera at all times; never leave the body open to the atmosphere. Avoid changing lenses in a dusty environment. Use a brush to wipe the lens mount area before removing the lens.

Many photographers don't realize that the lens itself represents a major dust danger. If

AB.4 You can use an inexpensive rubber blower to lightly clean the inside of your camera. A soft brush may be used on lens elements and the outside if your camera, but never inside where it might damage the sensor.

there is dust on rear element or on the lens flange, that dust will now be inside the camera, where it will be subject to the static electric pull of the sensor. Use a brush and air blower to clean the rear of the lens before attaching it to the camera.

Caution *Never use canned air to clean the inside of your camera. The aerosol released with the pressurized air can leave residue on the sensor. This residue can be very difficult to remove and the camera may need professional repair.*

If the worst happens and stubborn particles lodge on your sensor, you will have to resort to stronger measures. Don't try to use anything but cleaning tools expressly designed for cleaning digital camera sensors. The sensor is extremely sensitive and easily damaged. Many photographers simply send their camera in for cleaning rather than attempting to clean the sensor themselves.

Of course, it costs money to send your camera in for cleaning. More importantly, you will be without your dSLR while it is being cleaned.

There are several dSLR cleaning kits available. Expect to pay as much as you would for a single cleaning for one of the better kits. Of course, once you own the kit, you can clean the sensor numerous times, so it may be worth your while to acquire a high quality cleaning kit.

The A300 series has a Cleaning mode in the Tools menu. This mode actually locks the mirror up so you can reach the sensor. Don't confuse this with the mirror lock up offered on many competing dSLRs. The A300 series does not have a true mirror lock up mode, as you cannot take a photo when the mirror is up in the cleaning mode.

To raise the mirror for cleaning, enter the Cleaning mode. You will see a dialog

AB.5 You will find the Cleaning mode under the third Tools menu. Activating the command will present you with a dialog informing you to turn the camera off to escape the Cleaning mode.

informing you to turn the camera off when the cleaning process is finished. After accepting the dialog, you will hear a low hum and the mirror will flip up and remain up.

At this point the sensor is available for cleaning. Follow the instructions that come with whichever kit you have chosen. It is worth repeating. Do not use regular brushes and cleaning clothes on your dSLR's sensor. The kits aren't inexpensive, but they are far less expensive that replacing a damaged sensor.

Don't risk trying to clean your sensor with anything else. Try to avoid using liquid cleaners if at all possible. They can do a good job, but they have been known to leave a residue in certain cases. If you absolutely have to use a liquid, use a few drops on the approved cleaning utensil. Never flood the sensor chamber with liquid.

Some of the better-known cleaning products are listed in Table AB.2.

Table AB.2
Cleaning Products for the Sensor

Product	URL
Delkin SensorScope	www.delkin.com/products/sensorscope/
Dust Aid	www.dust-aid.com/?gclid=CPmSo4KryJMCFR6gnAodl1Goig
Visible Dust	www.visibledust.com
Photographic Solutions	www.photosol.com
Sensor Film	www.sensor-film.com

Resetting to the Default Settings

If certain features of your camera appear to stop functioning, and you haven't dropped or damaged the camera in some way, your first course of action should be to reset the camera to the default settings. Like many complicated electronic devises, the A300 series dSLRs are designed to operate in a complex sequence that depends on various settings to be in a specific mode. If those settings get out of order, you may not be able to use certain functions on the camera. What appears to be a faulty camera may simply be a camera with a menu command engaged that prevents it from responding to your instructions. In many cases, the camera is designed to prevent certain operations when particular menu commands are in force.

Because the A300 series relies heavily on menus, it is quite possible to set an obscure setting deep in the menu hierarchy and forget about it. Suddenly you notice that every picture you take is underexposed. Or the pop-up flash consistently washes out the subject. Or color casts start to appear on your images. Before you send the camera in for service, reset everything to the default and see if the problem clears up.

It would be time-consuming to set each menu back to the default setting. In addition to the time it would take to reset each command, you would probably have to do some research to establish just what the factory setting should be.

Fortunately, Sony has equipped the A300 series with a Reset menu. Located under the third Tools menu, the Reset default command will set your A300 series to the state it was in when it left the factory.

AB.6 You will find the Reset default under the third Tools menu. Activating the menu will bring up a dialog box asking you to confirm you want to reset the camera.

Even if your camera is working well, you should reset the defaults from time to time. Having your camera in a pristine state will help ensure you get the results you want when you start experimenting with new menu settings.

Battery Basics

The battery used to power the Alpha A300 series is a Lithium-Ion design, part of Sony's extended life M series of batteries.

Like all rechargeable power sources, a little care can make a big difference in battery longevity. Here are some tips to follow:

✦ **Do not store batteries in a discharged state.** Lithium-Ion (Li-Ion) batteries require a partial charge to stay healthy. If the battery is stored in a discharged state for a length of time, it is possible it will no longer accept a charge. If you are not going to use your A300 series camera for several months, you should take time to charge the battery from time to time. Some battery experts recommend storing Li-Ion batteries with a 40 percent charge.

AB.7 The NPF-M500H InfoLithium M battery used in both models in the A300 series.

✦ **Recharge your battery(s) whenever it is convenient.** Sony claims that the NPF-M500H battery will not develop a memory (a state where the battery thinks it's fully charged, but it's not), so you can charge it whenever you want, even if it is only partially discharged. Unlike other battery technologies, it is better to recharge Li-Ion batteries frequently rather than waiting until they become fully discharged. Because the NPF-M500H has a "fuel gauge," experts suggest fully discharging the battery every 30 charges or so to maintain the gauge's accuracy. The rest of the time, the battery should not be fully discharged, as this can cause the battery to age more quickly.

✦ **Avoid heat.** Li-Ion batteries do not like heat. Heat can damage a Li-Ion battery's ability to hold a charge. All Li-Ion batteries discharge more quickly as they age. Heat intensifies this problem, causing the battery to hold a charge for a progressively shorter time. Once a battery starts to age prematurely, the damage is done and there is no way to restore the battery to full health.

✦ **Avoid freezing.** Although heat can damage a Li-Ion battery, freezing can kill it. It is good to store batteries in a cool place, even in a refrigerator. Just don't freeze them.

✦ **Don't buy more batteries than you need.** Li-Ion batteries start to age as soon as they are built. It is a good idea to have a second battery on hand, especially if you often do extended shooting. If you buy more batteries then you need, however, those seldom used backup batteries will wear out just as quickly as a battery that sees extensive use.

Finally, use common sense when handling and storing your A300 series. Never expose the camera to moisture, which can affect

the sensitive electronics inside the camera. Protect the camera from freezing. Never leave the camera inside a hot car. Don't point the camera directly at the sun or extremely bright lights.

Unlike older manual cameras, modern dSLRs are packed with electronics that can be easily damaged. With a little TLC, however, you can expect your A300 series to provide many years of service.

 Caution *Note that viewing the sun through your dSLR viewfinder can also seriously damage your "sensors" — your eyes!*

Glossary

AEL Lock Auto Exposure Lock. The button that allows the user to pre-lock the metered exposure until a shot is made. Locking the exposure is useful when lighting conditions might confuse the camera's meter. In a case where intense back-lighting would cause a subject to be silhouetted, you can move close to fill the viewfinder with the subject, lock the exposure, and move to another location. Because the exposure is locked, the camera will override the meter to use the close-up exposure. The A300 series features an AEL lock button on the back of the camera.

APS-C Advanced Photo System-C. The designation of the sensor size of the Sony A300 series, as well as many other digital single lens reflex (dSLR) cameras. These models are identified as full-frame cameras. The A300 series has a sensor that matches the film size of the APS cameras introduced the 1990s. Some dSLRs have larger sensors that are the same size as 35mm film negatives. These models are identified as full-frame cameras.

ambient lighting The light in a scene that is not provided by the photographer. Also known as existing light or available light, ambient light may come from lamps, street lights, windows, candles, firelight, even a television monitor.

anti-alias A technique used to smooth bitmap images so curves and diagonal lines look correct in a digital image.

antishake See *Super Steady Shot.*

aperture The opening inside the lens that limits how much light passes through the lens. Some specialty lenses have a fixed aperture, but most lenses have a variable iris that can be adjusted to admit more or less light as needed. Also a measure of the lens' focal length by the width of its light-collecting diameter, expressed as an f/# (for example, f/2.8). See *f-stop.*

aperture priority A semiautomatic mode on the A300 series that allows you to select the f-stop to shoot with. The camera then attempts to set an appropriate combination of shutter speed and ISO setting.

aspect ratio The ratio of the width and height of a photograph. The Alpha 300 series can record in either a ratio of 4 × 3 or 16 × 9. 4 × 3 is the most common photograph format.

autofocus The system that adjusts the focus of the camera's lens to obtain the correct focus on a subject, without intervention from you.

Auto mode A fully automatic mode on the A300 series that allows the camera to determine all the settings for a balanced image. In addition to setting the aperture, shutter speed, ISO, white balance, and focus, the Auto mode also determines when to use the camera's popup flash.

backlighting Light coming from behind a photographic subject. When the backlighting is predominant, the subject appears as a silhouette.

barrel distortion Bulging distortion in an image, primarily seen when wide-angle lenses are used. Straight lines appear to bend in from the corners of the image. Usually software can be employed to correct barrel distortion in post-processing. See also *pincushion distortion.*

bokeh A Japanese word referring to the shape or quality of the out-of-focus areas in an image. Lenses differ in the bokeh they create, with highly desirable lenses producing very pleasing bokeh effects. Using a low f-stop produces more bokeh.

bounce flash A technique where an electronic flash is aimed at the ceiling or wall to "bounce" the light from an angle rather than fired directly at the subject. The resulting light is more diffuse and usually looks more natural and pleasing to the eye.

bracketing To shoot the same scene with a range of different exposure settings. By bracketing in challenging lighting conditions, you have a better chance of capturing a usable image. The A300 and A350 can automatically record a bracket series or you can bracket by manually adjusting the exposure while taking a sequence of shots.

buffer Nonremovable memory in a digital camera used to temporarily store an image before it is permanently saved to a memory card. Writing to the internal buffer is quicker than writing to a removable card, so the camera can be ready to record additional images while the data in the buffer is being written to the memory card in the background.

Bulb mode A manual setting on the A300 series that holds the shutter open as long as the shutter release is held down. It is used for very long time exposures.

Camera RAW The name of Adobe's raw image converter. Also the native capture format of a digital camera's sensor. See also *RAW Image.*

CCD sensor Charge-coupled device (CCD) sensor. The type of sensor used in the Alpha A300 and A350 dSLRs. CCD sensors are economical to make, and many very high quality dSLRs and medium format data banks rely on the CCD sensors. See also *CMOS sensor.*

chromatic aberration, axial Unnatural bands of color around the edges of objects in a photo. Chromatic aberration (CA) occurs when a lens fails to focus all color wavelengths at the same plane. Often, blue or

red light will be out of focus and spill into otherwise white areas. The result is often referred to as purple fringing, although the actual color of the fringe can appear as almost any color. The anomaly is usually seen around the edges of dark areas in an image. Superior quality lenses display little or no fringing. Post-processing can also minimize the effect.

chromatic abberation, lateral A spectral blurring of a bright image detail along a line radiating from the center of the image, with blue on one side and red on the other. CA occurs when a lens fails to keep all wavelengths at the same magnification. The anomaly is usually seen near the corners of an image. Superior quality lenses display little or not lateral color, but the effect can be corrected in post-processing software.

CMOS sensor Complementary metal-oxide-semiconductor (CMOS, pronounced "cee-moss"). An alternative digital sensor technology used in certain Sony Alpha dSLRs, but not in the A300 series. CMOS sensors are more expensive to build; however they can have superior noise characteristics and transfer data faster than the CCD sensor used in the A300 and A350. See also *CCD sensor.*

color management The process of maintaining consistent color from capture to display to print. This includes proper white balance on capture or processing, calibrating your monitor, and calibrating your printer.

color space The palette of available colors a digital camera can use to record an image. Changing the color space can affect how a photo looks, as more or less colors will be available. The Alpha A300 series can use either sRGB or Adobe RGB color spaces (this does not apply to RAW files).

contrast The intensity difference between the bright and dark areas in an image. In a high contrast image, the difference between the whites and blacks will be pronounced, while in a low contrast image, the tones appear to be washed together.

crop factor The multiplication factor used when a lens designed for a full frame 35mm camera is used with a camera with a smaller size sensor. The A300 and A350 both have a crop factor of 1.5, meaning that an actual 200mm lens will be the equivalent of a 300mm lens on a full frame camera.

dedicated flash A flash unit that can be controlled by a camera to regulate exposure. Dedicated flash units must be matched to the camera they will be used with. See also *TTL Flash.*

depth of field The area of an image that is in sharp focus (measured in distance from the lens). When shooting with a wide open aperture or with a long telephoto lens, there usually will be a shallow area that is in perfect focus. Objects outside this area will lose focus in relationship to how far away they are from the focused area. Shorter focal length lenses appear to have greater depth of field because details are shrunk down on the image plane.

A wide-angle lens stopped down to its minimum aperture may render everything from a few inches away to infinity in focus. Shallow depth of field is not necessarily bad; photographs often rely on creative use of depth of field to isolate the main subject from a distracting background. On the other hand, a group shot would be spoiled if certain members of the group were out of focus. Stopping down the lens or using a smaller aperture, will maximize the depth of field but require higher ISO speed and/or stronger lighting.

D-Range Optimizer (DRO) Sony technology incorporated in all Alpha dSLRs that attempts to break a high-contrast image into smaller, similar areas, then adjust each area's contrast so the final image displays improved dynamic range. Note: The D-Range Optimizer only works with JPEG images produced by the camera. It has no effect on RAW files, since these only contain unprocessed sensor readings. See *RAW.*

dSLR The digital camera adapted from the single lens reflex film camera, or SLR. These camera employ a moving mirror to allow you to look directly through the lens until the exact moment of exposure, when the mirror flips up to allow the sensor to record the image.

dynamic range The range between the darkest and lightest portions of an image. Cameras cannot reproduce the same dynamic range as the human eye, so you need to pay close attention to balance the highlights and shadows to prevent exposure problems. Methods such as combining various exposures can create very high dynamic range images.

EXIF data Exchangeable Image File format. Embedded text data in image files that list the camera model, lens, exposure settings, date, copyright, and other information about the image. EXIF data isn't visible in the image; software programs are required to read the embedded data from a photo. Although EXIF and metadata are frequently used interchangeably, they are not the same. Metadata is the data the camera knows when it captures an image, such as camera model, shutter speed, aperture, ISO, lens focal length, and so on. Your camera doesn't know your name, your phone number, or in what location a particular image was taken, but EXIF data can include all this and more. Various software programs allow you to add this information to the EXIF data.

exposure latitude The ability of a digital sensor to tolerate under- or overexposure and still produce an acceptable photo. If the sensor has good latitude, the exposure can stray from being correct, but the image will still be usable.

fill flash The technique of using an electronic flash in broad daylight. The flash fills in harsh shadows but has no effect on highlights and midtones. Properly executed, fill flash can create excellent outdoor portraits and group shots.

filter A transparent devise placed over the lens to alter the lens color and contrast rendition or add other optical effects. In image processing software, filters often mimic optical filters' functions but also include effects that are only possible with mathematical transformations.

firmware The operating system software stored inside a digital camera. When new firmware is produced by the camera maker, owners can download the updates from the Internet to fix bugs, add features, and sometimes improve in-camera image processing.

flash sync The maximum shutter speed that a camera can use when shooting with an electronic flash. The A300 series has a maximum flash sync speed of 1/160 sec. Certain Sony flash units offer a High Speed Sync mode that will allow the A300 and A350 to shoot flash exposures at higher shutter speeds.

focal length The distance from the Principal Plane of a lens to the image plane. Focal length determines how large the lens renders an image. Long focal lengths magnify the subject and are sometimes classed as *telephoto lenses.* Short focal lengths produce wide-angle lenses.

fringing See *chromatic aberration.*

f-stop A value derived by dividing the focal length of the lens by the diameter of the light-collecting aperture. Smaller f-stops allow more light to pass through the lens, while larger f-stops restrict the light and display more depth of field.

gray card A neutral gray card used in an aid to determining the correct exposure. Because different colors can affect how the meter evaluates the exposure, metering the light off a standard gray card ensures the meter reading will match the camera's internal calibration. Color-corrected gray cards can also be used to set a custom white balance, requiring no additional post-processing to correctly render colors.

grayscale image An image made up of a series of shades of gray, with no color — a black and white image.

high contrast An image or scene with dramatic differences between the highlights and shadows. High contrast images can look sharper than low contrast ones; however if the contrast ratio exceeds the sensor's dynamic range, the camera will not be able to record the scene properly.

highlights The brightest areas that retain detail in a photograph. Typically the highlights will be white or near white.

histogram A bar-graph representation of how tones are displayed in a digital image, from black to white. The greater the number of pixels of a particular shade, the higher its bar will be. This information can be used to determine if a particular exposure captured the full range of tones in an image.

hotshoe The slot on a digital camera designed to accept an external flash or accessory. The A300 and A350 rely on the ISO style flash shoe originally developed by Minolta. This is an advanced shoe design, but most non Sony/Minolta flashes and accessories cannot be used on with this shoe without an adaptor.

image stabilization See *Super Steady Shot.*

International Organization for Standardization See *ISO.*

interpolation The practice of using a mathematical formula to create new pixels that did not exist in the original image. Interpolation is used by image editing programs to increase the size of an image beyond its original size. The process is also used by some digital cameras to create a digital (non-optical) zoom effect by enlarging the center porton of the image. Also known as *resampling.*

ISO International Organization for Standardization. The international body that sets standards for many industries. In the photography arena, the group has established a rating system for light sensitivity which applies equally to film and digital sensors. The higher the ISO number, the more sensitive the sensor is to light, but the more prone to exhibiting noise in dark regions of the image.

JPEG A standard digital image format overseen by the Joint Photographic Experts. JPEG is an efficient storage format, allowing for various levels of compression. However, JPEGs are lossy and only have 8 bits of color depth. One of two file formats used by the A300 series to store images. (RAW is the other.)

Kelvin (k) A scale used to measure the temperature of light illuminating your subject. All light sources have a specific Kelvin temperature which affects the hue of the light. The Kelvin scale can be used to match the white balance setting to the light source

being used, ensuring white looks white no matter which light source is employed.

Live View The system that allows users of dSLR cameras to compose and focus using the camera's LCD screen rather than the view finder. Both the A300 and A350 feature an advanced Live View system.

macro Shooting a close-up of small subjects where the recorded image is at least the same size on the sensor as the subject is in real life. Generally special macro lenses are used to magnify the subject, although filters and extension tubes may also be used. The A300 series features a Macro Creative Style designed to be used with macro and close-up lenses.

megapixel A numeric measurement equal to one million pixels. Used to indicate the number of recording pixels on a digital camera sensor.

metadata A collection of basic information about how an image was recorded. The Sony A300 series captures metadata such as f-stop, shutter speed, date, time and whether the flash fired. It also records the camera model and the type of lens used. This information is retained in the image file, so this information can be accessed years after the photo was taken. See also *EXIF data.*

midtones The tonal values in an image that do not fall into either the highlights or shadows.

mirror lock up (MLU) Some dSLR cameras enable the user to lock the mirror in the upright position. This is used to eliminate vibration in time exposures as well as when cleaning the sensor. The Alpha A300 series does not have a MLU option.

neutral density filter A light controlling filter designed to reduce the light passing

through the lens without affecting color and tonal values in the image. Neutral density (ND) filters allow you to use very low f-stops, even in bright sunlight.

overexposure An incorrect exposure setting that allows too much light to be recorded by the sensor. Overexposed images are characterized by blown highlights and ghostly shadows.

PC sync port A camera connection that provides a place to attach a cable to a remote flash unit. The remote flash will then fire when the camera's shutter is tripped. The A300 series does not offer a PC sync port. If you want to work with remote flash, you must use wireless flash or purchase an optional adapter that attaches to the hotshoe.

pincushion distortion Image distortion where straight lines appear to bend inward toward the center of the image. Usually seen in inexpensive telephoto lenses, pincushion distortion can usually be corrected by software during post-processing. See also *barrel distortion.*

pixel The smallest single element in a digital photo, camera sensor, or computer monitor display. All digital images are made up of a tapestry of pixels, arranged to reproduce the scene the camera recorded.

point-and-shoot camera The term used to describe small digital cameras with electronic view finders and permanently attached lenses. These cameras do not offer as many adjustments as a dSLR.

polarizer filter An optical filter that eliminates haze and reflections. Polarizers also increase contrast in washed-out skies, dra-

matically improving landscape photos. Autofocus lenses require a circular polarizer; older style linear polarizer filters confuse the autofocus and meters in digital cameras.

Program mode The automatic mode on the A300 series where the camera determines the best combination of aperture and shutter speed settings. Unlike the Auto mode, the Program mode does not fire the popup flash unless you raise it first.

purple fringing See *chromatic aberration.*

RAW A file format that records the camera sensor's unprocessed output. RAW files are not actually images, and so cannot be used directly from the camera. Rather, they must be uploaded to a computer where processing software is used to render a TIFF or JPEG image. (This may be confusing, because many image viewers and image management packages render RAW files transparently and display the previews right next to JPEGs and TIFFs.) RAW files allow the user to correct exposure, enhance shadow and highlight detail, sharpen fine detail, correct for lens characteristics, apply various filters and adjust color in a range not possible once a JPEG has already been rendered.

red eye The phenomenon that causes blood in a person's eye to glow red when an electronic flash illuminates the retina. Animals can also exhibit this distracting effect, although their eyes may look green, blue, gold, or orange. The A300 series has a red-eye reduction mode that can reduce this effect. A remote flash is the best way to eliminate red-eye completely. The farther to the side a flash unit is from the camera's line of sight to the subject, the less chance you will see red-eye in an image.

resampling See *interpolation.*

RGB The color model used to display images on a computer monitor or LCD screen. Colors are displayed by mixing amounts of red, green, and blue light. When all three colors are displayed at their maximum value, the image will look white; if all three colors are set to zero, the image will appear pure black. Because RGB images are lit from within, they sometimes look very different from prints, which use a completely different process to display an image with colored ink on opaque paper.

saturation A term photographers use to indicate how rich and vibrant various colors are in an image.

shadow area The darkest tones in a photograph. Shadows do not have to be completely black; in properly exposed images, some details may be visible in the shadows. See also *highlights* and *midtones.*

sharpening The process of using post-production computer software to make an image look sharper than it came from the camera. Most images can benefit from selective sharpening; however, too much sharpening can spoil an image.

shutter lag The amount of time that elapses between pressing the shutter release and the actual firing of the camera. The A300 series cameras, like all dSLRs, have an extremely short shutter lag, a major advantage over point-and-shoot cameras.

Shutter priority mode An automatic mode on the A300 series that allows you to select the shutter speed to shoot with. The camera then attempts to set an applicable balance of f-stop and ISO settings for proper exposure.

shutter speed The length of time the shutter curtain remains open during an exposure. Shutter speeds affect exposure by

controlling how much light the camera's sensor records; a longer shutter speed will record more light than a shorter one. Also, fast shutter speeds can stop action; slower shutter speeds can produce blur effects.

specular highlights The reflection of a light source in hard, shiny surfaces. Specular highlights can be distracting, but many times they are essential to show off a particular subject.

Super Steady Shot Sony's in-camera image stabilization technology. Super Steady Shot (SSS) allows users to hand-hold their cameras at slower shutter speeds than would otherwise be possible. The big advantage to SSS is every lens attached the camera can be stabilized, in contrast to in-lens systems that require expensive image stabilized lenses. It is important to realize that image stabilization only prevents blur due to camera motion; it has no effect on moving subjects.

TIFF Tagged Image File Format. A popular lossless image format for digital images which also allows for saving 16-bit color data. The Sony A300 series does not create TIFF images; however, you can save in the TIFF format from a RAW file using Sony's Image Data Converter SR program.

time exposure Exposure made to either allow motion of the subject to be captured in the image or to allow for exposures in dim light and can last minutes or even hours in length. With the A300 series, you must set the camera to manual exposure or shutter priority and use the Bulb mode to keep the shutter open for the required time.

TTL flash Through-the-Lens flash. Technology that allows a camera to measure the light from a dedicated flash unit and turn off the

flash when sufficient light has reached the camera's sensor.

tungsten light The light from a typical household incandescent light bulb. Tungsten bulbs generally display a red or yellow cast unless white balance mode is set to Auto or Tungsten.

underexposure An incorrect exposure setting that results in too little light being recorded by the camera's sensor. Under-exposed images look dark and dull, with no detail in the shadows and gray or muddy highlight areas.

unsharp mask An option in many desktop software programs that make images appear sharper by "masking" the unsharp details in the photo, accentuating the fine details.

vignetting A steady falling off of light in the corners of an image, generally appearing with lower quality wide-angle lenses. Filters and lens hoods can also cause vignetting. Usually considered a defect, some photographers exploit vignetting for an artistic effect.

white balance A camera adjustment that compensates for variances in light temperature to ensure white areas do not take on the hue of the light. The Alpha A300 series features an automatic white balance setting, which is often quite accurate. The cameras also offer preset, custom, and full manual white balance control. Note that if you capture RAW files, you can reset the white balance when you process the image.

Index

Continued

Continued